Remapping Performance

Remapping Performance
Common Ground, Uncommon Partners

Jan Cohen-Cruz
Syracuse University, USA

With contributions from
Nancy Cantor
Maria Rosario Jackson
Julie Thompson Klein
Todd London
Helen Nicholson
Penny M. Von Eschen

First published 2015 by
PALGRAVE MACMILLAN

Palgrave Macmillan in the UK is an imprint of Macmillan Publishers Limited,
registered in England, company number 785998, of Houndmills, Basingstoke,
Hampshire RG21 6XS.

Palgrave Macmillan in the US is a division of St Martin's Press LLC,
175 Fifth Avenue, New York, NY 10010.

Palgrave Macmillan is the global academic imprint of the above companies
and has companies and representatives throughout the world.

Palgrave® and Macmillan® are registered trademarks in the United States,
the United Kingdom, Europe and other countries.

ISBN 978–1–137–36639–9 hardback
ISBN 978–1–137–36640–5 paperback

This book is printed on paper suitable for recycling and made from fully
managed and sustained forest sources. Logging, pulping and manufacturing
processes are expected to conform to the environmental regulations of the
country of origin.

A catalogue record for this book is available from the British Library.

A catalog record for this book is available from the Library of Congress.

Typeset by MPS Limited, Chennai, India.

Contents

List of Illustrations

Acknowledgments

I am grateful to Deborah Mutnick, Dana Edell, and Linda Burnham, intrepid readers of various versions of this text. Sonja Kuftinec and Marvin Carlson offered helped suggestions at particular junctures. Mady Schutzman continues to stimulate my thinking and has doubtlessly affected this work. Elric Kline, Rosa Cohen-Cruz, Lorie Novak, and Karen C. Boland offered invaluable technical assistance. Dionisio Cruz, Daniel Cohen-Cruz, and Syracuse University supported me throughout the writing of this book, each in their own ways. Paula Kennedy and Peter Cary of Palgrave Macmillan were responsive and helpful throughout.

Participation in other writing projects informed this book. A chapter for Randy Martin's edited collection, *The Routledge Companion to Art and Politics*, contributed to my thinking in the Introduction. Thanks to Mark Valdez and Pam Korza, I attended and wrote about the Network of Ensemble Theaters' Microfest-Honolulu, reflected in Chapter 1. Reflecting on engaged performance projects in higher education for Anne Basting's book about The Penelope Project helped refine my Chapter 3. Another version of Chapter 4, in Max Stephenson, Jr. and Scott Tate's *Tensions, Tactics, and Imaginaries: The Roles of Art and Culture in Community Change*, helped clarify my thoughts on the neighborhood base for this book. In 2011, Bronx Museum Director of Education Sergio Bessa brought me on as the evaluator for smARTpower, at the heart of Chapter 5. I heartily thank them all for these opportunities.

The people I write about were abundantly generous, responding to a stream of questions, engaging around ideas, and welcoming me into their meetings, workshops, rehearsals, and performances. The photographers and copyright holders graciously allowed me to reproduce the images here at no cost. The authors of what I have come to think of as the "companion pieces" accompanying each chapter brought expertise beyond my own in keeping with the book's premise that much of what we want to achieve on the social stage cannot be realized through our individual discipline alone.

Notes on Contributors

Nancy Cantor is Chancellor of Rutgers University–Newark. She is recognized nationally and internationally as an advocate for reemphasizing higher education's public mission. A prominent social psychologist and higher-education leader, she was Chancellor at Syracuse University and the University of Illinois at Urbana-Champaign, and Provost at the University of Michigan. A former dancer, she fervently believes in the "unique power of the arts to demolish corrosive barriers and foster honest intercultural dialogue."

Maria Rosario Jackson is Senior Advisor, Arts and Culture, at the Kresge Foundation and consults with national and regional foundations and government agencies on strategic planning and research. She is also the James Irvine Fellow in Residence at the Luskin School of Public Affairs, University of California, Los Angeles and adjunct faculty at Claremont Graduate University. Her expertise is in comprehensive community revitalization, systems change, the dynamics of race and ethnicity, and the roles of arts and culture in communities. In 2013, with US Senate confirmation, President Obama appointed Dr. Jackson to the National Council on the Arts.

Julie Thompson Klein is Professor of Humanities in the English Department and Faculty Fellow for Interdisciplinary Development in the Division of Research at Wayne State University in Detroit, Michigan. Holder of a PhD in English from the University of Oregon, she is past president of the Association for Interdisciplinary Studies (AIS) and former editor of the AIS journal, *Issues in Integrative Studies*.

Todd London, a former Managing Editor of *American Theatre* magazine, has written, edited, and/or contributed to over a dozen books, and received the George Jean Nathan Award for Dramatic Criticism. At the time of the Q and A session, London had been artistic director of New Dramatists, the nation's oldest center for the support and development of playwrights, since 1996. In 2014, he became executive director of the School of Drama at the University of Washington.

Helen Nicholson is Professor of Theatre and Performance at Royal Holloway, University of London, UK. She is co-editor of *RIDE: The Journal of Applied Theatre and Performance*. Her self-authored books include

Applied Drama: The Gift of Theatre (2005, second edition 2014), *Theatre & Education* (2009), and *Theatre, Education and Performance: The Map and the Story* (2011).

Penny M. Von Eschen is Professor of History and American Culture at the University of Michigan. Her books include *Satchmo Blows Up the World: Jazz Ambassadors Play the Cold War* and *Race against Empire: Black Americans and Anticolonialism.* She co-curated "Jam Sessions: America's Jazz Ambassadors Embrace the World," a photography exhibition on the jazz ambassador tours, with Meridian International Center, Washington, DC, that opened in April 2008, and toured globally as well as in the United States.

List of Abbreviations

ABoG	A Blade of Grass
AFP	American Festival Project
ASITW	A Studio in the Woods
BTS/D	*Beneath the Strata/Disappearing*
CAN	Community Arts Network
CCC	Centro Cultural Chacao
CCUSA	Catholic Charities USA
CHP	Chinatown History Project
CU	College Unbound
CUNY	City University of New York
CY1	*Cry You One*
DFR	The D.R.E.A.(M.)3 Freedom Revival
DTE	Dance Theatre Etcetera
FAB	Fourth Arts Block
FST	Free Southern Theater
GFC	Gulf Future Coalition
GRN	Gulf Restoration Network
HTEP	*How to End Poverty*
HUD	US Housing and Urban Development
IA	Imagining America: Artists and Scholars in Public Life
LES	Lower East Side
MoCA	Museum of Chinese in America
MRGO	Mississippi River Gulf Outlet
NEA	National Endowment for the Arts
NET	Network of Ensemble Theaters
NOCD	Naturally Occurring Cultural Districts
NOCD-NY	Naturally Occurring Cultural Districts-New York
NPN	National Performance Network

NYU	New York University
OSF	Oregon Shakespeare Festival
PRTT	Puerto Rican Traveling Theater
QM	Queens Museum
ROOTS	Alternate ROOTS (Regional Organization of Theaters South)
SNCC	Student Nonviolent Coordinating Committee
SU	Syracuse University
TCG	Theatre Communications Group
THN	Town Hall Nation
TIE	Theatre in Education
TO	Theatre of the Oppressed
UBW	Urban Bush Women
UW-M	University of Wisconsin-Milwaukee

Part I
Grounding

Introduction: A Vibrant Hybridity

> The best collaborations emerge from the recognition of
> some kind of common grounding between uncommon
> partners.
> > – Pam Korza (qtd in Bartha et al. 2013),
> > co-director, Animating Democracy

> Where does the stage begin and end?
> > – Melanie Joseph (2014 interview),
> > director, Foundry Theatre

The focus of this book is partnerships between people from performance and other fields, when neither collaborator's goals are attainable by their expertise alone. They are what Pam Korza calls uncommon partners, brought together by commitment to a common, social concern. When performance is part of such projects, they may or may not include the creation of a show, take place on a stage, direct themselves to established audiences, or even be recognizable as performance, but they rely deeply on aesthetic training, methodologies, and mindsets. The context of such work is not art but a larger, social frame.

By social, I mean the systems we inhabit with other people to acquire basic human needs such as food, shelter, clothing, employment, education, health, peaceful coexistence, meaning, and recreation. While artistic responses to the social world are often the *subject* of performance, I focus on collaborations in which the artist is part of initiatives not of their sole devising and whose products are not only art. In such instances, the frame is as likely to be the social context as art.

Art as part of social initiatives in the US emerged out of multiple traditions, with one strong root being community arts. The sense of the

3

issue as the frame for such practice was articulated at a 2004 gathering of longtime practitioners convened by the directors of the Community Arts Network (CAN). For a decade, CAN had been the primary online source of essays by and about US artists working in community contexts, that is, grounded in affinities of place, tradition, or spirit (deNobriga 1993, p. 13). The resulting CAN Report emphasized the shift from art-centered projects to cross-sector collaborations incorporating the arts:

> The most significant discovery ... was the emergence of a new energy: a vibrant hybridity, an accelerated fusion of community-based arts and other fields of activity, such as community development, activism, education, aging, civic dialogue, cultural policy and globalization. The center of activity is not a "field," but an intersection of interests and commitments ... While these practitioners have always collaborated across disciplines and outside the arts, they have tended to identify primarily as arts-centered, hence the need to describe the work as its own field. There is now a hunger to do more. (Burnham et al. 2004)

Community-based theater's integration of performance professionals with people who have relevant lived experience of the subject extends naturally to people whose pertinent insights come from other disciplinary expertise. That is, the sense of "something new" articulated at the CAN gathering went beyond underrepresented people telling their own stories, as valuable as that is, to people with professional expertise around the *issue* contributing as well. Each in its own way provides rich content, grounds the work concretely, and expands the potential venues, publics addressed, and array of strategies so that the work usefully effects the issue.

An example of the move from community-based performance to the use of performance in uncommon partnerships is artist Marty Pottenger, in her integration of creative engagement into the practice of government in Portland, Maine. In 2004, Bau Graves of Portland's Center for Cultural Exchange approached Pottenger to facilitate a participatory cultural response to federal government raids targeting immigrants and refugees. Over the course of nearly a year, she made monthly trips to Portland, interviewing a range of people impacted by the raids, and then writing, casting, rehearsing, and producing a play entitled *home/land/security*. The cast included local people in a range of circumstances: a homeless man, a French Canadian union organizer/retiree, a leader

of the local Sudanese community, a Mic'maq/Native American college student, the mayor, the state senate president, Portland's fire chief, and the director of Maine Emergency Management.

Pottenger was so effective in using performance tools to bring diverse people together that the city manager and mayor invited her to move to Portland and set up an office in city hall through which to use the arts to deal with entrenched challenges around race, community relations, labor issues, and diversity within the city's police, public services, and health and human services departments. She took them up on the offer, relocating to Portland. There she used artistic tools not to create a play but as the basis for workshops within city agencies through which workers could get to know each other in a different way, contributing to a municipal culture more experienced with and inclusive of difference. Pottenger's focus is identifying opportunities waiting to be seized and using art techniques to those ends, not beginning by inviting people into an art project *per se*. Pottenger's work manifests being moved to collaborate with people because of their indispensable lived knowledge, as well as with those whose formal knowledge of the subject matter renders the art more useful systemically.

Another source of cross-sector art is that which takes into account the artist's own multiple passions. Being an artist need not mean abandoning one's other concerns, be they the environment, international relations, or education. Just as theater-in-education is a respected method of embedding the arts in non-arts curricula, and drama therapy is an established field of its own, art has long been integrated into efforts including community organizing, conflict resolution, humanizing medicine through narrative, and expanded methods of educating communities about their legal rights, to name just a few.

Then, too, many performers do extensive non-arts research in the course of making work, so much so that the project brims over the boundary of conventional theater. This may reflect, in addition to a personal impulse, the orientation of artists training less frequently in independent studios and more in universities, where many study ideas and theories at the same time as they learn aesthetic practices. Particularly experimental artists who already question, like Melanie Joseph in the epigraph above, where the stage ends, are predisposed to exploring with whom, where, and for what purposes they are making art.

Some art that extends beyond aesthetic boundaries into social territory is called civic practice, which director Michael Rohd, a strong practitioner of such projects, defines as "an activity where an artist employs the assets of his/her craft in response to the needs of non-arts

partners as determined through ongoing relationship-based dialogue. The impulse of what to make comes out of the relationship, not an artist-driven proposal" (Rohd 2012). Civic projects draw on many of the same dramaturgical techniques that he and his company, Sojourn Theatre, have honed in the creation of original plays. An example of art as civic practice is the community-building workshops Sojourn facilitated in response to an invitation from Catholic Charities, a national anti-poverty organization, to apply its theater-based techniques to their 2012 national conference.

Rohd distinguishes civic from social practice, the term he uses for initiatives that artists generate:

> Social Practice ... initiates with an artist's desire to explore/create a conceptual event or moment of their design. The design and/or execution may engage non-artists in any number of ways: it may leverage non-arts partners and community resources, it may intend to specifically impact the social or civic life of the context in which it occurs in measurable ways, or it may intend to exist as an aesthetic interruption from which impact is to be derived in an open, interpretive manner. But alongside whatever social or civic needs the project addresses, the leading impulse and guiding origin energy is from the artist. (Rohd 2012)

An example of social practice is Sojourn's *How to End Poverty* (2013), which while combining elements of a play, a participatory workshop, and a lecture, and drawing heavily on conversations between Sojourn and anti-poverty organizations and policy thinkers, was initiated by Rohd and the company.

More has been written about social practice in the visual arts than in performance, although the latter is equally robust and long-standing. This may be because more of such performance projects have been situated in communities to which the artists are committed than in art world spaces, and use the language of "community-based," whereas the language of "social" is more art world-palatable.[1] More familiar to visual artists may be critic Andy Horwitz's description of art as social practice as that which

> enlists "non-artists" in the creation and development of a project and has as a goal some kind of awareness-raising or social impact. This doesn't preclude aesthetic considerations or the possibility for the realization of a singular artistic vision, but it implies a set

of conditions that are outside of more traditional artistic practices. (Horwitz 2012)

Social practice within the visual art world largely aligns with one of two formats, as theorized most prominently by art historians Grant Kester (2004) and Claire Bishop (2006). Kester distinguishes between "collaborative, 'dialogic' works and projects based on a scripted 'encounter'" and Bishop identifies "an authored tradition that seeks to provoke participants and a de-authored lineage that aims to embrace collective creativity" (Finkelpearl 2013, p. 4).

Numerous initiatives promote both performance and visual art as social practices. Artists-in-Context, for example, was founded in 2009 "to support the research-based, multidisciplinary, embedded practices of contemporary artists and other creative thinkers who seek to invent alternative approaches to existing societal challenges" (Artists-in-Context n.d.). Many of the participating artists in the cultural diplomacy initiative smARTpower (Chapter 5), grounded in the visual arts, used performance in their collaborative projects. Other artists conversely begin in performance and extend into the visual arts. Shannon Jackson insightfully addresses the complexities of artistic forays into other media in *Social Works: Performing Art, Supporting Publics* (2011).

Jackson's understanding of the avant-garde adds art world credibility to her critique of "models of political engagement that measure artistic radicality by its degree of anti-institutionality"; and her familiarity with social reform, as manifested in her publication about Chicago's Hull-House settlement, *Lines of Activity* (2000), situates her authoritatively to address the equal importance of "art forms that help us imagine sustainable social institutions" (S. Jackson 2011, p. 14). She continues: "When a political art discourse too often celebrates social disruption at the expense of social coordination, we lose a more complex sense of how art practices contribute to inter-dependent social imagining" (p. 14). Jackson exemplifies the importance of critics in this field allied with both art *and* social institutions to affirm as well as question aesthetics that engage with the social.

New York City Department of Cultural Affairs Commissioner Tom Finkelpearl (2013) sees artists working with people outside of the art world but not letting go of the dominant vision, hence calling the practices cooperation rather than collaboration.[2] The performing artists I write about often shape the vision of the overall project with their cross-sector partners even while providing aesthetic leadership.

Journalist Scott London's description of collaboration and why it is important captures why I gravitate towards that term:

> [C]ollaboration can be a powerful alternative to conventional mechanisms for effecting change ... [which] tend to be structured vertically. Decisions are made at the top and people derive their influence and authority from their positions within the hierarchy ... Collaborative groups, by contrast, are structured horizontally. Leadership ... is broadly distributed. Job titles and professional affiliations fade into the background and people derive their influence from having their ears to the ground, from being well-connected in the community, and from being engaged in a multiplicity of projects. Membership usually spans silos and divisions in the community, processes are guided by norms of trust and reciprocity, and communication is more personal, more conversational, more exploratory than in formal settings. (London 2014)

> Horizontal collaboration[3] across sectors presumes that both parties need to learn something about how knowledge emerges, is activated, and spreads in each other's contexts. Rooting such partnerships in all collaborating sectors increases the likelihood that art's contributions will be useful and sustainable in contrast to artists working in a sector without equal engagement from someone from the other knowledge-area. (London 2014)

A recurring thread in much socially oriented performance is the intersection of commitment to place and to locally significant action. In the US in the early twentieth century, for example, civic leaders involved performance makers in efforts to either absorb immigrants into US culture, on the municipal level, through the creation and performance of giant pageants, or preserve their relationship to their natal culture even as they "became Americans," often through neighborhood-based settlement houses. The 1930s, given the extremity of the Depression, was a period of extraordinary social art, as government supported artist employment in the general effort to get people back to work. Hallie Flanagan's account of directing the highly decentralized, government-supported Federal Theatre Project, in her book *Arena*, recounts its experiments with regional specificity and diverse social purposes of art.

Performance accompanying political movements is another kind of social practice. In 1963, for example, John O'Neal, an aspiring actor and

playwright of color, was about to move from his Illinois home to New York City to begin a career in the theater. But the civil rights movement was heating up in the south. O'Neal reasoned that he needed to give the movement one year, after which things would surely have improved and he would embark on his long-sought theatrical profession. He moved south and co-founded, with Doris Derby and Gil Moses, the Free Southern Theater (FST), which worked closely with SNCC, the Student Nonviolent Coordinating Committee. The FST was a cultural wing of civil rights in the south – contributing theater-generated activities to lead people to greater consciousness about the struggle. The umbrella under which the FST operated was the movement, not theater *per se*. O'Neal did not leave after one year, though in 1985 he and the company "buried" the FST in a full-out New Orleans jazz funeral in recognition that with the end of the movement, it had no reason to continue to exist. Out of its ashes, O'Neal immediately launched Junebug Theater, which continues to this day. O'Neal never made his theater career in New York City, never had to; all he needed was in the south.

Art in uncommon partnerships also emerges in response to multi-disciplinary local efforts. The Local Initiatives Support Corporation (LISC) "help[s] community residents transform distressed neighborhoods into healthy and sustainable communities of choice and opportunity" (Local Initiatives Support Corporation n.d.). Mobilizing corporate, government, and philanthropic support, they build on neighborhood assets of all sorts, including artistic. For example, Franklin Avenue in Minneapolis was designated as the American Indian Cultural Corridor, and features a Native American gallery and coffee shop. Arts workshops now animate what were empty storefronts in North Minneapolis, "conceived ... to boost community engagement and economic development. The Springboard for the Arts' Irrigate project funded more than 100 art projects in six inner city St. Paul neighborhoods to create 'a unique sense of place' along the Central Corridor." Local LISC deputy director Erik Takeshita explains: "The arts can help people love a place ... and make [it] more welcoming to others ... both qualities you find in places that thrive" (qtd in Walljasper n.d.).

The above examples point to the book's title, *Remapping Performance*. I am not describing wholly new performance phenomena. Rather I am articulating their place on a map of where art actually takes place, a much broader terrain than where plays and other more recognized aesthetic artifacts are presented. This map is not centered in New York and other large cities because uncommon partnerships are broadly dispersed across the country (and world). The larger map supports two theses of

this book: that one can make a life that is committed to both art and to a social issue/s; and that all the partners, from the various fields, stretching beyond their base in service of a shared goal, have much to gain from such collaborations. Innovation in the theater emerges not only in specialized districts such as where John O'Neal imagined he needed to go to make an artistic life, but also in places where the need to create something different than exists propels artists to new explorations, audiences, and partners. These are places of idealism and always have been. Such commitments do not require leaving theater altogether. Concomitantly, one does not have to "go to the theater" to benefit from the creative processes that inform it.

Finally, in bringing cross-sector uses of art to scale, I focus on the role of networks – be they consortia of professionals nationally, such as the Network of Ensemble Theaters in the theater world, Alternate ROOTS at the crossroads of art, activism, and community, and Imagining America: Artists and Scholars in Public Life in academia; across sectors in one locality, such as Naturally Occurring Cultural Districts-NY, whose members are part of neighborhood art and culture initiatives; or international programs, such as the US State Department's cultural diplomacy efforts. I explore ways that artistic and cultural practices and products that contribute to social issues are recognized and expanded through local, national, and international organs.

Three modes of performance and the social

Because I situate this book in the context of theatrical modes addressing social issues, what follows is a brief review of three such approaches. The first and most familiar are finished artistic productions that bring a social issue to public attention and take place in designated aesthetic spaces. Second are participatory modes for people who are not professional theater makers, including workshops and situations where the process of making the play is the heart of the experience. The third mode introduces the focus of this book, performance methods that artists seeking both aesthetic and efficacious impact employ with people who can extend their reach into a relevant social frame. Each of the three modes provides a way to make a life in performance and commit energy to other issues of importance without forsaking one for the other. Some initiatives draw on one of these modes to interface with the social world; others explore the possibilities inherent in two or all three, depending on the issue, the moment, the goals, and the partners.

The finished production

Growing up in a small town in Pennsylvania in the 1950s to 1960s, I thought theater was synonymous with the production of plays, which for me were a lifeline. Like Kafka's desire for the book to serve as "an ax that smashes the frozen sea within us," viewing performances of plays (on precious trips to New York City) like Peter Brook's 1963 *Marat/Sade* and the Open Theater's 1966 *America Hurrah* thrilled me and many others by bringing the outside world in – *Marat* resonating with the Vietnam War and *America Hurrah* with the toxicity of US conformity and consumerism. I recall my fascination when resistant theatergoers hurried down the aisle and out of the building at a matinee performance of *Marat/Sade*. Also of this period and even earlier, and perhaps most iconically, the Living Theatre's very name suggested the aligning of art and one's everyday life that grounded political aspirations of much Western performance at that time.

Peter Brook directed *Marat/Sade* during the period that he was exploring the work of Antonin Artaud (1896–1948), the French mystic/creator of "Theatre of Cruelty." Artaud saw everyday life as false and looked to performance to get beneath that veneer to our more uninhibited, socially unconstrained selves. His "Theatre of Cruelty" was intended to be raw (the literal translation of the "cru" in the French word "cruauté," not "cruelty" as harshness in the English sense), to provoke spectators through emotional violence and put them in touch with deeper feelings. Influenced by Artaud, Brook wanted spectators to *go through* something and shaped the theatrical event accordingly. The idea that theater could be a place where something happened to the spectator as well as where something was imagined was an underpinning for theatrics that aspired to political activism later on.

America Hurrah (1966) by Jean-Claude Van Itallie is a trilogy of three short plays that were a harbinger of the growing counterculture. That was important in itself – theater companies that provided the occasion for like-minded people to gather. (At the time, someone told me I went to countercultural theater the way other people go to church.) Directed by Jacques Levy and Joseph Chaikin and developed with Chaikin's Open Theater, my favorite company of that period, they peeled away the mask of everyday life in very theatrical ways – the giant insatiable puppet that dominated one of the three playlets, the transgressive scrawling on the walls that overtook another. The Open was an ensemble theater; the level of commitment from all the actors was palpable. They were communicating something about contemporary US life differently than was done in realistic theater. Equally significant, all

the performers helped make the plays and were part of an ongoing company, so were co-creators rather than interpreters, the role open to most actors (albeit, there are many exceedingly creative "interpretive" actors). This so-called collective creation was a political move in the sense of expanding agency, from the writer and director to the actors, an artistic expression of the participatory democracy taking hold in social movements characterizing that time.

Later hearing creator of Theatre of the Oppressed Augusto Boal say that theater is the capacity of the human being to create a space within a space gave me a way to understand what was such a lifeline about those productions. I could imagine breaking out of the constraints of how to be a person in Reading, PA. This resonates with Judith Butler, who has written famously about the constraints of gender, which, as something performed, can be enacted in other ways than inherited. By extension, how one performs personhood generally may similarly be reinvented. The epitome of the space that theater gave me as a child to perform a self larger than the one that felt restricted by everyday small-town life was in a summer stock production of *The Miracle Worker* playing Helen Keller, whose outside expression was of a piece with inside sensations. I thrashed around, not seeing, hearing, nor speaking; I felt that even people who loved me wanted me socialized. And (certain) theater was where, as a young person, I experienced the greatest freedom.

In addition to collective creation, the impulse to make theater an experience that loosened the boundaries between art and life was manifest in experiments like environmental theater, which seated spectators in the midst of the playing space,[4] and increasingly, auto-biographical solo performance. For many, the logical next step was to physically move beyond the safe confines of the theater building. A performance could unfold anywhere, with passers-by unexpectedly ensconced in prepared dramas. In feminist experiments in the 1970s, women created alter egos who then performed in real life as a way of trying out their fuller selves. The compulsion to move from theater buildings to a "theater-without-walls" was epitomized by the phrase "it's just theater," signaling the limits of theater as a space to concretely address social ills, the sense that it was inconsequential before the first spectator ever entered the institutionally marked place. Radical street performance – "expressive behavior meant for public viewing, set in places with minimal constraints on access, that question or re-envision engrained arrangements of power" (Cohen-Cruz 1998, p. 1) – could appear anywhere at any time as a rapid response to something happening. The idea that theater could be disruptive, that the world outside

could tear through the imaginary construct of such pieces, now strikes me as a rehearsal for bringing art out of an institutional space in order to interrupt a social space.

Participatory theater

Participatory workshops and productions integrating people not trained as actors but deeply invested in the subject gained ground as being as significant socially as are performances with trained actors. Augusto Boal's Theatre of the Oppressed[5] (TO) and community-based theater broadly are vibrant examples of theatrical practices that spread to spaces – union halls, community centers, parks, and city streets – that are welcoming to a range of participants and audiences, while nonetheless manifesting what Boal identified as characteristics of aesthetic space:

> 1. Plasticity: transforming reality such that, for example, time can go forward or backward, and events can be enacted that are simultaneously in the past, present, and/or future;
> 2. Dichotomic/dichotomizer: doing an action and looking at oneself doing it at once; and
> 3. Tele-microscopic: bringing close what is far and making big what is small. (Boal 1995, pp. 20–7)

These qualities of aesthetic space not only expand art's reach, but also respond to Claire Bishop's criticism that art with social goals is accountable to social but not artistic outcomes (2006, p. 13). Much of social art's efficacy happens precisely through its aesthetic capacity including the qualities noted above.

The theory of change underlying TO explains the significance of its broadly participatory formats. TO is based on the potential for initiating change on the part of people without apparent power but with the most motivation, for themselves and others in their social situation, in the pursuit of social justice. It provides theatrical methods for experiencing the social dimension of the personal and collectively coming up with solutions. TO workshops take place in groups struggling around the same oppression – the homeless, the incarcerated, employees low in a hierarchy, undocumented workers, and so on. Boal believed that theater could be a rehearsal for the revolution; participants who spoke out and acted in the safety of a workshop could then transfer that proactivity to the social stage. Workshops often begin with games, freeing people to be expressive and create bonds of fellowship in order to move forward collectively. Scenes provide a context in which to practice possible

solutions. Later Boal invented "legislative theatre," whereby challenges that people in a problematic situation could not overcome in workshops were brought to the attention of the legislature and voted upon as the basis for passing new laws.

Community-based art, encompassing TO as well as many other artistic modes, and foregrounding participation in plays and other theatrical processes, is expression facilitated by artists with people aligned with each other by virtue of shared geography, tradition, circumstances, or spirit, and whose lives directly inform the subject matter.[6] This is not the place to address the complicated "romance" of community that scholars including Miranda Joseph (2002) warn against. But in order to celebrate the profound work that performance does in engaging people and enabling new and revised relational formations, it's important to remember some of the cautionary tales around "community." One of my own touchstones is community organizer Saul Alinsky's story about training residents of a working-class community in Chicago in organizing techniques, only to have them use their new skills to keep the neighborhood segregated. Community as an idea does not contain an intrinsic set of values and is used to exclude as much as to include.

Nonetheless, the recognition that people may get more from making art than from seeing it is at the root of community-based art's power. Exploring a topic of shared interest, engaging with techniques to facilitate sharing different points of view, and going through the process of making and presenting something involve aesthetic skills that are also useful in human interactions outside of art. The story circle is the epitome of the democratic impulse in art: participatory, welcoming all; pluralistic, having no conditions that would leave anyone out; non-hierarchical, taking place in a circle; and inviting stories that come from firsthand experience, a great leveler because experience cannot be "wrong."

In the same spirit, and involving a range of artists and institutions, from large and mainstream (such as the Jewish Museum in New York City) to small and community-situated, in the 1990s the Animating Democracy Initiative focused on arts-based civic dialogue. They supported 37 art projects that engendered communication around issues that are "complex or multi-dimensional, cross-cutting, that is, of concern to multiple segments of a community; and contested by various stakeholders, eliciting multiple and often conflicting perspectives on the issue" (Korza et al. 2005). Belief in involvement in decision-making by all stakeholders bespeaks the politics of participatory democracy enacted through the arts.

Nevertheless, community-based art is critiqued for catalyzing only temporary change, as is the norm with enacting utopia: when carnival ends, we go back to our regular lives. This limitation was articulated by cast member Mary Curry in Cornerstone Theater's 1989 production of *Romeo and Juliet in Port Gibson, Mississippi*, performed by white upper-middle-class and black working-class residents from two sides of the track: "[H]er son Allan and another ten year old cast member, Athena Hynum, a [white] Academy girl, may be playing together now, but as soon as the show is over everything will return to normal – whites will once again pass black people in the streets without so much as a hello" (qtd in Kuftinec 2003, p. 70).

The temporary nature of change in much community-based theater is predictable given that artists do it as art, albeit a deeply democratic and inclusive art. Indeed, not all community-based theater artists see social change as a goal. The exemplary Cornerstone Theater's founding co-director Bill Rauch has said that whatever happens in a community after they leave is strictly in the hands of the people who remain (personal correspondence n.d.). From 1986 to 1992, when Cornerstone went from place to place and project to project, they typically left a couple hundred dollars as seed money to build on the experience with them, but that was the extent of it. Nor did they go out of their way to identify local people to continue the social processes the play had set in motion or supported. Community-based art intersects with politics on a modest scale: as a context for many people to express their views and hear different perspectives. It provides a context to enact democracy. More than that depends on the initiative of local participants besides the artists. This is not a limitation of community-based theater but a description of its purview.

Cross-sector collaborations

The third mode, and the subject of this book, is partnerships integrating performance with people from other sectors who are in positions to augment the art's efficacy. These three modes are not sequential, with cross-sector performance an advance over finished productions and participatory theatrical forms, but rather ebb and flow at different moments. But this third mode is not always recognized as performance practice.

One source of cross-sector collaborations is US socially engaged theater in the second half of the twentieth century, which was strengthened by the national movement of art situated between aesthetics and efficacy through its ties to energetic social movements. In the 1960s, the

San Francisco Mime Troupe was aligned with the free speech movement in the Bay area; Bread & Puppet built strength through its role in anti-Vietnam War protests and marches; El Teatro Campesino on the west coast was a cultural wing of the Chicano movement as was the Free Southern Theater of the (African American) civil rights struggle in the south; and companies including It's Alright to be Woman accompanied the women's liberation movement. Many of the artistic leaders of these theaters were also involved in the corresponding movements, which their companies served through performances, workshops, and other ways of participating such as providing a strong visual presence at protest events and a platform to teach about pressing issues.

Working across sectors has long been part of some artists' socially committed artistic practice. But by and large, such relationships have stayed in the context of a piece of art. Liz Lerman and Jawole Willa Jo Zollar, two icons of US dance who have stretched who dances, where, and about what, explored cross-sector partnerships integrated with a production and workshops in a joint project called *Blood, Muscle, Bone: The Anatomy of Wealth and Poverty*. Beginning this multiyear collaboration in 2011, they knew they would make a dance performance and, in the process, engage a group of people in a creative process. But they wanted to take a third step and explore ways to leave something behind that extended beyond the aesthetic experience. To that end they expanded their research, at one point consulting with economist Shanna Ratner,[7] an expert on the equitable generation of community-based wealth.

Ratner was working with the Ford Foundation to identify "intermediaries" in communities who continue initiatives that Ford helps develop, from finding local sources to generate wealth to keeping wealth in communities. In the course of a public conversation, Ratner described artists, considering the nature of the wealth they contribute, as among the intermediaries with whom the Ford Foundation might partner. They drew from seven kinds that Ratner articulated – individual, intellectual, social, political, natural, financial, and built.[8] That is, Ratner's expertise in economics brought the possibility of another dimension to Lerman and Zollar's project, a new way of thinking about art's ongoing local contribution.

In *The Limits of the City* (1986), Murray Bookchin views municipal confederations' distinctiveness from nation-states as important in their "recovery of politics as an activity that must be distinguished from statecraft: politics in the Hellenic sense of wide public participation in the management of the municipality" (1986, 50). These three modes of

performance also offer "wide public participation," which is where they most broadly intersect with politics. Art is the imagining of something else, providing a context and a set of prompts for daydreaming individually and collectively. Politics is the process of putting something into place in our public lives on a collective scale, or having one's collective imaginings seriously considered by others in order to put them into effect broadly.

Imagining publicly is socially useful through its capacity to embody alternatives. Jacques Rancière identifies the main problem with critical art to be not that the dominated lack understanding of the mechanisms of their domination (which, he assures readers, they don't) but that they "lack the confidence in their own capacity to transform it" (qtd in Bishop 2006, p. 83). Or maybe they have the sense to recognize the wide gap between an imagining and a reality. After participatory art like TO, a well-received street presentation, or an affirming expressive experience in one's own community has boosted confidence, what would it take to make an imagined change permanent? Peter Marcuse noted the challenge facing the Occupy movement wanting to go "beyond" Zuccotti Park where it began in New York City, but to exactly what government office do they bring their grievances? Or do they go to a government agency at all? Who can "fix" the lack of agency most people experience when trying to contribute to the polis? (*Beyond Zuccotti Park* panel 2012).

If an artist wants her work to lead to what it imagines, more than dancers and actors are required to get there. People like Ratner with knowledge of community-based wealth generation similarly need not only economics but also a space people can dream in together such as a performance component can provide. While valuable as a context for many people to express their views, hear different perspectives, and thus enact democracy, stand-alone art seldom contributes lasting interventions in social issues. Concrete change depends on integrating components beyond the arts.

The organization of this book

> What is the real map of US theater and what is the one we carry around in our heads?
> – Todd London, executive director, theater program, UW-Seattle

Part I of this book, "Grounding," begins with this Introduction. To integrate uncommon partners into my work on this book, paralleling the case studies I write about, the Introduction and every chapter except the

last is followed by a "companion piece" by someone whose expertise is other than but complementary to my own. Given the preponderance of US case studies, British applied theater scholar/practitioner Helen Nicholson contributed the first companion piece, framing the book for readers from the UK.

In Chapter 1, "The Breadth of Theatrical Territory," I contend that the *"either* social *or* aesthetic" conception of US theater that characterized much of its modern history, with those theater makers committed to the social risking marginalization, is morphing into the possibility of "social *and* aesthetic." While artists nearly always respond to social stimuli in their subject matter, they do not typically do so in partnership with people outside the art world or as a form of action, but that is becoming more acceptable. I look at the pivotal role of theaters with a strong sense of place – be they regional, ensembles, or community-based – in breaking down boundaries between aesthetic and social purposes. I highlight examples of the integration of social and aesthetic goals across nonprofit theater: in the Network of Ensemble Theaters (NET)'s 2013 MicroFest and *Cry You One*, a performance project created by two ensemble companies, ArtSpot Productions and Mondo Bizarro, in response to the disappearing wetlands in the Gulf; director Bill Rauch and the community-based Cornerstone Theater's early collaboration with a regional company, Arena Stage, and Rauch's current leadership role at the regional theater Oregon Shakespeare Festival; and the Public Theater's launch of Public Works under the direction of Lear deBessonet. Following the chapter is my interview with Todd London, a leader in US nonprofit theater, for 19 years artistic director of New Dramatists, and now head of University of Washington's theater program.

In Chapter 2, "Partnering," I focus on different ways that professionals in performance collaborate around social issues with experts from other disciplines. I draw on scholar Julie Thompson Klein's ideas about multi-, inter-, and transdisciplinarity. Multidisciplinarity recognizes the value of different bodies of knowledge working alongside each other but not merging into something new. In such cases, artists rely on performance techniques that are particularly transferable to nonaesthetic contexts. My example is director Michael Rohd and Sojourn Theatre's work with Catholic Charities, an anti-poverty organization. Interdisciplinarity entails a closer relationship between fields, suggesting that the problem *needs* knowledge from more than one source. I elaborate on founders of the early Free Southern Theater who were at the same time SNCC (Student Nonviolent Coordinating Committee) organizers, bringing

consciousness-raising through performance and post-performance discussions to the movement's grassroots. Transdisciplinarity focuses directly on the problem, beyond participants' professional orientations. My example is ArtSpot Productions and Mondo Bizarro's *Cry You One*, which encompassed a performance piece, a website, and a series of one-day salons in partnership with environmentalists, organizers, and people living along the ravaged Gulf Coast. I briefly consider what kind of education supports cross-sector performance projects. Following the chapter, scholar Julie Thompson Klein identifies advances in the theory and practice of what she now calls border crossings.

Part II, "Platforms," evidences the proliferation of contexts integrating performance in partnerships towards social goals. Its three chapters address, respectively, higher education, neighborhoods, and government-funded cultural diplomacy initiatives as sites of uncommon partnerships. Many theater makers want to "make a difference" in the world, yet the arts are typically viewed as their own sector with few concrete outcomes. It is instructive to see diverse platforms from which artists are stretching into such partnerships. While many frameworks could have been the focus – the possible combinations of performance *and* ... are endless – I have selected contexts in which I had access to compelling case studies.[9]

In Chapter 3, "Universities, Performance, and Uncommon Partnerships," while acknowledging the opportunities of the university base for cross-sector projects, I ask: How are interdisciplinary projects with core non-university partners justified as appropriate components of the college experience? What of the relationship between such projects and their disciplinary base? How do cross-sector performance initiatives that don't align with strictly aesthetic criteria secure a place within theater and performance departments? I focus first on how such projects gain recognition in higher education by framing them as pursuits dedicated to expanding knowledge and contributing to higher education's mission to serve the public good. I elaborate on one such frame, civic professionalism – the intersection of a robust undergraduate education, hands-on experience of potential professional pathways, and participation in civic life. I then give examples of performance-based projects generated from a higher-education platform, describing how they both fulfill the criteria of civic professionalism and have been accepted within their discipline.

I begin with two short-term projects initiated by theater director Michael Rohd: Town Hall Nation, accompanying the 2012 presidential elections; and *How to End Poverty*, a one-week residency/performance

piece that Rohd instigates at universities and regional theaters. I then turn to The Penelope Project, a two-year initiative exploring the role of the arts in healthy aging. Playwright and scholar Anne Basting at University of Wisconsin-Milwaukee rewrote the end of Homer's *Odyssey*, when a much-aged Odysseus returns to the ever-waiting Penelope, engaging an entire long-term care facility with her students in its production. Her partners included gerontologists, staff and residents of a long-term care facility, professional theater makers, students, and multidisciplinary faculty. I then consider other structures for such partnerships, involving scholar-administrators and nontraditional students. Rutgers–Newark Chancellor Nancy Cantor, formerly chancellor of Syracuse University, which hosted the organization Imagining America: Artists and Scholars in Public Life when I served as director, adds insight through her national perspective on the potential of community-engaged arts in higher education as "scholarship in action."

Chapter 4, "Art and Culture in Neighborhood Ecosystems," is about artists who engage with people and organizations in the neighborhoods where they work, with an emphasis on appropriate metrics to assess their value. I focus on Naturally Occurring Cultural Districts-New York (NOCD), a network of such constituents spanning all five boroughs of New York City. Some NOCD artists work strictly locally; others have national and even international reputations. All are nourished by the neighborhood base, and in return engage with diverse local residents and institutions. NOCD brings such artists and cultural professionals together across the city, facilitating activities to impact policy. NOCD emphasizes that neighborhoods have powerful cultural and artistic assets that contribute to a resilient and thriving city and are deserving of more municipal support. At the same time, NOCD recognizes that the arts and culture sector is not more important than other local entities like small businesses, housing, and schools; they are interdependent. NOCD-NY advocates for policy tools and support mechanisms for community-based networks including arts and culture to develop strategies in response to the city's opportunities and inequities. In the companion piece following the chapter, urban planner Maria Rosario Jackson extends the chapter's purview through her national lens.

In Chapter 5, "Cultural Diplomacy as Collaboration," I look at a collaborative model of cultural diplomacy supported by the US State Department through a project called smARTpower. Designed and administered by the Bronx Museum, it was carried out in 15 countries in 2011–12. In many cases having to first overcome skepticism because of

US government involvement, 15 cultural organizations around the globe each hosted a US visual artist for 30 to 45 days. Local people participated in problem solving using the US artist's approach. SmARTpower was an alternative to the dominant, one-way model of presenting US artists' work to the largest possible number of people. As smARTpower evaluator, I briefly observed 11 of the projects. Penny M. Von Eschen, who has written about the jazz ambassadors of the 1960s and early 1970s, elaborates on smARTpower from her historic vantage point in an exchange with me following the chapter.

The Coda, "The Future of Performance with Uncommon Partners," begins at a gathering of Alternate ROOTS, a network of artists who make work in, with, by, for, and about their communities. It took place ten years after the CAN meeting with which I began this Introduction, at the same conference center and around essentially the same issue – performance integrated into and framed by social initiatives. The ROOTS gathering is my jumping-off point to reflect on what it would take for performance to be more fully integrated in cross-sector initiatives. I identify seven promising directions: more expansive and accessible education in artists' formation; systemic appreciation of artists and scholars in each other's professional cultures; writers who both sharpen discourse among artists and disseminate cross-sector practices to a larger public; assessment aligned with the field's joint aesthetic and social goals; funders who support jointly aesthetic and social initiatives; networks linked more deliberately to organizing; and artists embedded long term in various ecosystems.

While in no way encyclopedic, this book suggests some of the venues to consider in drawing a more accurate map of contemporary performance activity. It brings to mind my revelation, in the 1970s, upon seeing a photograph of Liz Lerman Dance Exchange with people aged 17 to 80-something dancing together. Intergenerational images were rare in performance, especially dance. As a person past middle age (unless the 60s really are the new 40s), I need to see images of different ways that people age. I am lucky to be a baby boomer; there will be more movies, plays, and books about people over 60 than ever before, because of the growing number of consumers. What do you need to see? What do you need to do? Art grants you wings to imagine it, and depending on the company you keep, colleagues with whom to make it fly.

The Silence within the Noise: Reflections from the UK on "A Vibrant Hybridity"

Helen Nicholson

The challenge to write a response from a UK perspective to this stimulating introductory chapter is daunting. Following the twists and turns of socially engaged theater over the last 50 years or so traces a contested history; there is a rich legacy of different perspectives and complementary voices that has contributed to diverse contemporary practices in the UK. Socially engaged theater also travels, and the networks and practices Jan describes so eloquently have extended beyond national boundaries leading to dialogue between practitioners and scholars across the world. This rhizome-like activity means that sharp distinctions between practices in the UK and the US cannot always be made.

And yet, there are differences. The three aspects of practice that Jan identifies – the finished production, participatory theater, and cross-sector collaboration – are recognizable to practitioners in the UK, but patterns of history and geography mean that they are differently nuanced. Reading about how the civil rights movement led to the vibrancy of the Free Southern Theater, for example, or the influence of the Vietnam War on theaters of protest, invited me to reflect on the same historical period in the UK, and the ways in which historical events shaped performance practices. Anyone whose childhood was spent in a British city in the 1950s or 1960s will have memories of playing on bombsites, often with slum clearance taking place around them, the aftermath of the Blitz. Those of us living in the UK in the 1970s, 1980s, and 1990s were accustomed to regular bombings in shops, pubs, and other public areas, often a consequence of the Troubles in Northern Ireland. Theater historian Marvin Carlson memorably notes that all theater occupies a haunted space. Since the 1950s it seems that socially engaged theater in the UK has been doubly haunted; it is haunted by the noise of bombs.

One of the playwrights whose work straddles socially engaged performance and building-based theater (such as London's Royal Court Theatre) is Edward Bond, who grew up in London during the 1939–45 war. It is hard to imagine the scars and sense of disorientation that were left by living in cityscapes that could change, literally, overnight. Speaking in 2010, he reflected on how this experience influenced his writing:

> One of the things that makes me a writer is that, from the age of three, I was constantly bombed ... People would fly overhead and try and kill me. A bomb is coming down and you say, "it must hit me" ... And so you write out of the noise – and the silence within that noise. (Bond qtd in Todd 2010)

Bond's metaphor of writing out of the "silence within that noise" seems to summarize the impulse that continues to define socially engaged theater. And although memories of the war Bond describes have faded, and a different generation of practitioners has embraced what it means to live in a New Europe, a fierce sense of social justice still guides practice. Writing about twenty-first-century performance "in a time of terror," Jenny Hughes suggests that politics in today's age of uncertainty is "defined by the production of waste and wasted life" (2011, p. 21). Radical, socially engaged theater still appears to occupy a wasteland in which the sound of bombs is never far away.

Hughes's emphasis on waste is instructive, as it points to the relationship between materiality, performance, and social change. If, as Marx suggests, social change is only possible when material circumstances become equitable, it is worth paying attention to the ways in which "basic human needs such as food, shelter, clothing, employment, education, health, peaceful coexistence, meaning, and recreation" that Jan invokes in her Introduction are experienced at different times and in different places. This distinction of wealth, precarity, and poverty inflects the history of all three modes of socially engaged theater that Jan identifies. For radical theater makers such as Joan Littlewood and John McGrath, "The Finished Production" in mid-twentieth-century Britain involved popular forms of theater, which offered one way to challenge entrenched class-based politics and uneven distribution of wealth that scarred everyday life. Participatory practices arose, literally, from the ashes of a bombed-out city when Coventry Belgrade Theatre began their Theatre in Education (TIE) programs in the 1960s. Predating Augusto Boal's TO by at least a decade, Theatre in Education

practitioners developed a lexicon of participatory processes designed to disrupt the perceived rigidity of an outdated education system. In the words of Gordon Vallins who designed the first TIE program, TIE aimed to engage young people in stories that enabled them to move from the "known to the unknown" (1980, p. 2). Unlike TO, therefore, the emphasis in much early TIE was on grappling with the ambiguity of fragmented narratives rather than resolving social issues. It is interesting that TIE did not travel particularly well to the US and, as Jan attests, Boal's methodology gained widespread popularity perhaps because it aims to inspire motivated individuals interested in "coming up with solutions."

The third mode Jan articulates, and the subject of this book, is collaborations between different sectors. This is timely; cross-sector collaboration throws values and beliefs into relief, raising questions about how the expectations of artists, participants, funders, and others involved in the process converge. The challenge to define what collaboration (and community) means in an increasingly biopolitical world where the locus of power is often diffuse or unclear is increasingly pressing, and speaks to broader questions about the social and cultural ecologies in which theater takes place. Furthermore, the double ontology of community and art is often constructed biopolitically, as representation of divergent formations of experience and as a new articulation of power, knowledge, and embodiment. This means that the values ascribed to arts practices are politically porous, as Eleonora Belfiore and Oliver Bennett comment, and can be used to further "governmental agendas" by "instrumentalising the cultural sphere," or serve as a mode of resistance (2008, pp. 155–8). Collaboration across sectors illuminates these intrinsic values and, as Jan points out, suggests how performative boundaries are blurred and transgressed when people are encouraged to "embody alternatives" as a result of "imagining publicly."

Debates about collaboration in the UK have similarly prompted discussion about asymmetrical relationships between artists, funders, participants, and others involved in the process of socially engaged theater making. The tensions between artists' vision and authorial content have been articulated in different ways over the years, with Anthony Jackson identifying the relationship with art and instrumentalism in theater in education (2007), and James Thompson articulating the significance of affective experiences in applied theater (2009). Cross-sector performance, at best, has the potential to dissolve or disrupt tired old binaries between art/instrumentalism or affect/effect, and breathe new life into artistic collaborations that rely on the differentiated knowledge

and understanding of everyone involved. In my own work I have articulated this uneven ebb and flow as a gift relationship, recognizing that gifts, however generously offered, can be both welcome and unwelcome (Nicholson 2014). The rich and diverse case studies promised in this book offer further insights into the ways in which different performance practices can benefit from the contributions of people with diverse perspectives and experiences, working on common ground. Yet finding this common ground, with uncommon partners, is often a messy and unpredictable process.

The observation that, as Jan points out, artistic practice "needs knowledge from more than one source" is equally relevant in the UK. Cross-sector collaboration clarifies the ways in which the material and immaterial labour of art-making is divided, not only illuminating the biopolitical relationship between art, labor, and life but also posing questions about the economic structures in which art-making takes place. On the one hand the artist's voice can be strengthened by recognizing the distinctive patterns of labor involved in each project, clarifying the particular qualities that artists bring to a particular setting. On the other, the pressure from funders to meet instrumental targets for well-being, for example, can assume that the role of the arts is as panacea, an easy remedy that will ameliorate contemporary social pressures, whether they may be alleviating loneliness in the elderly, crime in the city, or the educational underachievement of young people. It also draws attention to the fact that artists, funders, and social intermediaries are often paid for their labor, whereas participants almost always work for nothing. In the UK, where state funding for socially engaged arts is always susceptible to the interests of the political class and has been significantly eroded at the time of writing, the labor that artists bring to collaborative practices is often integral to the social structure of communities and sustains arts organizations. Hughes points out that performance's critical potential is defined by its "capacity to discomfort, unsettle, and estrange by providing encounters with life and worlds that exist outside habitual frames of recognition or appreciation" (2011, p. 20). It is the role of artists, when working in partnership, to provide the aesthetic labor that will enable participants to find the metaphors to articulate the still point of these unsettling encounters.

The metaphor of silence within the noise of bombs dropping that I have borrowed from Edward Bond is, perhaps, surprising given that the vibrancy of socially engaged theater making is often loud and robust. Collective silence, however, can act as a temporal break in everyday life, a moment to reflect or disrupt the "normal" patterns of living. Emma Cocker, writing

about her collaboration on *Open City*, a series of artist-led participatory interventions that took place in Nottingham, UK in 2008, says something similar about stillness:

> Stillness presents a break or pause in the flow of habitual events, whilst illuminating temporal gaps and fissures within which alternative, even unexpected possibilities – for life – might emerge. (2011, p. 87)

Cocker is writing about stillness as an actual performative event, but thinking about silence as a metaphor for socially engaged and collaborative forms of art-making points to the symbolic power of listening. Listening draws attention to the noise of human activity within a nonhuman world, to the vital materiality of the daily landscapes we each inhabit, where the silent gap in the world of noise opens new potentialities. The metaphor of silence invites pressing ecological questions that traverse and transcend national and international borders about the waste and waste of life on the common ground we inhabit. It offers an invitation to act when the silence is broken.

1
The Breadth of Theatrical Territory

> The real job of all good dramaturgs is to extend and
> explore territory that the theater has not yet made
> its own.
> – Anne Cattaneo (1997, p. 14)

While performance makers frequently respond to social issues as their subject matter, they do not typically do so in close partnership with people outside the art world or as a form of action, other than at all-consuming moments of social turmoil.[1] More prevalent in the US has been an "either social or aesthetic" conception of performance, in the context of which artists committed to the social, beyond subject matter, have risked marginalization.

Signs point to a shift from the "*either* social *or* aesthetic" norm to the possibility of "*both* social *and* aesthetic" purposes, a prerequisite to the acceptance of performance in uncommon partnerships across disciplines in the theater world itself. In what follows, I look at the pivotal role of theater companies and artists with a strong sense of place, a socially inclusive vision of theater, and creative excitement about performance with a larger reach, for both political and artistic reasons, in breaking down boundaries between aesthetic and social engagement. My examples stretch across ensemble, regional, and community-based theater contexts.

A house divided

> At MOMA treating tribal objects as art means excluding
> the original cultural context [which] ... we are firmly
> told at the exhibition's entrance, is the business of

anthropologists. Cultural background is not essential to correct aesthetic appreciation and analysis: good art, the masterpiece, is universally recognizable ... Indeed, an ignorance of cultural context seems almost a precondition for artistic appreciation.
– James Clifford (1988, p. 200)

Sunrise and sunset performances, graffiti artists, pre-school children, stories of volcanoes and radical arts-based political action – the MicroFest USA National Summit & Learning Exchange will ... bridg[e] the local and national through performances and conversations that address the impact of art and artists in revitalizing communities.
– MicroFest Honolulu program (2013)

The quotes above suggest two contrasting philosophies of art. The former sees anything other than the finished aesthetic product as a deterrent to what makes something art – universal appeal, the unencumbered individual genius as creator, time-and-placeless-ness, and self-contained-ness. The latter finds meaning in art in its various contexts – in the cultural and geographical milieu from which it emerges and further uses to which it may be put. Most US regional theaters have been identified with the former philosophy, community-based theater with the latter, and some ensemble theaters with the one, some with the other. All these theatrical categories have gone through changes since the late twentieth century.

Kathryn Mederos Syssoyeva notes three overlapping waves of theaters whose members create work collectively (aka ensembles). The first wave, from about 1900 to 1950, followed closely upon the rise of the modern director, and called for more "collaboration with designers, composers, and writers, and an actor capable of conceiving her work within a complex mise en scene" as well as attraction to "political impulses, such as Bolshevik collectivism and progressive protest in Depression era United States." The second wave, from the 1950s to the early 1980s, is associated with leftwing activism – "utopic, communitarian ethos, anti-authoritarianism and Marxist-inflected politics ... in noncommunist states" corresponding to "the striving toward radical artistic democracy and leaderless ensemble." Performance like other fields was breaking down hierarchies in favor of broad participation. The third wave, from the early 1980s to the present, is "post-utopic ... dominated by an ethical

imperative (over the ideological) and an interest in the generative creativity of the actor" (Syssoyeva qtd in Proudfit and Syssoyeva 2013, p. 8). Such groups, such as Grotowski and Barba's, were less interested in political ideologies than in "an ethical leadership that aims to facilitate and support the centrality of the actor in the creative act" (p. 9). Extending pro-activity to the actor sets the stage for the social turn in ensembles that I write about here.

As regards community-based theater, the practice of aligning theater with marginalized communities rather than foregrounding only individual and company goals is often dated from the late 1960s, when numerous theater troupes functioned as cultural wings of social movements. But community-based theater practice stretches back to the early twentieth-century settlement house movement and earlier, with the 1960s a particularly robust wave, receding somewhat in the early 1980s as the political climate in the US and Europe was less galvanized by questioning from the left. In Britain, François Matarasso notes a shift from the term community to participatory art around 1979, the beginning of the Thatcher era. He describes that renaming as both "a symptom and an indicator of a profound change ... that saw individual enterprise promoted at the expense of shared enterprise and the recasting of the citizen as a consumer engaged in transactions rather than relationships" (Matarasso 2011, p. 216). Also in recent years, more companies seek to balance their commitment to the place they live and the range of people they include in their work with artistic rigor.

Regional theaters have been slower to change, tending to stay apart from the particulars of their place and more mainstream in their choice of material. Their seasons have often seemed interchangeable with each other – some combination of Shakespeare, European modern, and American plays with a dash of new work. While called regional, they largely produce whatever canon reigns currently in the nonprofit theater sector. A minority, though growing number, of regional theaters produces work that expresses their specific place. This is not to say that the others don't produce interesting work, just that it is more a result of individual artistic visions than an expression of the particulars of that place and the people who live there.

The organization in the US that best represents community-based art-making is Alternate ROOTS (Regional Organization of Theaters South), founded in 1976 by performing artists in the southeast, but now extending to artists of all disciplines and from other regions of the US as well. ROOTS "provides the connective tissue for a distinct segment of the arts and culture field – artists who have a commitment to making

work in, with, by, for and about their communities, and those whose cultural work strives for social justice" (Alternate ROOTS n.d.). ROOTS' notion of community is broad, as articulated in its founding mission: "to support the creation and presentation of original art, in all its forms, which is rooted in a particular community of place, tradition or spirit."

A number of ensemble theaters over the past 40 years have settled in small towns and communities (Proudfit and Syssoyeva 2013, p. 22), their members integrating themselves into the life of those places, setting up conditions for the plays they co-create to have significance to those communities. The emphasis on collective meaning sometimes applies strictly to company members, and sometimes to all those in the situation about which a play is made. Either way, establishing ensemble companies in small towns has brought their purpose into frequent overlap with community-based theaters. The organization that represents the largest contingent of US ensemble theaters is the Network of Ensemble Theaters (NET).

Regional theaters are also place-based. However, Jerry Stropnicky and Laurie McCants of the Bloomsburg Theatre Ensemble note that 15 or 20 years ago, Theatre Communications Group (TCG), the national service organization for US regional theaters, now composed of nearly 500 theater companies compared to NET's 200, did not much acknowledge the work of ensemble theaters. It focused on theaters with largely fixed hierarchies of job areas (director, designer, actor, manager, and playwright). The decision to start NET was, for some, simply to foster exchange with other theater people whose artistic identity was more collective than what TCG supported. Others joined NET because of a vision of art integrated in community life, engaging partners from fields such as education, healthcare, and the environment. Today, some NET companies create original performances, others interpret or adapt existing dramatic literature. Some emphasize rootedness in a community, defined by shared geography, aesthetics, culture, or circumstances; others stand apart so as to critique and provoke. Some regularly embrace social and civic contexts as central to deepening and broadening their art, others do so only when one or two company members spearhead such efforts, while still others never seek non-arts partners. What NET members have in common are a shared decision-making process and a commitment to work together over extended periods of time (Network of Ensemble Theaters n.d.).

Reinforcing theaters' different stances to their specific contexts is their financial bases. Regional theaters have relied financially on their subscribers, which are historically largely white middle and upper-middle

class, and thus have tended to prioritize their interests. Community-based theaters (CBT) are largely supported through grants and, given shows that are frequently free or low-cost, occur at broadly accessible venues, integrate non-actors, and take on local themes, their audiences have been more diverse. They have sometimes found support from non-arts sources, reinforcing cross-sector partnerships. Producing structures also have tended to be different among these three sectors of nonprofit theater: with larger staffs and hierarchical decision-making characterizing most regional theaters, they are not as likely to be responsive to issues of concern to a broad base. CBTs tend to have smaller staffs integrated into the overall life of the company, which facilitates fuller participation. CBT company identities often extend beyond the production of plays, exploring issues that are not addressable only through a show.

Regional and community-based theater: tension and attraction

Scholar Sonja Kuftinec describes a dramatic example of the attraction and tension between regional and CBT theaters in the late twentieth century. Cornerstone Theater, a quintessential community-based company, began in 1985 with director Bill Rauch and writer Alison Carey at the helm. Founding member Christopher Liam Moore explained, "[W]hen we started there was a kind of 'burn down the house' mentality. The company evolved because of a growing dissatisfaction we had with [professional] theater, being really upset by the audience ... it just didn't look like the world" (qtd in Kuftinec 2003, p. 145). Nevertheless, Cornerstone has collaborated with regional theaters on multiple occasions, beginning in 1993 with the Arena Stage in Washington, DC. It is to that fraught collaboration I now turn.

Doug Wager, then-artistic director of Arena, admired Rauch and the company's "aesthetic, humanism, and large-scale storytelling" (Kuftinec 2003, p. 146). Cornerstone appreciated Arena's production staff and comparatively abundant resources. Kuftinec notes that "Arena aspired to 'mainstream Cornerstone's energy' while Cornerstone hoped to change the mainstream" (p. 147). Reflecting on the collaboration 20 years later, Wager confirmed in a 2013 interview that because of Cornerstone's high level of artistry and commitment to diversity through community engagement rather than a missionary (known as outreach) approach, combined with the resources of Arena Stage, he believed the production they made together would be "indistinguishable" from what Arena did in the rest of its season. Integration of the production into the main season was crucial to Wager; Arena already had a much-respected component called Living Stage that only performed in communities for

communities, not at the Arena nor for their typical audience, which, Wager said, was the case with their Washington, DC-specific production of *A Christmas Carol*, called *A Community Carol*. While many regional theaters include productions of *A Christmas Carol* in their holiday repertoire, the Arena–Cornerstone production adapted the story to the East of Anacostia River Washington, DC neighborhood in which it was set:

> Ebenezer Scrooge makes his living as a loan shark in one of the capital's most disadvantaged neighborhoods. Bob Cratchit is an out-of-work chef. It's his wife, Penny, who puts in the long, thankless hours in Scrooge's freezing offices. Their son T. T. (for Tiny Tim) has been confined to a wheelchair ever since a random bullet struck him in the spine while he was playing in the street. (Richards 1993)

Wager noted that the production was part of an ongoing NEA challenge grant to diversify theaters "from backstage forward": that is, including people hired as crew and actors, and who came to see the shows.

Challenges abounded and both sides compromised. For Cornerstone, "Staging the show at Arena was far for the collaborating East of Anacostia River community but as many pay-what-you-can tickets were set aside for them as had they performed there" (Kuftinec 2003, p. 147). Arena's major concession was allowing nonprofessionals on their stage, a deal requiring Cornerstone's company to join Equity, the actors' union. Cornerstone and Arena relied on different metrics in keeping with different goals and artistic philosophies. Then-associate artistic director Laurence Maslon defined Arena's excellence and reputation as "artistic craftsmanship, the quality of artists brought in to the Arena, and quality of the plays produced," which, however, do "not indicate how to measure craftsmanship and quality other than through agreement among practicing regional theater artists" (p. 160). Why not also assess performance skills that come from other traditions such as church choirs, everyday storytelling, and the vigor of expressing something very close to one's own experience? Where were criteria to measure the inclusion of what a broad demographic of Washington, DC residents brought to Arena's stage?

Methodological differences were also apparent. Cornerstone co-founder and writer Alison Carey encouraged community participants to "add their voice to the adaptation at an early read through" which Maslon felt "violated the rigors of theatrical writing" (Kuftinec 2003, p. 162). Some of the cast resented that Rauch cut some of the community input. Arena administration saw as overly political correctness Carey and the

company's decision to change the name of the Washington Redskins in the production to "Potatoskins" out of sensitivity to "the appropriation of Native Americans as sports mascots" (p. 162). And given how seldom women of color were represented on the Arena stage, community actors wanted to make sure to give them a positive spin which Arena administration critiqued as "focusing on political issues of representation rather than pace, characters, and timing" (p. 164).

Nonetheless, Wager believes the production had lasting effects beyond the show, at least in that some Washingtonians became aware that the Arena was producing work that spoke to a more diverse constituency than in the past. It came at a cost; a substantial number of subscribers did not want to see shows that weren't "for and about them" as defined by race and class. Wager mused: "Film audiences look across culture; they are used to otherness in the storytelling they enjoy. Our audience should have enjoyed that otherness as well." From the point of view of a liberal agenda, they would have, but "Washington is a southern town ... People went from eight to six play subscriptions and over the course of my tenure as artistic director, the number of subscribers went from 20,000 to 15,000" (Wager 2013).

How has the relationship between regional and community-based theater changed since then? Reflecting on the Cornerstone–Arena collaboration 20 years later, Larry Maslon notes that *A Community Carol* "was a huge airlift, dropped down in the middle of the Arena instead of cultivating it slowly" (Maslon 2013). The production, so unlike anything that the Arena had done before, was simply inserted in the season alongside Chekhov and Shakespeare without preparing anyone – the Arena's subscribers, company, or staff – for a different kind of experience. Maslon explained that today they would know to have Rauch speak to subscribers and tour individual scenes around Anacostia. Perhaps it would not be part of the regular Arena season so as not to set up what he calls "unrealistic expectations." Maslon elaborated: "How do we do this? Promote it? House people? What if it had begun in Anacostia and created such a buzz it *had* to move to the Arena so more people could see it?" Maslon never suggested it was a mistake for Arena to have produced *A Community Carol* but rather the differences between it and their typical season meant everyone involved needed preparation for the new experience.

While Wager also spoke of the newness for the Arena – in having to house an entire second company (Cornerstone), double cast many parts because community participants were not free for all 50 performances, and deal with some unhappy subscribers – he did not see the

production as that different in spirit from other work he produced there. For Wager, theater's task is "exploring what it means to be human in the time you're living; how theater becomes a healthy part of the life of that community. It's more of a spiritual mission: that the audience find themselves in it." It might not be relevant in the sense of what's blatant in the subject matter. But, Wager continued,

> I don't like the idea of doing theater just for registered democrats. You have to be above the fray of democrat or republican if you are an artist; able to appreciate all points of view, go to what unifies people. People walk into the theater polarized already. Storytelling can be a healing and redemptive force in the community. Certainly Bill uses theater for that. For the audience of the Arena to celebrate the residents of the Anacostia community that was a stone's throw away but none of them ever went there – that was a good use of theater. (2013)

Maslon also noted that whereas 20 years ago there were many theaters with resident companies, practically the only theater with a resident company today is, ironically, the one Rauch now directs, Oregon Shakespeare Festival. Now associate chair of Graduate Acting at NYU Tisch School of the Arts, unlike previous chair (and Arena Stage co-founder) Zelda Fichandler, Maslon and chair Mark Wing Davy are not preparing actors to be resident players, doing a European classic one night and a new American play the next. They are preparing "robust actors" who do theater when they can but also film and television; and they are encouraging the students to be entrepreneurial and produce their own work.

From communities of practitioners to systems of influence

The entrepreneurial spirit required in the theater world generally has helped make a place at the table for initiatives of all kinds, including those equally committed to the social. Overlapping networks have done much to soften the line separating such uses of theater from more traditional aesthetic missions. NET has contributed to recognition that community engagement is not a code word for bad theater. NET membership includes a critical mass of aesthetically exciting ensembles that value civic engagement and are unwilling to compromise on either front.

The National Performance Network (NPN) has also supported companies that are both aesthetically and socially committed, thus contributing to aligning public perceptions of engaged art with reality. NPN was founded

in 1985 as an antidote to artistic isolation, the challenges of touring per-
formance, and the commitment to both artistic and community voices
(National Performance Network n.d.). They have made the diversity of
such companies more visible, supported their work, and helped move a
dual commitment to community engagement and aesthetic excellence
into a broader system of influence. Alternate ROOTS also provides evi-
dence of performance people committed to the social without forsaking
aesthetics. Individual artists and companies frequently participate in
more than one of these networks as well as in Theatre Communications
Group (TCG) and others.

These overlapping networks contribute to a theory of change that
Margaret Wheatley and Deborah Frieze call the Lifecycle of Emergence.[2]
Charting the move from networks to communities of practitioners to
systems of influence, they ask:

> What makes a flock of birds or a school of fish suddenly change
> direction? What seemingly unconnected individual actions led to
> the end of the Soviet empire or the fall of the Berlin Wall? The world
> doesn't change one person at a time. It changes as networks and
> relationships form among people who discover they share a common
> cause and a vision of what's possible. (Wheatley and Frieze 2006)

That is, change becomes possible when a broadly dispersed phenom-
enon is also broadly acknowledged. That happened with feminism:
widespread recognition across the US in the early 1970s that women's
personal experiences of oppression were seldom because of women as
individuals but due to established codes of conduct between men and
women, practices that could and needed to change. Similarly, the habit
of assuming that civic involvement means lowering aesthetic quality
is being dispelled through the interplay among more and more artists
who value both.

Ensemble theater makers strategically organized themselves in the
larger nonprofit theater world as a "community of practice" seeking to
become a "system of influence" at TCG conferences. They made sure
that every time there was an open mic, one of them would get up and
comment or question in such a way as to direct attention to them-
selves as ensemble artists – "just so that the word 'ensemble' would get
out there. And it worked," McCants avowed. A change began under
Ben Cameron's directorship of TCG, McCants notes, enlargening the
tent of who are considered theater makers, resulting in the situation
now that "'ensemble' is viewed as a viable way to do theater, and it's

actually on check-lists on grant applications" (2013). McCants also points to the increase in articles about ensembles in TCG's magazine, *American Theatre*. Further reflecting NET's growing influence, McCants was invited to speak at the 2013 TCG national conference's general assembly rather than at a much smaller breakout session. "In the TCG world," she affirms, "ensembles have moved from the margins to the main stage." In 2013, over 40 theaters were members of both NET and TCG. Indeed, NET director Mark Valdez is on the TCG board.

Having helped integrate ensembles into nonprofit theater culture, NET also contributes to appreciation of CBT's value amongst ensemble and regional theater makers. Segueing from a "community of practice" to a "system of influence," an increasing number of theater makers committed to both social and aesthetic outcomes are moving fluidly through a range of formats – plays, workshops, and cross-sector part- nerships. Central to this expansion is articulating what artistic skills contribute to social issues, what aesthetic innovations emerge when theater makers collaborate across sectors, and to what social actions theater contributes when a production is not the, or the only, outcome. All these issues were visible in the MicroFest that NET sponsored in 2013 in Hawai'i, to which I now turn.

A house diversified

MicroFest USA: Honolulu National Summit and Learning Exchange

Given the multiple identities of US ensemble theaters, a NET gathering is a good place to view what they are doing beyond strictly aesthetic boundaries and why. Executive director Mark Valdez estimates that a quarter of member companies regularly step beyond the aesthetic frame, often through work in schools or with community-based organi- zations (Valdez 2013). NET's June 2013 MicroFest gathering in Honolulu foregrounded cross-sector partnerships, and encompassed some 150 NET constituents, both local and from across the US, partaking in perfor- mances, workshops, discussions, site visits, and learning exchanges. In contrast to theater festivals that are only concerned with aesthetics, the Honolulu MicroFest depended on additional criteria as well. Cultural continuity was sometimes more important than innovation, so often dominating aesthetic values; and the discourse a performance gener- ated was often as significant as the performance itself. Partners from community-based organizations, government, and business were as key as were artists.

The Honolulu MicroFest's emphasis on the work that artists do for both social and aesthetic reasons still manifests ensemble theater values of inclusion, transparency, excellence, respect, active engagement, and knowledge building (Network of Ensemble Theaters n.d.). From 4:30 a.m. on the first day of the gathering, as our groggy cohort excitedly boarded school buses bound for Oahu's eastern shore for a sunrise ceremony, this MicroFest manifested respect for the host culture. It foregrounded local culture bearers, and approached the gathering as an opportunity to build knowledge, in this case about indigenous Hawaiian performance. NET's host in Hawai'i, Vicki Takamine Holt of the PA'I Foundation (www.paifoundation.org), instructed participants to refrain from conversation for the duration of the ritual, and to open up to hidden knowledge – if birds flew overhead, what was their message?

Aesthetic care was evident in every element of the ritual. Accompanied by the sound of a conch shell, a group of Hawaiians led chants in their native language. They enacted traditional movements, with attention to clothing, mood, and arrangement in space, as everyone stood in a circle by the ocean, learning how to clap in a specific way while facing east, almost cajoling the sun to rise above the clouds. This work manifested aesthetic excellence in the sense of beauty, sensuousness, and cultural significance, as articulated by scholar Barbara Kirshenblatt-Gimblett: "meaningful form and value for me are at the heart of what art is" (1995, p. 421).

To gather, reflect on, and disperse the knowledge generated, NET partnered with Pam Korza, co-director of Animating Democracy, a program of Americans for the Arts. Looking at the range of work in the field, Animating Democracy has identified six areas of art's *social* impact, in addition to economic and aesthetic measures: knowledge, discourse, attitudes, action, capacity, and policy. After the sun rose and participants immersed themselves in the ocean, NET artists Daniel Banks, Rachel Grossman, and Michael Rohd facilitated exercises so that participants could explore aspects of their work in relationship to these terms. Having a common vocabulary reinforced the values of NET as a community and pointed to theater's capacity beyond the aesthetic. The session provided deliberate learning together, which is not characteristic, in my experience, of theater festivals.

Theater's contribution to *community* outcomes was evident in the next sessions. Participants chose from four *contextualizations* of theater of significance in Honolulu: food justice, hula and music, Hawaiian language, and nature and storytelling. I attended the session on Hawaiian language, at a charter school dedicated to bringing back indigenous

language and local cultural practices. The students performed a play that they had created in the Hawaiian language. In the process of making it, they had learned the history of their school and more about Samuel M. Kamakau, the educator-historian for whom it is named. Intergenerational ties were strengthened by students interviewing elders, peer community was deepened through collaborating among themselves, individual capacity was enhanced by public speaking and self-presentation, and cultural identity was reinforced by incorporating a traditional story into the play. A group of University of Hawai'i-Manoa students performed traditional Hawaiian mele or songs on indigenous instruments, one accompanied by a hula, all exuding abundant joy (Figure 1.1). The university students noted that they had grown up with no connection to indigenous culture, given the dominance of the US mainland; learning and performing these songs, chants, and music were deeply important to their sense of themselves.[3]

The sessions on Day 2 foregrounded the contribution of art to a social issue with which people in Honolulu and "the mainland" both struggle. Participants chose from sessions focusing on immigration, community

Figure 1.1　University of Hawai'i-Manoa students perform traditional songs and dances for MicroFest participants and local school children.

development, the environment, and homelessness. In most cases two NET companies, one from Hawai'i and another from elsewhere, performed around that theme and discussed the larger projects of which the performances were a part to make the trans-local link and open an exchange. The session I attended on community development included not a NET company but an individual theater director, Michael Rohd, who facilitated conversation, first about an excerpt of a play created by the Kumu Kahua Theatre based on stories gathered from changing neighborhoods. The group then was given a tour of murals sprouting throughout the Kaka'ako neighborhood, followed by a workshop in which Rohd used theater devising skills to engender exchange about the rapid community development taking place there.

The walk through Kaka'ako was an unusual opportunity to visit a place on the brink of rapid growth, when interventions that could advance an equitable process were still possible. The murals are colorful and in some cases educational – one was captioned "Healthy people, healthy oceans, healthy land" and featured a 12-foot naked woman, her body ruptured open with traditional foods like octopus and taro pouring out, such foods barely accessible on the islands anymore because they are so heavily exported. A young artist who has approached private building owners to make mural space available was asked if he saw the owners as using artists to make the neighborhood more desirable and hence profitable for him, with no long-term benefit to artists. He said that just getting spaces to work and bring artists together was rare. He was focused on countering the argument that art in the street is a blight, not an asset. Thanks to 808 Urban, a local "collective of community cultural workers: artists, organizers and volunteers, committed to improving the quality of life for our communities through arts programming" (808 Urban n.d.), teenagers were among the muralists. One teenager testified to her personal growth through participating in the program, working with other youth from diverse geographic and economic backgrounds, learning to create murals, and becoming a spokesperson.

Fifty-some NET participants and 20 or so local stakeholders then discussed art vis-à-vis the imminent community development. Trap Bonner, a filmmaker and community organizer from New Orleans, noted that the murals provide neighborhood beautification which adds value and lowers crime, and provides opportunities for cross-pollination, an incubator space for artists working in partnership with the city, and a context for collaboration with other artists both locally and globally. Cultural consultant and small-town mayor Kathie deNobriga described the murals as an explosion of energy. She wondered aloud

how stakeholders balance this complex endeavor involving massive building. Are they getting and applying knowledge from people who currently live in the neighborhood and if so, how? What access to decision makers do current residents have? Given the nature of change and transition, how will they balance the "been-heres" with the "come-heres"? Marcus Renner, a playwright with an undergraduate degree in environmental studies, wanted to see a map of the neighborhood and the plan for redevelopment. Why, he asked, was change happening so quickly now? Who will be moving in? What will happen to the murals?

Rohd formed small groups of locals and outsiders to reflect on the tour and question art's place in community development. Some NET participants asked if, as elsewhere, the murals were being used as a marketing tactic to create an "art district" to make the area more attractive to potential buyers, not more inclusive of artists. While no answers were expected, questions were collected for people from the neighborhood as they continue to think through how they want to respond to changing circumstances. NET offered to provide a transcript of the session for local reflection, and both Rohd and MicroFest USA Event Coordinator Ashley Sparks (doing well more creative work in developing the festival than the term coordinator suggests) agreed to continue an exchange with them.

A segment of Day 3 was hands-on workshops, many of which emphasized the relationship between aesthetics and culture. I attended El Teatro Campesino's workshop, Theatre of the Sphere. Rather than stripping all particulars and regionalisms of the actor's identity as in much Western acting training, their approach is deeply infused with cultural meaning. Begun in 1965 to culturally support striking Chicano farmworkers in California, El Teatro was soon exploring the Mayan cosmological root of their culture, which shapes their theater and worldview. It integrates the body, spirit, intellect, and emotions and emphasizes connectedness among all living things. Links among particular aesthetics, places, and cultures reinforced that engaging with place and making art are not mutually exclusive.

The gathering ended with reflection on NET's 2013 cycle of four MicroFests (in Detroit, New Orleans, Appalachia, and Hawai'i) exploring how ensemble theaters and the places they are situated influence each other. One NET initiative to enhance cross-sector work is a Fellows Program to develop leadership among artists and community collaborators. Over this MicroFest cycle, six fellows from the four MicroFest venues met numerous times to build skills and discuss arts-driven, cross-sector collaborations with leaders in these practices. Selected for their dynamism, engagement in their own communities, and leadership

potential in art and community development, the fellows are expected to bring the skills they foster back home through sharing practices, leading a skills training workshop, or mentoring a community practitioner or organization. At the same time, NET strengthens its relationship to next-generation theater makers.

ArtSpot Productions and Mondo Bizarro: ensembles conjoining place and content

Ensembles and CBTs are typically grounded in a core group of theater makers who live in the same place, have more ownership over company decisions than actors jobbed in production-by-production, and are positioned to instigate cross-sector projects that have personal and collective meaning. A case in point is a trilogy collaboratively created by ArtSpot Productions and Mondo Bizarro, two ensemble theaters in New Orleans, whose members experienced the 2005 devastation of Hurricane Katrina. Even before the hurricane, ArtSpot director Kathy Randels felt compelled "to bring people outside to call all of our senses' attention to what is happening to our natural environment," a sentiment that became an imperative after the storm (Randels 2014b). Their first site-specific piece, *Lower 9 Stories*, for Junebug Productions Environmental Justice Festival in 1998, was on the levee where the Industrial Canal enters the Mississippi River.

They began the environmental trilogy in 2006 with *Beneath the Strata/ Disappearing (BTS/D)*, calling attention to Louisiana's coastal land loss crisis. It was set at A Studio in the Woods (ASITW), Joe and Lucianne Carmichael's home and artists' residency on 7.4 acres of hardwood forest. Now in their 80s, the Carmichaels, activists since the environmental movement of the 1970s, taught Randels about heightening the relationship between land, stewardship, humans, art, science, and the environment. For Randels, *BTS/D* had to be at ASITW because the project had begun as a conversation with that land at the center. Randels wanted the audience to see the overturned trees and be in the natural environment, outside of the city, they thought they had lost. In addition to initiating their first outdoors performance, this was the first piece Randels directed in which the audience was split into groups so as to facilitate more intimacy.

Randels directed the next piece in the trilogy, *Loup Garou*, with only one actor, Mondo Bizarro's co-director, Nick Slie, so as to be mobile. It was performed in New Orleans so more people could see it. The title character is a creature from French Louisiana legends with a human body and the head of a wolf or dog, similar to a werewolf.

In 2013, the two companies co-created the last piece in the trilogy, *Cry You One (CY1)*, which takes its audience over more than a mile of damaged Central Wetlands of Lower St. Bernard Parish. *CY1* also featured a website with stories and images of people with a stake in the Louisiana coastland whom the company had interviewed. The audience begins at the edge of a forest, where they are divided into groups, each led by one of the characters. Soon a man in a Cajun Carnival mask reveals a suitcase full of cash. The characters each make a case for how they would use it to save land or people:

> Dr. Carol Carl (Hannah Pepper-Cunningham) advocates freshwater diversion plans, allowing for replenishment of sediments in wetlands cut off from the river by levees. Zelda Culotte (Lisa Shattuck) wants to use plastic bottles and other recyclable materials to rebuild barrier islands. Dr. Ozane (Pamela D. Roberts) says it's too late to save many areas and resources should be used to help residents relocate and begin new lives elsewhere. (Coviello 2013)

Cry You One was performed in St. Bernard parish, an area that Katrina hit hard, in part thanks to Monique Verdin, who grew up there. She introduced company members to the Islenos Heritage and Cultural Society, a museum adjacent to the levee, dedicated to preserving the Spanish language, legends, crafts, customs, folklore, rituals, music, and history of Spanish Isleños heritage, through that environment. She drove them all around the parish, explaining the current river diversion and future diversion plans. Verdin's boyfriend (now husband) environmentalist Blaise Pezold showed them the pumping station, and how plants are being regenerated. She also got involved as a visual artist, and performed a central role as a Native American in the show.

Randels explained the importance of getting to know that place:

> The land provided its own dramaturgy, a story of great loss and rebirth. A huge navigational canal was dug in the 1960s (MRGO – Mississippi River Gulf Outlet); an entire wetland was destroyed by saltwater; and the little pumping station that gets water out of Violet, LA after storms, is regenerating the swamp. We wanted everyone to see this story, to see the immensity of the tragedy and to see the hope, the possibility of growth. (2014b)

The company worked on *Cry You One* for six months before settling on the exact site. Then they spent a lot of time simply taking in the

performance location, a two-and-a-half-mile stretch of levees overlooking the ruin of wetlands so damaged by the hurricane and bad human decisions even earlier that where cypress trees once flourished are now a scattering of dead tree trunks.

Slie recalls that the company knew *CY1* couldn't be a conventional play when they realized they wanted the audience to experience the journey that they had taken, from the Isleños Center. The need to have audiences see the dead wetlands meant crossing the water. Writer Moose Jackson came up with the idea to cross the water on a boat, to give the audience "the feeling of floating as a portal into the dream reality" (Randels 2014b). Given that the ferry they eventually designed could only safely hold 12 people at once, they decided, indeed felt required, to have five different stewards taking the people across the ferry one group at a time. That, in turn, created the structure of the piece (Randels 2014b).

The small groups facilitated a level of intimacy, germane to the feeling of connection to the land that the *CY1* ensemble sought. The groups also supported the choice to have each actor represent one approach to the environmental problem, a perspective that character's small group heard in depth, even though they only heard the broad outlines of the approaches that the other characters espoused. Each actor did his or her own primary research. For example, Rebecca Mwase and Hannah Pepper-Cunningham, who played two of the most environmentally active characters, spent time with environmentalist Blaise Pezold, learning about local plants that heal the earth, and butterfly silk said to cure cancer because of plants the butterflies eat from that field. The time Slie spent with local people shaped the character he created, Tom Dulac, the son of oil rig and pumping station workers from a fishing town devastated by hurricanes. The level of improvisational skills and sheer knowledge actor-by-actor also influenced the experience since spectators also conversed with their guides (Randels 2014b) (Figure 1.2).

Slie described the aesthetic impact of structuring spectators' primary relationship with one character:

> We realized guess what; not everyone is going to experience the same show, which for some of us as artists was shocking – the audience was not going to experience all of our brilliant ideas. Because that couldn't happen if spectators were going to be in small enough groups to process things as they went, with one actor/guide. (Slie 2014)

For Randels, even though the choice contributed to a challenging editing process, "Any piece has to be weaving one story, one experience

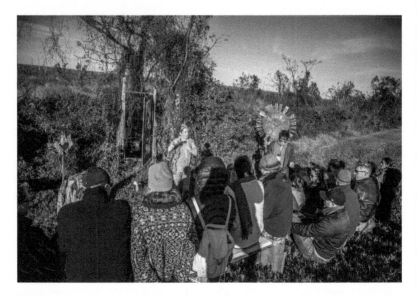

Figure 1.2 One of the *Cry You One* actor-guides addresses her group of spectators.

together for our audience. Jeff [the designer], Moose [the writer], and I still wanted to create a world, an experience through which our audiences were viewing this intense landscape as more than an eco-tour" (Randels 2014b). Having a personal guide for each group was a way to integrate an enormous narrative.

Making *CY1*, the ensemble questioned what a play is in the face of what served the specific experience, which was not only aesthetic but also social and political. Randels elaborated:

> How could we create a work that honored people's pain, healed the land, and gave us hope, driving us to some kind of action that we could all participate in to save this land. Voting is not enough. Singing to the land is not enough. Nothing is enough. But beholding it all together, meditating on the immensity of it all in community, without an agenda hanging over our heads – this was a gift that I think *Cry You One* in St. Bernard gave our Louisiana audiences – and it was precious to also have folks from outside of Louisiana present with us in that "beholding." (Randels 2014b)

Slie, who is Cajun-born, acknowledges the influence of New Orleans culture on Mondo Bizarro's work and on this production in particular.

He emphasizes the southern tradition of storytelling, citing Jo Carson's *Spider Speculations* as a powerful expression of its power. It's a tradition with a social as well as an aesthetic function – to gather, make community, and bring people together over food. Slie notes, "The storyteller is everyone here. I tell my students: you're in the land of completely awesome storytelling. It's part of everybody's needs but definitely of people in Louisiana" (Slie 2014).

Expressive culture in New Orleans is reflected not only in the wealth of storytelling in both art and everyday life, but also in how much people perform local identity. I was in New Orleans one day that the Saints were playing and people were strutting around in their colors, black and gold. They don't just show up, they become Saints; and when you go to second lines you don't stand and watch, you dance down the street. Indeed, Slie confirmed, most New Orleanians have a costume closet:

> At Mardi Gras, people wouldn't take what they wore last year and repeat it. That would be a major sacrilege. People's participation in the culture increases all the time, like a religious leader who can only preach Sunday because of what he's out there doing Monday to Saturday. Same thing with Mardi Gras; it's not just that day. The ordinary citizen's costume making skills are astonishing. The performance of identity in public happens maybe six times a year here. It's not so different from other traditional cultures around the world. (2014)

Traditional culture contributes to contemporary ensemble theater in New Orleans as well. Slie explains:

> When the cultural forms that you're looking at include storytelling, street dance and music, and parading, theater might become more like that. I have been particularly inspired by the social functions of these traditions. We need to codify what's particular about New Orleans theater. Some theater folk down here think we need more regional theater, but why just look at theater practices for inspiration? We deal with old forms – a Mardi Gras Indian down the street from me is weaving a half million beads in 300 days. That practice is more interesting to me as an artist than the latest opening of a play. (2014)

One of Slie's earliest images for the piece – a second line to and for their disappearing land – while not literally represented in *CY1*, was present

in the form the performance took of a public procession, traveling through that wounded landscape. Randels explained the significance:

> Parading, processing, is what New Orleanians do when we mourn someone's death; when we shake loose the spirit from the body; when we want to celebrate something amazing; when they want to look good and feel good; when our skin is too small for all these feelings housed inside of it. (Randels 2014b)

The importance of place since Katrina has further encouraged Slie to listen and think about his work differently than conventional theater, elaborating:

> The hurricane radically changed everyone's why and where they should do things. People looked at all these places with all these stories when they were threatened; we realized they might be gone. It was like ICU, you see a relative there and you think, "I'm going to appreciate you more while you are here." People appreciate if you have skills that bring community together, bring attention to their space and their rebuilding. After Katrina, people needed to be out with one another; that was part of the grieving process. What you do for ten years becomes habit. So the new New Orleans with site-specific theater has very specific cultural roots and history in Katrina; it's not simply a new aesthetic moment. (2014)

Cry You One was long and rambling, to give people time to take in the land upon which actors and audiences stood and moved. It asked audiences to do something for the land, which self-contained shows do not typically do. It was made as much to be useful to the movement to save the coast as to be a deep artistic expression of love, loss, hope, and rage. In brief, it demands a larger conception of what is usually understood by the word "theater," which it sought to achieve through both aesthetic and social choices.

Bill Rauch at Oregon Shakespeare Festival

The alignment of purpose among some CBT, ensemble, and regional theater values is evidenced in the work of director Bill Rauch, who left Cornerstone in 2008, after 20 years, to become artistic director of Oregon Shakespeare Festival (OSF). There he integrates his deeply democratic aspirations for theater in new ways. Rauch does not see regional theater as a monolithic block, with a totally different set of values and

producing methods than community-based theater. While acknowledging differences, Rauch recommends looking at what theaters say their values are and what they practice. He gives these examples from OSF's 2013–14 season:

> Last summer we opened with a play from our series of American revolutionary plays. We closed with a play based on a Chinese fable. On our free, outdoor Green Space, Iraqi students who had never been out of their country performed Shakespeare. I felt we were contributing to cross-cultural understanding in our own small way and was totally high about it. I feel very in touch at such moments with what makes me tick as human and citizen and artist. (2013)

Rauch notes that each institution has its own set of organizational values, even as each person does individually. He sees a constant interplay between the values of the individual and the institution; a huge part of leadership, he believes, is to stay on mission. When Rauch left Cornerstone he said he'd never work again with an organization "with such a pure sense of mission." It was not his values that changed but the material conditions, being on the inside of a large-budgeted institution. Rauch elaborated:

> In 2013, OSF had a $32 million budget and 600 people on the staff; compared to Cornerstone, it is necessarily very hierarchical. Still, OSF is a very value-centered institution that practices what it professes. We lead with our value statement and mission and that guides our work and work processes. (2013)

OSF and the early, touring Cornerstone share significant characteristics: producing work in isolated places of great physical beauty, devotion to interplay between new work and classics, support for a cohort of resident actors, a passion for diverse audiences who are passionate reciprocally: "People come on pilgrimages to the OSF" (Rauch 2013). Rauch emphasized that cross-sector work is a deep part of his identity although it is expressed differently at OSF, which is unionized and composed of professional actors, than it was at Cornerstone, which was best known for casting nonprofessional actors with particularly apt identities (such as a Native American chief playing a Greek king) alongside the company's professional actors. Of this practice, Rauch said, "I'm interested in it, scared of it, did it 20 years and left it, and would like to see OSF do it down the line."

Meanwhile, Rauch asks himself how OSF can be a better citizen of the community and the world. Producing a play about a female Marine returning home from Iraq, OSF offered free tickets to active duty military personnel and vets. This act and the resulting audience set a tone for the production and brought lots of different people to the show. It shifted the dialogue: this could not be just a diatribe against war. The production also featured post-show panels with veterans from the past four wars. OSF produced a *Julius Caesar* for which the director had banners created of leaders that had been loved and assassinated. Spectators saw the banners before proceeding into the auditorium to watch *Julius Caesar*, creating a "dialogue with the contemporary world different than had they just sat down" (Rauch 2013). Other heavily Cornerstone-influenced initiatives include the outdoors, free Green Show:

> Now it's completely eclectic. Last night was modern dancers with authentic renaissance music. Another night you could see 40 local violinists, the next night mariachis from Mexico, then hip hop from Brooklyn, professional, amateur, from near, from far. There used to be [the equivalent of] a town-gown thing; we had 85 percent tourist audiences. The Green Show became a gift to local residents; a free summer series, where people come and picnic, which shifted the theater's relationship to the community. (2013)

The Public Theater's Public Works

Growing recognition of the value of community participation on the part of regional theaters is evident in Public Works, launched in 2013 by New York City's Public Theater. A mainstay of New York theater with a national reputation, the Public was founded as the New York Shakespeare Festival in 1954 by Joseph Papp. Its venues include the Delacorte Theater, which provides free Shakespeare in Central Park; its downtown home, which houses five theaters producing classics and new work and a cabaret space; and the Mobile Shakespeare Unit, which tours Shakespearean productions throughout the city. Public Works is the theater's latest initiative to extend their "public" purpose and their first integrating nonprofessional actors into full productions.

Public Theater artistic director Oscar Eustis describes Public Works as "a series of interactive experiments ... It's not a social-service project – it's actually an artistic project to see if we can figure out the myriad of ways that the theatre can actually elevate the life of people: participating in it, viewing it, making it, performing it" (qtd in Soloski 2012). The project is grounded in five community-based organizations – Children's

Aid Society, Fortune Society, Brownsville Recreation Center, Domestic Workers United, and DreamYard – one in each borough, all of which committed to at least a three-year relationship with the Public. Eustis envisioned them participating, with several professional actors in anchoring roles, in a Shakespeare production at the Delacorte Theater at the end of a year of workshops, but was unsure which play and how it would be adapted. The play, while important, was not the end point but rather a stage in an unfolding relationship with participants from the five organizations.

Founding director of Public Works Lear deBessonet facilitated or brought in other artists to lead performance workshops at each partnering site. But because the play was not determined at the outset, the workshops could not provide a direct bridge into it for the participants. This was not necessarily a problem; in her previous work with large casts of untrained people, deBessonet did not adapt plays informed by the participants but rather created multicultural versions of classical literature, specifically *Don Quixote* and *The Odyssey*. She fears that basing plays on personal stories can easily be taking something from the participants (deBessonet 2013a). Nor does she cast nonprofessional actors for their specific perspectives on a play's core themes.

While I am not interested in prescribing why one might integrate people without theatrical training into professional productions, I do look for what the experience does for the professional instigators as much as for "the community" participants. That's where Eustis's description of using theater to "elevate" the lives of people makes me uneasy. Artists who work with nonprofessionals are usually looking for something they bring that professionals don't. Community-engaged theater typically provides a window into under- and misrepresented lives and perspectives. The people performing usually contribute content even if professionals enact and/or shape it. One of the first questions a community-engaged project raises for me is how do these particular people illuminate this production? Otherwise, why give up professional actors? Access is great, but in that regard, Public Works has nowhere the breadth of the Public's Mobile Shakespeare unit or Shakespeare in the Park.

DeBessonet's reasons for making performances with and for diverse constituents, while different than the other examples in this book, are nonetheless compelling, beginning as an expression of her strong religious feelings. Growing up in an evangelical home in Baton Rouge, Louisiana, she had an intense conversion experience at the age of ten. For the next 12 years, the church was central in her life. But when she was 22, her

religious convictions crashed; she came to the realization that there was no "kingdom of heaven," which she had imagined as a space of equity for people of all ages, races, nationalities, class, and religions; no afterlife, where no matter how hard things had been on earth, one got one's just rewards. She was angry at God or the absence of God and became convinced that if anywhere, the kingdom of heaven had to be on earth. Her religious convictions meet her artistic aspirations in theater productions involving broad groups of diverse people, where she makes spaces for what she calls "kingdom of heaven" experiences (deBessonet 2013a).

In rehearsals, deBessonet makes the choices herself, not collectively with the actors. The first Public Works production, in 2013, a pageant-esque version of *The Tempest*, was inspired by *Caliban by the Yellow Sands*, a 1916 adaptation which featured professional actors working with 1500 New York City residents. DeBessonet's production featured professionals as Prospero, Caliban, and Ariel, and some 200 nonprofessional performers, many from Public Works' five participating organizations, others from culturally grounded groups that exhibit great skill and presence. The community impulse was centered in this broad swath of people sharing the stage.

Viewing the production, I did indeed see diverse people on stage, while I did not experience their various perspectives. But there was an effective confluence between the spirits and sprites inhabiting the island where *The Tempest* takes place and the island of Manhattan where we sat. This *Tempest* was not a translation of a classic to participants' experience (like the Arena *Community Carol*), but rather deBessonet's expression of diverse New Yorkers as the magic hidden spirits of this island, Manhattan, and New York City broadly. It's a very particular interpretation of *The Tempest* in which Prospero, Caliban, and the royalty from the mainland were almost secondary to the island spirits, thus foregrounding the rich life of "the people" that is going on even as the main characters go through their dramas. I felt the kingdom of heaven, where people were seen and experienced themselves together in their expressivity as individuals and as part of the rich cultures and neighborhoods they come from.

My own taste leans towards community members' perspectives shaping a theatrical experience. Nonetheless, manifesting broad participation largely in the cultural forms those performing know intimately and integrating them into *The Tempest* thematically allowed a broad populace to participate meaningfully and the director to keep a strong aesthetic hold on the show. In contrast, I found the 2014 Public Works adaptation of *The Winter's Tale* less satisfying. While again stitching in

energetic performances of people from the five partnering organizations and New Yorkers from other cultural traditions, these spectacles did not, for me, add meaning to that particular play; though including members of the New York Theatre Ballet and the Muppets alongside equally gifted but amateur performers leveled the playing field regarding cultural excellence. Nonetheless, Public Works as a unit contributes to making a place at the table for community participation in institutional theaters, raising as well as responding to questions about it.

DeBessonet notes, "Community-based theater cuts across the despair that I have felt and heard from other theater artists, asking: 'Is this work actually doing anything? Does theater have any impact?" (2013a). This aligns with what seems to be Eustis's goal: that Public Works "reach people for whom theatre can't be something they buy – it can't be a commodity" (qtd in Soloski 2012). Such idealism is one thing that Public Works does for the Public rather than what the Public does for "diverse New Yorkers." Public Works has also been good for the Public financially. In 2014, it shared a million dollar grant with Pregones Theater from The Theater Subdistrict Council, for an organization with "a game-changing innovation for the theater business" (Agovino 2014).

Integrating the local into other regional theaters

Pregones Theater has been a "game-changing" ensemble since its founding in the Bronx in 1979 "when a group of actors led by Rosalba Rolón set out to create new theater works in the style of Caribbean and Latin American 'colectivos' or performing ensembles" (PregonesPRTT n.d.). Pregones shared the Theater Subdistrict Council award by merging with the Puerto Rican Traveling Theater, creating *"Plataforma*: The Latino Pipeline to the Theater Subdistrict." Under the initiative, the two companies create fluidity between Pregones' neighborhood-based theater in the Bronx and the PRTT's space in the midtown Manhattan theater district. The hope is to enrich not just the companies but to also lead their audiences to more varied theater experiences because of the mainstream and neighborhood-based venues.

Pregones has always been a vibrant professional theater allied with multiple communities – geographic in the Bronx, Latinos and ensemble theaters worldwide. The Puerto Rican Traveling Theater, founded in 1967, also has a history of commitment to communities in many senses of the word. The PRTT has launched countless professional careers, brought free theater to audiences without disposable income, and under Miriam Colon's long leadership, been a leader of the bilingual theater movement in the US.

Regional theaters are increasingly integrating projects inclusive of their geographic communities into their seasons. In 2013, for example, South Coast Repertory launched the CrossRoads Commissioning Project, hiring eight playwrights, locally and nationally, to create new work exploring the diversity of Orange County. The program's purpose is thereby "to use theater to explore the identity of where we live" (South Coast Repertory 2014). While South Coast calls these initiatives new works rather than community-based, they nonetheless should find resonance beyond a strictly theatergoing constituency. South Coast Rep may or may not be motivated by the need to fill seats or the availability of funding to encourage diversity, but the result is nonetheless a more inclusive and expansive theater reaching beyond the aesthetic space.

Jim O'Quinn, editor of *American Theatre*, notes that more regional theaters are bringing ensemble companies into their season. He gives the example of La Jolla Playhouse, which describes its approach as artist-driven, stating that it "advances theatre as an art form and as a vital social, moral and political platform" (La Jolla Playhouse 2013). In 2013, La Jolla launched the Without Walls Festival, with more than 20 shows at a variety of locations, which it intends to produce every other year. The festival of site-specific and immersive performances signaled "just how quickly this strain of theater is growing in the United States" (Lovett 2013). It is no surprise to O'Quinn that ensemble theaters, which are themselves collaborative, are leading an initiative that extends beyond theater buildings into an interesting mix of relationships (O'Quinn 2013).

Both ensemble and regional theater networks have been deliberately expanding diversity in recent years. In 2008, TCG launched The Young Leaders of Color Program, whose mission is described on their website as "to gather groups of young theatre professionals of color from around the US at TCG's national conferences to engage in a dialogue about the new generation of leadership." This corresponded to an earlier move, supported by progressive funders such as Roberta Uno at the Ford Foundation, to integrate ensemble leaders of color into NET. Both bespeak growing recognition of the diverse experiences and artists that need to find expression if theater is to stay vital in our times.

Funders are well positioned to support joint aesthetic and efficacious performance goals. The Duke Charitable Foundation's Artist Residencies to Build Demand for the Arts Program, launched in 2014, "support[s] partnerships between artists and organizations collaborating in inventive ways to create and pilot methods for reaching the public and developing their interest in and access to the performing arts." Among the

ten pairs funded are Lookingglass Theatre and Michael Rohd, to establish the "Civic Practice Lab to transform how Lookingglass engages constituencies and develops stakeholders, placing assets of creativity and collaboration in service to and in relationship with non-arts partners" (Doris Duke Charitable Foundation n.d.).

I return to the epigram by dramaturge Anne Cattaneo with which I began this chapter. Dramaturgy in the US usually implies working with playwrights and companies to build new or adapt existing plays. The process may begin with an idea, an image, or text, and develop through research, theatrical exercises, discussion, and other techniques, usually with a set of artistic collaborators. Michael Rohd sees dramaturgy as "the act or action of helping make meaning amid complexity in multi-party collaboration" (2013b). He draws on the same skills whether the final product will be a play or something else – listening to a broad range of viewpoints, noting where the energy coalesces, observing when interaction flows and where it constricts, shaping a collective process, and helping make meaning.

In *Cry You One*, the breadth of theatrical territory may have been most expanded, noted Randels, through their innovative use, in designer Jeff Becker's words, of *the dramaturgy of the land*: "More than ourselves, our constituents, stakeholders and even the community we found ourselves trying to serve, we wanted to serve the land itself, by finding a way to accentuate the story the land was/is telling of itself" (Randels 2014b). Freeing themselves of the need to make theater in a predetermined form, so consistent with ensemble theater values, opens the door to exciting forms of expression able to hold aesthetics and social purposes in the same container. Rather than impeding aesthetic experimentation, the desire to contribute to social issues spurs creativity. So, to paraphrase Cattaneo, the territory of theater expands.

Theater professionals who value both social and aesthetic impulses in art are finding like-minded communities through participation in NET, TCG, NPN, ROOTS, and other networks. They experience the work of artists also active in neighborhoods, education, and other sectors, and bring it back to their home companies. Terry Greis and Irondale Theater Ensemble are deeply embedded in their Brooklyn neighborhood and are also founding members of NET. Michael Rohd, Daniel Banks, and Bob Leonard are just a few of the NET artists who regularly work in higher education as well. The Bond Street Theater, also a NET member, regularly creates work and facilitates workshops in Afghanistan as part of a cultural diplomacy initiative. They all contribute to a long genealogy of theater artists extending the purview of performance.

Today, artists who studied with Augusto Boal, like Michael Rohd, are developing their own ways of making theater with unlikely partners that is at once efficacious and aesthetic; or who encountered Bill Rauch, like Lear deBessonet; or collaborated with Jo Carson, like Jerry Stropnicky, who has integrated community-based playwrighting into Bloomsburg Theatre Ensemble. Communities of practice are operating as spheres of influence all across the US.

Theater is in an integrative moment: artists collaborating with people with other expertise around shared concerns rather than staying on separate tracks are creating a new synergy. Civic engagement and cross-sector partnerships are increasingly recognized as legitimate theatrical practices through the dissemination of the work of companies and individuals across networks. My fundamental question remains: How can the significant ways that artists interact with others in different spheres of endeavor be embraced, made more visible, and brought to scale so as to integrate such robust creative contributions more fully into how we think about theater and how we move forward in social life?

Remapping US Theater: Q and A with Todd London

Jan Cohen-Cruz: So Todd – do you encounter theater companies and individual artists drawn to collaborating with people who don't work in theater?

Todd London: Yes, more and more. At New Dramatists I work with playwrights who create plays in many different ways with many different kinds of theaters. A good number of New Dramatists resident playwrights have worked with Cornerstone Theater Company, which is an exciting, if uncommon partnership – that of a playwright who primarily spins material of her own imagining with an ensemble company, working to find theatrical ways of giving voice to non-theater people from a range of communities. Many of our writers have worked with the Oregon Shakespeare Festival as well, which is influenced by [executive director] Bill Rauch's time at Cornerstone.

Other theaters, more process-conventional, in the sense that they find and stage plays, are digging into work within their communities in ways new to them, including by collaborating, at least on the research level, with people whose lives don't usually converge with theater artists'. Theaters have always been concerned with their communities, though maybe not in the sense of using the tools for co-creation and community storytelling that you and those you write about have pioneered. For example, Eisa Davis, Colman Domingo, Kate Fodor, Karen Hartman, Dominique Morisseau, and Kathryn Petersen are part of a "Community Matters" extended residency project at People's Light and Theater in Malvern, PA. The impulse for this work is People's Light's desire to listen better and embed itself more deeply in its region. It started, as I understand it, with the awareness that the community in suburban Philadelphia was a crossroads in the Underground Railroad.

The writers, though, have defined their own inquiries, in connection with specific communities and populations near the theater, its town and surroundings. The residencies, each different, led to play commissions, which will presumably lead to productions of plays born in the theater's backyard.

This kind of activity at professional theaters – I have sympathy for theater people like you mentioned to me who want to avoid the business-sounding term "cross sector" – is interesting, because the push for this work is coming from so many places. On one hand there's the political urgency of the artists themselves, who want their work to serve and connect with the people in the audience, to be meaningful, impactful. Younger artists, in particular, are mission driven and engaged. They don't think within disciplines as much as my peers grew up doing. So that work leads inevitably to this.

Then, of course, there's a pressing awareness that theater audiences are dying off and we haven't done enough to cultivate them. People in traditional theaters look to people who know how to do that, and encounter the 30-plus years' example and excellence of artists who work in non-theater communities.

Moreover, there's the funding push. Funders are more and more interested in quantifying social impact and community engagement. The theater is the natural seat for this activity, as opposed to, say, symphonies, which may have maintained companies of artists for decades without it ever occurring to them that they might use their music to engage more fully with their neighbors.

Plus if theaters are situated at all in relationship to universities or worlds of ideas, these are ideas that have become prevalent after all these years. This kind of professional/nonprofessional collaborative thinking has penetrated slowly, but it's coming from audience development needs, funders, a sense of social responsibility, and an awareness that all art is, on some important level, political. And it means facing that the professional theater has let too much slide in the name of art or through a narrow definition of excellence and quality.

Slowly, this new generation of artists is taking the lead. Lear deBessonet is a young emerging director, for example, trying to bridge the worlds of art and engagement. There are playwrights who've worked with her, as Lucy Thurber on their *Don Quixote* at a community center with homeless people in Philadelphia, or as Marcus Gardley along with composer Todd Almond, on their post-Katrina musical *On the Levee*. This kind of work is coming at the professional theater from many directions. You can't ignore it anymore.

JCC: I'm trying to get at the third of three of the ways I've seen theater engage with the social in my lifetime – through plays, workshops, and something else that requires expertise in addition to theater.

TL: Exactly. I take you to mean applying performance and theater techniques to other outcomes.

JCC: Yes.

TL: I think that's true. Partly this may have happened because education funding dried up so quickly. Theater people are like roaches; we adapt to survive. And if there's no funding for education, we'll figure out what we have to sell: How about theater skills to enable our communities to tell their stories or reconcile their differences? How about training lawyers or business people to make effective presentations?

Meanwhile, we have the example – this is why your work and that of people like Dudley Cocke, John O'Neal, and Pregones is so important – of artists who, in different contexts, have done engagement and community-based work for a variety of outcomes. We have people who've seen them and trained with them and are now serious, mature artists, and they are up to other things. I'm thinking of Michael Rohd, who trained with Bob Leonard at Virginia Tech, who comes out of the Road Company. Michael is now the pioneer, using theater in all sorts of contexts and communities.

I was at University of California/Berkeley last September, sitting in a room with PhD students talking about their projects. They speak a language of performance that didn't exist 25 or 30 years ago. They are interested in things that no one would have considered appropriate subjects of theatrical inquiry 30 years ago. Like intercultural, transgender work in Malaysia, truth and reconciliation, post-apartheid. Nine out of ten of these PhD students are artists too, trying to create an interdisciplinarity in their lives that there was no model for when I was in grad school in the late seventies/early eighties.

Think about that generationally. I just finished a book about the founding of American theaters in the twentieth century, *An Ideal Theater*. In the forties and fifties, these pioneers of the American theater were trying to make the case to universities that theater should be studied at all – that it was a legitimate field within the humanities. Twenty or 30 years later we were making a case for performance studies, and now we're discussing community-engaged work. That's a really short history! Every generation has actually revised what we think of "training." How can these quick-moving changes in attention not affect a calcified profession

struggling to survive with a dwindling audience and a sense of cultural decay or, at least, marginalization? How can this multiplicity of perspective not whittle away at a singular definition of theater?

JCC: I like your genealogy.

TL: Thanks. I've been thinking about the fact of you covering the Network of Ensemble Theaters (NET) [in 2013]. I've been occupied for a long time about the way discussions about American professional theater imply a map. And that map traces a world from Yale Rep to the Huntington, Arena, the Guthrie, Goodman, the American Repertory Theatre, the Center Theatre Group, Alliance, the Alley – large institutional theaters. But the real map has not been circumscribed like that for a long, long time. So when you have something like NET, or the National New Play Network, which is 27 or 28 mid-size theaters that do more traditional new play work, people are naming a geography that now exists – remapping. Just the fact that so many theaters in NET are using these techniques to make theater with non-theater neighbors or to make social progress, proves that the professional theater is changing. The changes may not be salient, but they're there.

Then you have places like Bloomsburg Theatre Ensemble, which is a long-lived, traditional theater living in a community in a way that theaters haven't previously existed in those communities. As they've investigated their place there, they've branched out and explored different kinds of work with different kinds of artists – explorations of aesthetics, collaboration, and process.

JCC: Do any companies or artists with a dual commitment to theater and something else come to mind? Like the Free Southern Theater – that was as interested in moving civil rights forward as making theater.

TL: The Free Southern Theater has coinciding examples. El Teatro Campesino and the early San Francisco Mime Troupe both were, in different ways, cultural arms of rights movements, as ACT UP was 20-some years later. Examples now? That's harder. Maybe those that straddle both theatrical worlds. Julie Marie Myatt is a past ensemble member of Cornerstone and also a resident playwright at South Coast Rep. I asked her about her writing for Cornerstone, assuming that her playwriting selves were two parts of a whole, but she surprised me by saying that they are actually very different. I got the sense of a playwright choosing two paths at once, in her case the community-based, social justice art of Cornerstone and then her personal playwriting, which is also often political. Or Luis Alfaro, whose work is always both. He lives in the professional theater and academia, and through his professional

playwriting reaches into communities he lands in, and cultivates the soil for richer inclusion. The theater and the relationships he makes are amazing. Catherine Filloux is a playwright whose work has grown out of time spent in international crisis zones – notably writing with survivors of the Khmer Rouge in Cambodia. She's a founder of Theater Without Borders. Erik Ehn is an incredible educator and experimental playwright, who's built an entire international artistic community around work about and with survivors (including artists) of the Rwandan genocide. All of these writers are activists, but they aren't all on-the-ground organizers the way Luis Valdez or John O'Neal, Gilbert Moses, and Doris Derby of Free Southern Theater were. And their rights or social justice work is as likely to be international in scope.

JCC: The creativity that comes out of the dual goals is so interesting to me. Some of what FST came up with was experimental theatrically even as, indeed because, they intertwined aesthetic with movement goals.

TL: You've got to read Harry Belafonte's memoir. He lives in that division. He says he's not an artist who's also an activist, but an activist who's also an artist. What does it mean to be that pivotal fundraiser, celebrity gatherer, and advisor to the civil rights movement, while at the same time being the bestselling recording artist in America?

JCC: Have you seen a shift in professional theater companies in terms of the place they are situated?

TL: Both yes and no. To go back: the beginning of the regional theater movement is in immigrant and rural communities, not, as we think of it, in determinedly institutional settings. It begins at the Hull-House Settlement House in Chicago and at the Neighborhood Playhouse, another settlement house, on Manhattan's Lower East Side. It begins with the rural arts movement in North Dakota and North Carolina with Arnold Arvold and Frederick Koch, with Alexander Drummond at Cornell, and, later, importantly, with Robert Gard in Wisconsin. It begins in the making of America in communities and outside the commercial center of New York. That is its root. The usual story of the resident regional theater movement begins in 1947 with the founding of Theatre 47 in Dallas, the Alley Theatre in Houston, Arena Stage in DC, and then the Guthrie in 1963, which sort of jump starts the whole thing.

But in fact the art theater movement in America begins in settlement houses and universities in far-flung places. That is a really important impulse. When that next generation booms, the institutional generation, in the 1940s and 1950s, and in the early 1960s thanks to W. McNeil (Mac) Lowry and the Ford Foundation, they boom in a way that is meant

to be resident and repertory like the great theaters of Europe and, in distinction to those theaters, regional, that is, native to cities outside of New York, away from Broadway. Reflective of those cities and the culture of their regions. They ultimately become none of those things: regional, resident, or repertory.

You are asking specifically about the regional. Over time the criticism of them – and no one is going to argue the other side except the most die-hard institutional people – is that, on the whole, they've lost that sense of regionalism, of being local. They're urban theater in urban centers that have mostly the same kind of audiences as each other, which have invested in them to a greater or lesser extent. While Minneapolis is different from LA, and LA from Chicago – you would find great agreement that the regional or local aspect of these theaters has diminished.

But in the meantime, starting in the late 1970s/early 1980s, another generation of theaters grew up to correct them. That's where you get not only the Bloomsburg Theatre Ensemble, Touchstone in Bethlehem, PA, but also theaters such as Penumbra, which produces within an African American context, or Pillsbury House also in Minneapolis, which is a theater functioning as an integral part of a community center, as Hull-House did. They grow up as antidotes in their own communities to the institutional theaters' lack of local specificity.

That's happened in urban settings. It's also happening rurally and outside theater centers. Pioneers like Roadside in Whitesburg, Kentucky, Pregones in the Bronx, and Junebug in New Orleans, which from the 1970s and 1980s were mostly about deep local connections, later started moving beyond their localities through collaborations – often with each other, sometimes internationally as well. So instead of having a co-production between the Huntington Theatre in Boston and Seattle Rep and the Chicago's Goodman that could, judging by the production, have come from Any Theater USA, you have Dudley Cocke, Rosalba Rolon, and John O'Neal doing collaborative projects that could not possibly happen in Appalachia the way Pregones would do them in the Bronx or the way Junebug would in Louisiana. That's the movement: See what we have lost, find what we are missing, and then a new generation digs down into it.

JCC: Ensemble companies, says Mark Valdez [director of the Network of Ensemble Theaters], are flowering, especially in the last ten years. Do you agree?

TL: I agree and I also think it started longer ago and gained momentum in the last ten years. It's also about the actual map vs. the visible map. I had this revelation last year: I was asked to review a book edited by

two practitioner/professors and written, similarly, by people who both make theater and write about/study it. It was about "established alternative theaters" in Chicago. The oxymoron being that a company could be both established and alternative. The title was *Beyond Steppenwolf*.

I've written about Chicago theater; I grew up there. I thought, what are they talking about? The story of Chicago is the story of Second City, the Goodman, theater training at Northwestern and the Goodman School of Drama (now DePaul), and Steppenwolf. But here they are writing about all these other theaters as if they are defining Chicago. I actually know some of the theaters, really interesting models, and others are new to me. They've been around for 20 years. They are functioning on a kind of amateur/professional border, where no one is making a living. They are often connected to one another and somewhat incestuous. We know about the artists who come out of some of them; others not so much.

And I thought, "Oh, Todd, here you thought you knew this, and you knew nothing. What you've been looking at is the shadow map or the over-shadow map." Epiphany of my own ignorance. Again, what is the real map of US theater and what is the one we carry around in our heads? This work has been going in lots of cities, for a long time, in Austin, Minneapolis, Seattle, and Boston, but not to the same extent.

And then there's this new boom, which is really exemplified in Chicago: people coming out of schools together and doing the storefront theater thing, whatever the particular exploration is. And doing it with groups. They've had professors or mentors telling them to find their people, their tribe, and stick together. Maybe there will always be the lure to the coasts for the individual trying to make a name for him or herself. Maybe that person is biding time with a group. But not everyone is. For many this collective, tribal path becomes the way of a life in the theater.

In talking about this activity, I think it's important to avoid a phrase like "devised theater." The term doesn't really describe the range of what's happening. The fact is a lot of devised theater ensembles don't devise theater at all. They work with playwrights in traditional and untraditional ways, or they work with plays in traditional and nontraditional ways. "Devised theater" is a convenient catchall that allows funders to say, "Wow, something really exciting is happening, and it belongs in this box. This is something we should support."

Mark Valdez and I have had this conversation, and I think we're in agreement about it. An ensemble's aesthetics grow organically, uniquely. The attempt to tie a ribbon around all of it is, I believe, misguided. I'm particularly sensitive to this as an advocate for playwrights. A lot of

so-called "devising" companies are all about the playwright. But the word "devised" suggests that we don't need playwrights anymore, that it's all improvised.

This attention on the ensemble is terrific, a light shone. It's clear that the institutional model is not where the heat is. So where is the heat? With these young companies. Have you ever heard of them? Some have been around for 15 or 20 years. More. There are a lot of them, and they generate students and other offshoot companies and new rebels.

JCC: What about the relationship between community-based and regional theaters? Who beside Bill Rauch began in the former and moved into the latter, both of which are place-based?

TL: An interesting counter-example is James Bundy, who early in his career was managing director of Cornerstone, and is now artistic director at Yale and dean of the School of Drama there. He's a different kind of artist and administrator than Bill is, and Yale is a different animal than Oregon Shakespeare Festival, though in its way similarly local.

I'm also encouraged by artists-of-color who previously worked in culturally specific organizations and are now acknowledged field leaders. Chay Yew is one. He used to run the Asian-American Theater Lab at the Mark Taper Forum, and now he's running Victory Gardens in Chicago. Michael John Garces is another: a widely in-demand director who was a production assistant at INTAR Hispanic Arts Center in New York, before becoming Cornerstone's artistic director.

I don't know the limits of community-based theater. I consider New Dramatists a community-based organization, based in a community of unaffiliated, individual artists. I approach the work as if my job as artistic director is to facilitate community by creating connections and engagement among the company's 50 playwrights. Because I never curate or select work, and because we make decisions as a group – staff and playwright, company and, in governance matters, board – I consider myself an activist, as much as an artistic director. I think of Chay similarly. He comes out of an Asian-American theater world, as an advocate and connector for Asian-American artists – and artists of color more generally. That's community-based work. But it may not fit a more traditional definition. How fascinating then to watch him make community at Victory Gardens [an established regional theater], to watch him make theater there.

Two of the artists Chay works with closely are Luis Alfaro, his great friend who used to run the Latino Lab at the Taper, and Marcus

Gardley, who in addition to being an amazing poet/playwright has also done community-based work in Oakland, where he's from, and in New Orleans with Lear deBessonet. It's a reminder that artists are citizens, too. We live in communities too. Though not necessarily underserved ones.

JCC: Yes, that's where the language is unclear. Instead of the term community-based, Dudley Cocke likes grass roots, what comes from the ground up. I see why you would call the organization you work with community-based, given the way you direct it.

TL: I also wanted to say that, as a connector, I'm moved by the distinction you make in your Introduction between lateral and hierarchical collaboration. I'm thinking too of what Bill Rauch says about larger organizations breeding more hierarchy. This may, in fact, point to the biggest gulf between different types and sizes of organization. There are people running theaters who literally don't know what it is to function through true consensus and true listening and true group process. They think like so many people do in corporate America: Take in the information. Make a decision. Pass it down. To me that's the greatest divide. It's not about outcomes or straddling communities, but how collaborative groups engage – with each other and their neighbors or partners. They engage not just in an atmosphere of respect, but also deep listening, the cause and effect of true mutuality, of the potential of being changed. This is very different than proceeding through hierarchy. In other words, *process itself* is to me the biggest divide. Different approaches to process embody different visions of the world. And I don't think it can be seen.

JCC: Yes, these collaborations have to be horizontal, what's called distributive leadership; that's built into my subject matter. Each of the players sees they can't do it without the other.

TL: They don't want to. They aren't just humoring the other – "I want you to design the set, as long as it looks the way I see it."

JCC: I know that in other contexts you've focused on a dearth of idealism. What antidotes do you see? Here you talked about how each generation tries to make up for what's lacking.

TL: I think the ensemble boom is deeply idealistic. The energy. The two-worldness of professional and amateur, artist and civilian, interculturalism. I'm so impressed by what our children know that we don't. Concepts I was introduced to in grad school – multiculturalism,

historicism, the genius of community – they take for granted. Those worlds of identity exploration and the deconstruction of prior authority are deeply idealistic and passionate. Personally, I experience a kind of manic-depressive oscillation between idealism and disillusionment. Anyone who engages in any form of culture-making without the rewards of money and celebrity possesses, I assume, a deep idealism, whether they know it or not. The fact that there is so much activity out there amazes me.

2
Partnering

I was never doubtful that the movement was more
important than the mover.
 – John O'Neal, co-founder of the Free Southern
 Theater, about its relationship to
 the civil rights movement (2014)

I don't think you can succeed in [social justice] work if
it does not become a part of culture.
 – Mark Davis, Director of the Institute on
 Water Resources Law and Policy, Tulane University,
 New Orleans (*Cry You One* n.d.)

In Chapter 1, I traced developments in US nonprofit theater from *either*
aesthetic experience *or* social engagement to the possibility of embracing
both. In this chapter, I focus on different ways that theater professionals
partner with other experts in social endeavors that are larger than any
one discipline – what O'Neal refers to above as the movement being
more important than the mover. I am equally interested in what art as
an expression of culture offers to social challenges that defy the efforts
of single disciplines, as Davis, above, avows, further explaining that

> the things we care about as a people, locally, nationally, internation-
> ally, are expressed, essentially, not in the number of white papers,
> not the number of lawsuits, not the number of public works projects,
> [but rather] in culture. You actually work for or fight for those things
> you care about. (*Cry You One* n.d.)

I turn first to what performance offers collaborations that move across
disciplinary borders, and some of the challenges of such partnerships.

Benefits and challenges of performance in cross-disciplinary social initiatives

Through most of history, performance has exceeded aesthetic frames. Richard Schechner, a founder of the field of performance studies, noted, "Deep in Asian, African, even European traditions, performance extends far beyond what happens on the stage" (Hemispheric Institute n.d.). In the broad sense of embodied behavior as deliberate public expression, performance is ubiquitous. For example, to bear witness, an act as important in religious contexts as in courts of justice, requires corporal presence before some recognized authority. Rituals are symbolic, physical actions that take place before an assumed higher power; believing may or may not follow. Demonstrating provides examples of how to do anything from the most mundane activity, like the steward/ess enacting safety precautions in an airplane, to modeling a far-reaching vision, like camping out at Occupy Wall Street as a snapshot of a more participatory society. Language captures some of the ways that embodied behavior enacts one's beliefs in public life, such as "standing up" for justice and "sitting-in" at lunch counters. When the goal of communication is part of a social interaction, performance often enters into play.

Performance knowledge extends across different kinds of spaces. *Conceptualizing and executing public events* goes beyond plays in theater buildings to, for example, demonstrations in the street, rituals both sacred in spiritual spaces and secular in public and private spaces (graduation, birthday parties), and events that serve an advocacy goal by increasing an organization's visibility and propelling its mission/message, like benefits or speaker series.

Performers who facilitate workshops and collectively create plays know how to *gather people* of diverse skills and knowledge, build groups, concretize ideas, and communicate them to others. This capacity supports political organizer and writer Harry Boyte's prioritizing of broad participation, warning would-be change makers that the "cult of the expert" strips non-technocrats of a sense of agency and excludes them from democratic processes (Boyte 2009, p. 2). That is, performance knowledge includes bringing together diverse people to contribute in a range of ways.

Many performers know how to *synthesize complex content* such that it can be articulated and understood in a live, public forum, a skill honed through working with metaphor and adapting material for a stage. Choreographer Liz Lerman's collaboration with Bob Harriss of the Houston Advanced Resource Center is an example. Citing his definition

of resilience as "our capacity to absorb impact," Lerman describes an occasion when the dancers then "embodied the idea with swift intense duets on the hard concrete floor. The audience had an immediate opportunity to investigate the premise of impact and absorption and the challenges of renewal" (Lerman 2011, p. 230). First with cross-sector participants and then with larger publics, artists expand accessibility by providing a sensorial experience of ideas.

Art practices involve particular tools for *problem solving*. An entire system for such ends is Augusto Boal's Theatre of the Oppressed (TO), a set of theater-based exercises created to trouble shoot and overcome oppression for and with people who seemingly have no power. Role-play, so prevalent in drama therapy and psychodrama as well as in political organizing, is a commonly used tool whereby people enact alternatives, in a safe space, to unresolved situations and troubling relationships.

Performance provides *practice in becoming active participants*. This generates "distributive" rather than top-down/hierarchical leadership. As Ella Baker called for in the civil rights movement, distributive leadership generates grassroots opportunities to achieve broadly dispersed goals rather than depending on a single charismatic leader like Martin Luther King, Jr. (Ransby 2003, p. 172). Indeed, one of the goals of much community-based theater is to support leadership development so that issue-based theater work can take place with a cadre of local facilitators.

Theater has the capacity to *move us through discomfort*. In *The Theatre and Its Double* (1938), Antonin Artaud calls for art that works on us like the plague. He yearned for a theater that would shake people out of their habitual perspectives. Towards the same goal, an important phase of Bertolt Brecht's work took advantage of theater's potential to estrange audiences from the subject matter in order to look at it critically. As Nazis consolidated power, partly through the emotional use of spectacle in the Nuremberg Rallies but more generally through the brute force of their actions, Brecht created yet another approach, "learning plays," to sharpen people's critical capacities and use performances for actors and spectators to think about alternatives.

Artists, broadly speaking, practice creativity, *making something from nothing*, a skill that can be applied to situations as well as products. Pam Korza writes: "What makes the most provocative work *work* is collaboration that doesn't just use art as a tool for some other end but that embraces the holistic integration of creativity as a core part of any civic or social endeavor" (qtd in Bartha et al. 2013). Creativity makes something new rather than merely repeating what is already known. Approaching one's work as inquiry and exploration rather than with ready-made

solutions opens it to full participation. Art is an invitation to imagine by allowing oneself free rein regarding a situation's possibilities. It opens participants to ideas they are not likely to have considered had they approached the issue only rationally. Something imagined is socially useful when it responds to a lack. Whatever gets one closer to knowing what is needed and where it might come from has value. Imagining as a step in a process for change is one of the greatest assets artists bring to social challenges.

Performance offers *a way to be in the moment together* and take pleasure in each other's company, through both good periods and hard times. It provides ways for participants to build relationships and come to know each other's aspirations and struggles. Living in the uncertain environment of New York City immediately following September 11, one of my most vivid and hopeful experiences was being in a large circle with a group of students learning and then singing a song facilitated by voice teacher Jonathan Hart, which felt like the singing of angels. Such experiences fortify and comfort people whether or not they lead to direct or immediate actions.

Art's capacity to bring people together in the moment is grounded in the senses and contributes to virtually any human endeavor. Living with all our senses engages us fully in whatever task is before us, and is an invitation to see fresh. As poet e e cummings writes, "now the ears of my ears awake and now the eyes of my eyes are open." As such it is an excellent approach to social endeavors, not requiring everyone to be on the same educational or economic level because we all have access to the world through our senses. Like the Socratic method, whereby one has only to be asked a good question to unlock an experience of the world neither more nor less "right" than any other, emphasis on what is known through the senses puts people in touch with things they know and could contribute to a common endeavor.

While many challenges beset cross-disciplinary initiatives, two that transcend specific contexts are insufficient time, which is often manifested in insufficient cultural orientation, and power imbalances. Relationship building, so fundamental to this work, takes time, and includes getting to know other cultural contexts. Artists find numerous ways to build relationships with non-arts partners, facilitated if they live in the same place and become acquainted organically – through attending the same church or food co-op, say – as well as deliberately, through undertaking a joint project. Getting to know other cultures is trickier and can even be dangerous, as one may not initially know the consequences of breaking other contexts' codes. When I was 21, for example, I co-facilitated

a theater workshop in a maximum-security prison. Seeing an inmate in the hall who hadn't been to our sessions in some time, I impulsively went to hug him in greeting. Instantly bells sounded, lights blinked on and off, and two guards restrained him. I explained that I was the one who had reached out but it hardly mattered. I clearly had much to learn to comply with prison protocol in order to make it safe for people in that system to participate in our theater workshops.

A related challenge is working with people who have come out of extreme circumstances and developing awareness of the limits on what ought to be evoked. Newcomers to such work need guidance to make sure they do not bring up material that participants would prefer to avoid because of either the social or the psychological impact of revealing it. Safeguards are needed, often in the form of the cross-sector partners orienting the performance partners. Art-making in cross-sector partnerships is a combination of knowing what to refrain from doing as much as figuring out what to do, sometimes spontaneously in the moment.

Power imbalances persistently undermine the very important aspect of joint ownership, that is, making sure that collaborations represent and benefit all the partners. If a project is perceived as largely serving the interests of only the most powerful collaborators, results will be distrusted and most likely disregarded. The arts can contribute to joint ownership through tools such as open-ended exercises that participant choices guide, like much Theatre of the Oppressed, or even simply inviting participants to involve more of themselves than their professional or circumstantial identity. A case in point is the mindfulness with which Cornerstone Theater casts local people, paying attention to personal skills that deepen actor engagement and enliven productions, which are vessels for expressing community concerns. For example, in Cornerstone's adaptation of a Chekhov play, *Three Sisters ... from West Virginia*, the actor playing one of the sisters was a virtuoso clog dancer, which was integrated into the show. Experiencing each other's multidimensionality bespeaks nonhierarchical community, and is a way that everyone helps shape the initiative. However, integrating everything that people offer would result in incoherent results and not best serve a project's goals either. Clarity in how decisions are made to further some ideas and not others is key. Knowing if consensus or some other leadership structure is in place must be transparent. Cross-sector partnerships must combine insights diverse people offer without losing focus.

Also significant for instilling joint ownership is agreement on common language. Artists who generate work that someone else – a scholar, funder, or policy person – then describes and names have been

known to feel that something has been taken from them. Indeed, I've observed the words "cross sector" and "social practice" met with discomfort on the part of numerous artists who integrate their art across fields. While some artists accept the language by which practices come to be known in policy, funding, and academic circles, others feel so co-opted that they do not enter those conversations and thus do not always benefit from growing recognition of the value of practices they helped develop. The question of terminology equally acceptable to all the stakeholders of this field remains unresolved.

Modes of crossing disciplinary borders

While I do not believe that art, by itself, materially impacts social issues, the three case studies below evidence that performance has much to contribute through various kinds of collaborations with experts from other sectors. How much must artists know about the issue and their partners, and how much must their partners engage with them, for such conjoining across sectors to be effective?

On one end of the spectrum, people with other expertise may simply recognize that selected tools of performance are useful to their effort and add them. Such is the case with Catholic Charities USA, a poverty-reduction organization that invited director Michael Rohd and Sojourn Theatre to insert some of their theatrically honed community-building techniques into Catholic Charities' 2012 national conference. Catholic Charities provided the framework for all of them to meaningfully contribute.

In other instances, people who are equally called to art and to a social issue function as both artists and something else. That was the case with the founders of the Free Southern Theater (FST), who were also organizers with SNCC, the Student Nonviolent Coordinating Committee, activists during the civil rights era. SNCC as an organization had access to policymakers, legislators, and others who could take concrete, systemic steps towards solving problems that the FST artists helped communicate. SNCC also provided the FST with important access to grassroots publics and venues, like churches and their congregations who were active in civil rights.

In yet other cases, artists who begin by expressing their commitment to a social issue in a piece of theater and their organizer-collaborators may find their tools combining into something new. Such is the trajectory of the ArtSpot Production and Mondo Bizarro collaboration *Cry You One (CY1)*, especially with Gulf Coast Futures, in response to the

wearing away of the Gulf Coast wetlands. I thus elaborate on the case study of *CY1* that I introduced in the previous chapter.

While many of the *CY1* company members had long been involved in local climate change issues, this formal collaboration further educated the artists, raised the level of discourse on the subject in the performance, and led to more engaging organizing follow-up activities.

Multidisciplinarity: *adding* a performance component to efforts around a social issue

Some aesthetic techniques are transferable to many contexts with little or no specialized knowledge of the subject, nor an in-depth relationship with people addressing the issue from other disciplinary bases. This exemplifies what scholar Julie Thompson Klein calls multidisciplinarity, which juxtaposes specialized learning and practices and "fosters wider knowledge, information, and methods. [But] disciplines remain separate, disciplinary elements retain their original identity, and the existing structure of knowledge is not questioned" (Klein 2010, p. 17).

My example is Rohd and his Sojourn Theatre's participation in Catholic Charities USA (CCUSA) 2012 national conference, at the invitation of the organization's president Father Larry Snyder. Their goal was to create a set of "dialogical opportunities" using the power of theater to deepen constituents' relationships with each other and offer new approaches to their anti-poverty work. Snyder explained that CCUSA's gatherings bring together attendees from cities, towns, and suburbs nationwide, "hoping to learn something, ... recharge, and ... believe that what they do not only matters, but is recognized by colleagues they never see, with whom they want to feel a sense of solidarity."[1] To Rohd, this meant that Snyder recognized creativity as "a tool for both motivating and empowering his community of colleagues to take new tactics back to the often fractious task of building local movements."

Neither party changed what it does in order to work together. Rohd explained: "The assets we bring as artists ... are skills of collectively building story and forming coalitions out of disparate perspectives ... We are able to create charged yet playful performative encounters that can, in short periods of time, bring issues and relationships into sharp relief" (Rohd 2014a).

One of Sojourn's sessions at the conference involved about 60 people focused on specific poverty-combatting policy platforms they wanted their representatives to adopt, and strategies to contend with the political and popular opinion factors that they encounter when doing advocacy. Participants were seated at tables, each with a Sojourn artist.

Rohd instructed them to discuss their respective challenges and identify policies they'd like to see receive serious legislative consideration. Each table then built a specific poverty reduction platform with their Sojourn company member role-playing a candidate for a national Congressional seat. They prepared two-minute stump speeches for their candidate as well as strategies to withstand ideologically oppositional questioning, which CCUSA staffers and a DC lawyer provided, performing the role of a press corps in a Q and A following each speech. Each actor playing a candidate consulted a non-performer on questions that required specialized knowledge. After the exercise, the groups debriefed at their tables, paying particular attention to recurring policy ideas across candidates and effective responses to press questions. The lawyer then moved the policy ideas that Sojourn helped generate into a nuts and bolts session on legislative process.

Rohd led another session with about 30 CCUSA executive directors from various local agencies. After brief introductions, he had them describe challenging experiences such as "working in ideologically polarized communities. Encountering dwindling resources and rising need. Creating visionary programs that face external and internal fear of change." They then shared stories, in pairs, of a successful day at work that they would love to have. Rohd instructed them to listen closely as they would then be doing something with what they heard (Figure 2.1). Rohd explained how this exercise was an imaginative act:

> You had to create, internally, a vision of something that isn't real. Then you spoke first person present tense words of the story you'd made up to someone else. You pretended. To me, that's one half of what makes a time-based experience between people, theater. Imaginative Acts. To get at the other half – "Listener, I need you to think about the story you were just told. I want you to think about the challenges, the obstacles that prevent your teller from actually having the day they just described. We're going to go around the circle, and I want you each to name one of those challenges. The one we hear the most times is the one we move to the next step." What we hear, in one form or another, is getting people with different opinions to collaborate. We spend the rest of the session creating and performing ways to improve the possibility for productive collaboration in their work and community settings. These (sometimes emotional, often playful) moments happen through improvisation, through groups creating new stories and sharing them in the form of images or monologues.

Figure 2.1 Sojourn Theatre artists at the 2012 Catholic Charities USA national convening reflect back to the large group recurring ideas they heard.

Rohd's relationship with CCUSA encountered challenges common to such undertakings. Sojourn had to figure out how to work within "the complicated inside politics and communication idiosyncrasies" of the large organization, which sometimes made it hard to know with whom to connect about what issues, when to push with material that would clearly cause discomfort, and when such material didn't serve the goal of dialogue they shared with their hosts, "so we didn't feel censored but so we were in respectful conversations with our hosts about what we produced with and for their community" (Rohd 2014a).

Rohd recognizes the advantage of being approached by people outside of theater who see what performance skills might contribute to them. He therefore does not have to convince them of performance's worth, but they do have to be clear about the intent and context of the work so Rohd can design something appropriate. Notwithstanding, Rohd recommends that artists interested in civic practice not wait to be approached but rather:

> Seek out and explore relationships with non-arts-sector partners, and then, through dialogue and curiosity and a needs assessment carried out with that partner, learn about how their artist assets may

be deployed, and then perhaps make a proposal as an invitation to move towards co-design of a civic practice project. (Rohd 2014a).

Functioning more as consultants to and less as partners with CCUSA, the Sojourn artists were positioned to ask hard questions that people embedded in a situation are not always free to bring up. Rohd has experience being the outsider; in Lima, Ohio as part of Animating Democracy's Arts Based Civic Dialogue initiative, Rohd opened up the Common Threads project to an unspoken issue of race underlying relations between city and county government partly because he was used to taking critical distance as a director but also because he is not from Lima (Korza 2014). As an outsider, he had not been drawn in to polarizing local issues and could simply state what he saw, respond to what he heard, and then leave. That is, the extractability of a component from a multidisciplinary relationship can be a strength. Moreover, disciplines have not been so interlaced that leaving destabilizes the whole.

Interdisciplinarity: *integrating* artistic and other approaches to problem solving

Interdisciplinarity refers to people with different expertise working closely together towards a shared goal. It

> integrates information, data, techniques, tools, perspectives, concepts, and/or theories from two or more disciplines or bodies of specialized knowledge to advance fundamental understanding or to solve problems whose solutions are beyond the scope of a single discipline or area of research practice. (NAS et al. 2005, p. 188)

This idea is exemplified by the Free Southern Theater, founded in 1963 by artists John O'Neal, Doris Derby, and Gilbert Moses, who also participated as political activists with SNCC (Student Nonviolent Coordinating Committee) in the fight against Jim Crow.

Although from a young age O'Neal felt called to be an artist, he knew it was inevitable that he'd be involved in the struggle for justice "because injustice was so overwhelming and would not yield to inactivity" (O'Neal 2014). Through serious engagement as community organizers as well as theater artists, FST members' relationship to civil rights was interdisciplinary, integrating performance's capacity to further grassroots critical thinking and active participation and organizing's capacity to meet people where they are with well-honed tactics and strategies for social change.

As regards performance's contribution, Derby described an information blackout in Mississippi because of segregationists' control, making it harder to develop tactics and strategies, in the absence of other examples, so as to obtain civil rights. Derby thought a theater could fill that gap (Derby 2013). Her vision involved the FST traveling around the state, communicating the message of civil rights through expression in the arts, and involving movement organizers to engage people in their communities in arts-instigated critical thinking. This activity led to new questions, such as ought FST focus on producing writers of color. The FST performances in the summer of 1966, which company members described as manifesting "the spirit of black pride and consciousness that the Movement was also undergoing at the time," were largely by black playwrights, such as Gil Moses's *Roots*. Post-show discussions lasted well longer than the shows (Dent et al. 1968, p. 133) (Figure 2.2).

Writer and scholar Jerry Ward notes that Derby was calling for the use of theater to provoke "new forms of cognition" for civil rights workers and other black citizens of Mississippi: The FST "encouraged new and deeper ways of thinking about the nature of political and social struggles," initiating in Mississippi "a process of sharpening vernacular

Figure 2.2 Seret Scott in Free Southern Theater's production of *Roots*, by Gilbert Moses, performed in Jackson, Mississippi in 1966.

consciousness and common sense about the quest for justice in a closed society by using theater" (Ward 2014). Post-show discussions included audience members, performers, and local activists, bringing participatory learning into the movement.

Ward notes that interdisciplinarity depends on "yoking and negotiating contradictions which may exist between methods" (2014). The contradiction in this case was the movement's initial lack of attention to progressive culture even though segregation was strangling people cognitively as well as economically and socially. That contradiction began to be untangled through the cultural tools the FST brought, which for its part could not have served the movement as well without the activists' community connections. FST co-founder Gil Moses avowed that even more attention ought to have been paid to art, noting the movement's lack of clarity, which he attributed partly to "the revolt ha[ving] not [had] time for art":

> We found, when we lived in Jackson, that the thinking there was circumscribed: newspapers omitted news, radio stations played only rock-and-roll, churches were medieval, schools were state-controlled. But there must be more than emotions behind actions ... To go beyond that first beautiful moment when the slave says "No," there must be a clarity, a subtlety which the revolt is at no time able to give simply because it is a collective call to immediate action. (Moses 1965, p. 67)

This suggests the necessity of a space for reflection and dialogue that art could instigate between movement leaders and the "rank and file," made possible by on-the-ground opportunities to think critically. The FST could supply the material, in the form of plays, around which to practice reflective thinking and further a civil rights discourse. But this called for working together; the FST would have to foreground plays and discussions that served the movement and the activists would have to make time for such events and build them into organizing.

One of the challenges that the FST faced was getting full participation in post-show conversations. Looking around him in the Mississippi freedom movement, O'Neal observed how much work took place in circles. He saw that the circle was a great equalizer, putting no one in front or in back and making it possible for everyone to see each other. O'Neal began developing the story circle as a way to hear from everyone around a relevant issue. In a story circle, a theme is identified and then everyone tells a personal story that identifies his or her relationship to

it. In this context, the theme of the play that the FST had just performed might be discussed through story circle methodology. By emphasizing people's stories instead of using argument as the form of discourse, everyone had something to contribute; the quality of the exchange and recognition of their place in the struggle were greatly enhanced. It's striking that the FST's impulse to develop the story circle as a cultural practice came out of the use of the circle in political discussions, especially since now the story circle is considered one of the fundamental tools that performers bring to social discourse.

Also significant is the FST's founding context as the Tougaloo Theater Workshop at Tougaloo College in Mississippi, where it benefitted from the college's recognition of the centrality of culture. Even in its early days in the late nineteenth century, Tougaloo did more than provide agricultural and industrial training to formerly enslaved people by also including a liberal arts education. If, as then-president Frank G. Woodworth noted, "the New England boy with all his cultural heritage and environment needed such an education, 'how much more one whose heredity and surrounding have been the opposite?'" (Campbell and Rogers 1978, p. 83). Woodworth saw the value of a utilitarian education but also its limits: it "could not give a race the wider, nobler visions seen from the loftier heights" nor develop leadership (p. 83). He avowed that the soul of formerly enslaved people "daily scarred by slights, insults, restrictions, discriminations, and contempt, needed to find solace in a 'mind well stored with philosophy, science, history, literature, art, and in communings with the intellectual aristocracy of the past'" (p. 83).

Culture is thus a prerequisite and a support for political aspirations. Jerry Ward, who was a student at Tougaloo when the FST was founded, commented, "It seemed so natural for Tougaloo College to embrace the civil rights movement and the people who made it happen. This was the environment that Gilbert, Doris, and John encountered; it was fertile ground for the planting of the FST seeds" (Ward 2013b). Ward further pointed out that the movement also addressed people who were not Tougaloo students, whose need for cultural enrichment was only greater (2014).

Applying a cultural approach to organizing was not easy. A newspaper review of the FST's production of *Waiting for Godot* at a black church portrayed a largely bewildered audience, with more than half leaving at intermission (Minor 1965). But examples of successful FST activities are also in evidence. Tom Dent, FST's manager, wrote an account of a play in Bogalusa, Louisiana, that the theater developed with black high

school students about their participation in local protest marches. It featured "the inflexibility of the Mayor, his City Council and the police in the face of that violence, and the determination of the Negro citizens to fight back, to fight for their rights, and to take action to insure their safety while protesting for their rights" (Dent 1966). Certainly participating as performers as well as spectators provided valuable time for reflection on the entire experience.

The first-voice nature of the production was also critical:

> The audience responds to the subtleties, humor, truth of every situation as it develops on the makeshift stage ... this play is about *your* life, *your* problems, what you have been through – and you have heard truths stated tonight which have only been whispered in Bogalusa. And you wished ... every white person in Bogalusa could be in the Union Hall tonight to see themselves portrayed as they really are. (Dent 1966)

Dent noted that the play drew a huge crowd, both inside the union hall where it was presented and outside, where the police chief and several deputies lurked. Both kinds of attention further affirmed the value of the young participants' actions.

The FST and SNCC together strengthened the movement. The FST needed to reach the people most adversely affected by Jim Crow, not likely to be found in theaters. The movement needed a more developed discourse and dialogic opportunity to practice critical thinking to help people name what they were experiencing and envision something else. Ward goes so far as to say that, "We ought to attempt to locate the origins, growth, decline and death of the Free Southern Theater within the context of the revolution that was the long struggle for civil rights that began in the 18th century and went into hibernation in the 1980s" (Ward 2013a). In other words, the larger frame of the FST was not "theater" but the movement.

Transdisciplinarity: *synthesizing approaches to problems* beyond single sectors

One of the foci of transdisciplinarity is an emphasis on real-world problem solving, in the face of which boundaries between specialized fields wear away. Transdisciplinarity is a response to big issues, beyond individual specialties that are "governed not only by *scope* (that is, what is considered within the boundaries) but also by *method* (how one carries out research and understands it to be valid)" (Salmons and Wilson 2007).

While like interdisciplinarity in close collaboration across fields, trans-disciplinarity calls for disregarding disciplinary boundaries and methods, and drawing on whatever means present themselves at a given moment.

One grounding for transdisciplinarity is shared culture, the lived connection to one's people and/or place, a connective tissue beyond professionalism. A project that builds on cultural grounding is *Cry You One (CY1)*, produced by two New Orleans-based experimental theater companies: ArtSpot Productions, whose artistic director, Kathy Randels, directed *CY1*; and Mondo Bizarro, whose co-director, Nick Slie, performed in it. In Chapter 1, I discussed *CY1* as part of a long-term body of work that integrated ensemble and community-based theater making. Here I build on that description to illustrate how theater can be part of a transdisciplinary partnership contextualized by an intractable social issue.

CY1 was informed by scientists, government officials, nonprofit activists, cultural leaders, fishermen, and others affected by the erosion of the Gulf Coast post-Katrina. A powerfully expressive experience of worsening environmental disaster, this performance/ procession/ eco-tour/ ongoing project was performed along a stretch of wetlands over a mile long where spectators experienced a still beautiful landscape damaged by climate change. The location itself as well as the production content put audiences in touch with the abiding beauty of the land, communicating how intertwined that place is with their ancestors, how much meaning that land brings to their lives, and the risk it is facing.

Randels and Slie underlined the contribution of both artists who had been long connected to the Gulf and others who were new to the region. That is, many of the project's creators come from families deeply vested in Louisiana, and who in some cases have worked on this issue for over a decade. Slie noted the advantage of these multi-generational connections: "We are allowed to enter and explore relationships that go beyond individual disciplines with a trust that is rooted in our blood level connection to the soil, the people, the traditions, the songs, the industry." The value of some of the team members being relatively new to Louisiana, he continued, is that they "question assumptions, offer different perspectives, and reframe habits we sometimes sink into. I think of Jo Carson's notion that an outsider who enters a community with respect and good intention may offer a perspective that is lost on folks that are too close" (Slie 2014).

The team gave careful thought to *CY1*'s cross-sector partnerships. Slie credits Alternate ROOTS' Resources for Social Change (RSC) workbook as a source of principles, including partnerships, which Mondo Bizarro

embraces. Slie explained that before *Cry You One*, Mondo had gotten into a habit of partnering primarily with one organization per project, and were not as flexible about partnering as the RSC advised. The *CY1* Community Engagement Team (led internally by Rebecca Mwase and Hannah Pepper-Cunningham) pointed out that the strategy of having one primary partner privileges organizations that have the capacity (such as staff, time, and money) to maintain such a relationship but may not fulfill their every need. Slie gave the example of the Gulf Restoration Network, "a great organization that is well resourced and is primarily white," with which they had partnered happily in the past, as an important collaborator for *CY1* but not the only one:

> Our community engagement team brought concern about environ-
> mental racism to the table ... They encouraged us to invite a wide
> variety of people to come to *CY1* and table after each event. Then,
> on Sundays we would have a community conversation/dinner with
> targeted groups. (Slie 2014)

In the spirit of transdisciplinarity, different partners were best suited for different aspects of the project and allowed them to reach a more diverse public.

Slie explained that in addition to their human collaborators, their partner in *CY1* is the land itself, which requires a very special time frame:

> *CY1* is a site-responsive work that attempts to listen and respond to
> the impulses of the land, people, and policies that inform its modes
> of creation/ engagement ... Time is not just duration but also experi-
> ence. Duration time is 12 months but what are you doing within that
> to have a density of experience? Rehearsing at dawn ... crossing the
> water on boats ... all of a sudden that time goes deep. Watching the
> birds. Encountering nature. What separates what we look for in any
> piece and what we got in *CY1* came from the change in the quality
> of listening. The shift in the rhythm of our lives, coming from New
> Orleans, passing through the cityscape, and getting to the marsh.
> Leaving our cars and spending at least five hours in nature, it was
> inevitable that the wild was going to do its work and slow us down.
> (2014)

Slie's description of the company's relationship to the land as a partner aligns with transdisciplinarity in its profound impact on them. As they

continue to work on policies to reclaim the land, their reciprocal impact could be as profound.

Director Kathy Randels elaborated on what performance brings to the environmental issue:

> The play opens the door for people to feel the intensity of the loss, and encourages us to move from that place – in small groups, working together, taking responsibility for this one seed of this one plant on this one day. It is small actions over time that will rebuild our coast, or keep it from eroding. We had an exhibit up at the Islenos Center [where the performance began] and pamphlets from different organizations that are doing direct action work around the issues. But policy and action: how do we push those further? I think it happens after the performance, in ways that we stay connected or connect our direct action partners to the audiences who come to see the work. (2014a)

Randels raises the important question of what artists contribute beyond the performance to the larger social change context: how far they want to or can be expected to go or how much they facilitate other people's actions to move the issue beyond the performance. While art has the specific capacity to open people with all their senses to a situation, few artists are trained to coordinate political action and only some are interested in extending to such areas. On the other hand, being an artist and knowing a lot about another issue are not mutually exclusive. Monique Verdin was the only member of the *CY1* team from St. Bernard, and, according to Randels, knew the issues better than any of the others, both from her lived experience and from "her intense years of study of how the oil industry and state policies add to the oppression of the communities in this parish, and how Louisiana's industries have negatively impacted the French Indian tribes and communities along the coast for centuries" (Randels 2014b).

The practitioners of each discipline were altered in the course of making a new approach to the issue that brought them together. One of the lessons environmental consultant Blaise Pezold learned from *CY1* resulted from the company's inclusion of multiple perspectives on the issues. He was impressed that they brought together people who normally wouldn't get along. He notes, "At times I was afraid they'd believe the wrong thing. Sometimes I'm like, 'science says this; it's set in stone.' They made me realize that while I believe this I should hear another side and give them a little justice to express that opinion"

(Pezold 2014). The actors learned about nature not only to build facts into the play's content, but also to actually portray environmentalists and advocate for particular interventions.

Randels and company collaborated in depth with community organizer Jayeesha Dutta, coordinator of the Gulf Restoration Network (GRN), committed to uniting and empowering people to protect and restore the natural resources of the Gulf region. Dutta's role involves addressing the needs of Gulf Coast communities for environmental and community restoration in the aftermath of the BP oil-drilling disaster. Dutta explains why she wanted to organize around *CY1*, itself a testimony to what the art contributed to organizing:

> Until I saw *Cry You One*, my work was a job; it was good work, not a sell out, but I'm in school half time getting a graduate degree. That was my focus; I hadn't planned to get emotionally involved but I did. Going through the *CY1* experience cemented my emotional engagement and changed how I thought about my work. I felt the need to figure out how to work with them. (Dutta 2014)

Dutta told them about Gulf Future, a coalition of 50–60 community organizations across the five Gulf states formed to expand GRN's ad hoc work with musicians and artists. When the BP oil spill happened, the coalition responded, and helped get the Restore Act passed, although it has yet to be determined how the funds will be spent. In the meantime, Dutta stressed the importance of broadening the coalition and keeping people emotionally engaged. She saw, in these original art partnerships, a model for collaborating with *CY1*, to keep people engaged while this one initiative is tied up in legislation.

Dutta and a number of the *CY1* players designed all-day workshops, one held in each of the five Gulf Coast states. The gatherings, Randels noted, "gave folks from different sectors approaching this dire work the chance to problem solve together while sharing their different life stories as well as their different areas of expertise" (Randels 2014b). The day began with the screening of documentary films about Gulf Future Coalition (GFC) communities, both to give everyone time to arrive and to get grounded in the GFC network. Then *CY1* ensemble members did a performance excerpt. Everyone told stories over lunch, in response to the prompt, "How does what we just saw and experienced resonate with something in your own story?"

After lunch was a more informative, simple but fun, interactive, "alphabet" workshop, so-called because it focused on acronym

organizations, like NRDA (Natural Resources Damage Assessment) and NFWF (National Fish and Wildlife Foundation), explaining what they are and do. People obtained solid knowledge about what's happening and what funds are available, in criminal (for people who died) and civil (negligence) categories. They ended the day in small-group creative visioning sessions. The artist facilitators each used a different art media – music, singing, theater, visual arts – through which participants responded to the prompt: what would you do with the funds? "So," notes Dutta, "They began the day as consumers of culture and ended it as makers" (2014).

Randels attributes attending Alternate ROOTS since 1999, especially noting their annual "uprooting racism" workshop, with helping to sensitize her to fundamental issues on which she as a performer may not have focused. ROOT's ethic and aesthetic is undoing oppression, which is part of the content of their work as artists responding to their community and country. She learned not to be afraid to go deeper into race conversations; she and the company were sensitive to issues of environmental racism, noting the influence, too, of John O'Neal's work with Junebug, the heir to the FST, on the subject some years earlier. As Jayeesha's co-facilitators of that event, the artists also used ROOTS' modified socio-metrics, songs, and principle of infusing culture into every aspect of organizing, even with the lawyers and other people working on nitty-gritty aspects, to keep everyone grounded in our common humanity. Which, Randels explains, is what they have been doing with *CY1* all this time: thinking about these issue with their hearts, minds, and spirit, and drawing on older ways of thinking/knowing/being, connected to native American traditions, another anchor to *CY1*, and placing humans in an interconnected web rather than having dominion over the land and the creatures that abide there (Randels 2014a).

Cross-sector theater education

Though in the next chapter I address higher education as a platform for performance that crosses sectors, I want to underline here the role of education in predisposing a theater artist to branch out to cross-disciplinary collaborators. As an undergraduate, Randels wanted to be an actor/creator, not an interpretive actor, the training typical of programs that by and large prepare students to be in plays (of which the playwright, director, and designers are the only ones considered creators). Studying in both the theater and performance studies programs at Northwestern, Randels focused on craft/interpretation in theater classes, and authorship and ideas in performance studies. One of Randels's most formative classes was Performance Studies (PS)

professor Dwight Conquergood's Performing Non Fiction, which students called "the solo class." Conquergood engaged students in both corporal exercises such as mask work and intellectually focused research and adaption. One integrative assignment was to create a performance for oneself, which had to be 51 percent nonfiction. Randels focused on Tennessee Williams, who wrote *Glass Menagerie* while living in New Orleans, deepening the connection between her own roots and aesthetic expression (Randels 2014b).

But the connection went further: theatricalizing fictional and nonfictional material together opened Randels to the intersection of immense personal and social energy around rage, which she realized she had been suppressing most of her life. That led to the creation of her first professional solo performance, *Rage Within/Without*, which explored anger, aggression, and violence in women, and for which Randels interviewed women incarcerated for killing their long-time abusers. Randels went on to found what is now an 18-year-old ensemble at Louisiana Correctional Institute for Women, which she has co-directed with Ausettua Amor Amenkum since 2001. Randels writes,

> When a personal subject is connected to a larger injustice, it is the ignition for becoming an artist who uses their work for social change. My first hit around that was to fight oppression of and violence towards women; in the wetlands trilogy the ignition was Hurricane Katrina – oh, land loss is not only coastal, it is in my living room – it is almost up to the second floor! When the affect of the oppression hits so close, you want to use any tool you have to fight, and for artists this is simply our primary tool. (2014b)

Nick Slie majored in performance studies at Louisiana State University, where "the theater faculty used to say, 'We love your work but there's no craft.' The performance studies people said, 'We love your plays but there are no ideas.' You can make a show without incorporating both but you can't do your best work, or at least I can't" (2014). Not only does PS foreground ideas but also some of its best-known pioneers, such as Dwight Conquergood, were equally rigorous about ethics. LSU alumnus Ross Louis asserts that Conquergood's highly ethical standard in doing performance fieldwork was one of the hallmarks of his approach, passed on through two of his former students who direct the LSU program. For example, when Conquergood worked through the World Health Organization at a Hmong refugee camp, he used indigenous healing methods when he got hurt and encouraged people to use Western

resources like rabies shots for their dogs in the case of an epidemic (Conquergood 2008). This attitude of reciprocity with participants is critical in cross-disciplinary contexts generally.

The City University of New York (CUNY) Masters of Applied Theatre is one of a number of programs nationally that prepare graduate students for cross-sector art-making. It culminates in a thesis consisting of the design and execution, in pairs and trios, and then an individually written analysis, of a project applying the theoretical and practical theater knowledge they've acquired to particular contexts and people. The tools are offered in a Freirean spirit, emerging from dialogue with participants, not imposed from the outside. As they make initial contact with possible sites for their thesis projects, students review the relevant literature, articulate intended goals and outcomes, and contextualize their project historically and culturally. They appraise ideas they have encountered in the MA program that are most relevant to their project and "identify deficiencies in their knowledge and broaden their reading accordingly" (CUNY Master's Degree n.d.). The bottom line is an understanding of what is needed to make both the art and the social component effective.

In December 2013, I listened to the students present their thesis proposals. One of them, reflecting on the challenge of setting up the project, said: "I struggled with how much I needed to know about the context into which I was inserting my project." The other students' identification with that statement was palpable. Ideas about especially multi- and interdisciplinarity are relevant in response.

Some CUNY thesis projects are multidisciplinary, with students providing theatrical knowledge and partners providing something else. One 2014 project, for example, took place with second graders studying rocks and soil. The school's goal was to encourage thinking and learning *as* scientists, an experiment initiated in citywide elementary school science classes. The CUNY students facilitated role-play with the children as scientists and paleontologists. Through their knowledge of role-play's capacity to problem solve, build confidence, conjoin study with play, and build on children's natural sense of curiosity, they helped carry out the experiment with only a modest knowledge of earth science if any at all. And that was sufficient.

Some of the MA students are fluent in a relevant body of knowledge in addition to theater, tipping their projects towards interdisciplinarity. I was the advisor to Olivia Harris and Marissa Metelica on their 2014 thesis with Afghan women in New York City. They built on the sociological theory of "cultures of silence" that Harris had studied as

an undergraduate to understand how certain important topics can be known by everyone in a community but never discussed. They asked how theater can not only help people become conscious of those silences, but also be used to examine steps they could take, if they so choose, to challenge underlying social norms reinforcing them. They used applied theater techniques to help Afghan immigrant women recognize where they have some agency if they want to bring up difficult topics, poignant given the women's traditional subservient role. Their grounding in theories of cultures of silence was a definite asset.

A limitation on interdisciplinary (and transdisciplinary) projects in most training programs is their short duration. Over six weekly two-hour sessions (disrupted by a snowy winter and various holidays), Harris and Metelica had just built enough trust with the participants to invite content through which breaking silence could occur when the workshop ended. Metelica questioned the structure of entering a community-based workshop with a research question at all. Oughtn't they have first explored various subjects together and see what came up for participants? And if bringing in a focus is acceptable, were they sufficiently transparent about what they wanted to explore? Though their host organization, which supports Afghani women in New York City, was enthusiastic about the theme, Harris and Metelica had no way of knowing at the start what participants themselves thought.

Director Chris Vine describes several ways they deal with these issues. The Applied Theatre faculty welcomes students adjusting their focus if something else emerges over the course of the thesis project, but there is not time for a complete direction change. Students can begin workshops sooner so that the focus emerges over a longer period of time. They can take courses with an internship component or develop their own relationships to organizations. Vine notes that "building of trust, mutual understanding, and knowledge at the institutional level is clearly an advantage, but the idea of letting the focus for the work emerge from the participants themselves is not always as simple as it might seem." Vine gave the example of a student team that began their thesis research early but by the time they initiated their project, the participant body had changed substantially: "The students still had to bridge afresh the gaps between the wants and needs suggested by the host organizations, the *anticipated* needs and interests of the participants (based on the students' earlier work), and the *actual* needs and interests expressed by substantially changed groups of participants in the second encounter" (Vine 2014).

Vine points out the challenge of time in the general context of academic study and training. He muses:

> What differences, if any, can or should reasonably pertain to student learning projects – and the "contracts" that govern them – by contrast to "professional" engagements? The reality of a program such as ours is that time is always at a premium and there are frequently conflicting priorities and limitations that do not impinge upon practitioners in other contexts. (There are of course certain freedoms too.) How do we balance the time devoted to "real-world" projects with the time required to prepare students adequately to undertake them? Can we do this with integrity *and* meet the demands of academia? Should the "freedom to fail" be more extensive than in other situations? How much theoretical and practical preparation and "practice" can or should be offered in such short time frames?

<p style="text-align:center">* * *</p>

I close with two broad points about cross-disciplinary collaborations. The first is that performance brings to cross-sector partnerships not so much additional content as useful processes. It offers containers for working across borders, and processes for bringing people together across differences of discipline as well as life circumstances (race, class, education level, et cetera). Performance establishes common ground, uniting people in their shared concern about the issue even if their opinions about action steps are different. The capacity to link personal experience to a shared social reality is one of performance's great strengths. All the artists in this chapter have used story circles – occasions where people sat together in a circle and listened to each person respond, from a very personal perspective, to a prompt. At the CCUSA workshop, each person described an ideal day in his or her anti-poverty work. During the civil rights movement, the FST sometimes began post-show conversations with story circles. On *CY1*'s website and at its one-day salons, story circles are a core approach. Hearing people talk from their own experience brings the discourse beyond argument, that is, who is right and who is wrong, to an appreciation of what each other has been through.

My second point is that performance, as an expression of culture, keeps the social issue aligned with its lived meaning for the great range

of people who are impacted. Specialized scholarship, while providing necessary research, can dry issues up, pursuing them in terms only legible to other specialists of the same field. Collaborations based in various social sectors, as manifested in the next section of the book, bear witness to a life in the theater not necessitating forsaking other sources of meaning and value, which may be effectively addressed through such uncommon partnerships.

From Multidisciplinarity to Boundary Work

Julie Thompson Klein

This chapter builds on distinctions in the core vocabulary of multi-, inter-, and transdisciplinary forms of research, practice, and education. Cohen-Cruz invited me to comment on the relationship of performance to developments in theory and practice of inter- and transdisciplinarity. In doing so, I also indicate why boundary work has become a more appropriate concept for crossing not only disciplinary borders but also interdisciplinary fields, occupational professions, and sectors of society beyond the academy. "Boundary work" is a composite label for claims, activities, and structures that define, maintain, break down, and reformulate boundaries between divisions of knowledge (Fisher 1993; Klein 1996, pp. 1–2, 36–7, 57–84).

Interdisciplinarity

The distinction between multi- and interdisciplinarity is a crucial first step. *Multidisciplinarity* (MD) broadens the base of knowledge, widening students' horizons in general education and interdisciplinary field studies while expanding the repertoire of content and methods in research projects. The keywords in Klein and Roessner's schematic of degrees of integration are *juxtaposing*, *sequencing*, of separate disciplinary inputs, and *coordinating* of different experts. The relationship of inputs is typically additive, limited to separate accounts and reductive service of one discipline to the needs of another evident in arts education construed as a way to teach transferable skills for problem solving in math and science, art as decorative illustration for other disciplinary studies, and performance as entertainment. Nonetheless, multidisciplinarity plays a vital role in raising awareness.

Interdisciplinarity (ID) differs. It entails a conscious effort to integrate multiple disciplinary approaches to a common question, problem, or

topic, captured in Klein and Roessner's keywords of *interacting, linking, blending, integration,* and *synthesizing.* The spectrum of activities is wide: from borrowing a concept or method from another discipline to creating a new hybrid field. The scope and scale of projects, mix of expertise, and degrees of interaction also vary. And, team-based projects exhibit different degrees of integration, from incorporation of borrowed information or tools to a synergistic process that entails mutual learning of each other's perspectives, development of a shared language, and interdependence in the creation of new knowledge or solution to a complex problem. In the case of Michael Rohd and Sojourn Theatre, they contributed performance-based, community-building skills to Catholic Charities USA (CCUSA), leveraging the power of theater in meetings at a CCUSA conference that crossed social and cognitive boundaries to deepen constituents' relationships with each other and offer new approaches to the challenges of poverty work.

Understood more broadly as an expanding field, Mindy Fenske reported in a review of the "Interdisciplinary Terrains of Performance Studies," the subject of performance appears across an array of contexts, including theater, speech, dance, English, film and media studies, and communication studies. Many scholars and artists trained in practice and theory of performance, she adds, craft creative ways to sustain their performance identity while teaching courses in cultural studies, women's studies, African American studies, intercultural communication, visual studies, and communication pedagogy. Fenske identified three common themes in the practice of interdisciplinary research in humanities: concept or method appropriation (borrowing from another discipline to add depth and complexity to an argument or conversation in a scholar's home field), theoretical pastiche (producing a "jack-of-all-trades" collage or montage criticized for lack of rigor and regard for disciplinary origins), and Shannon Jackson's notion of the "synecdochic fallacy" (assuming a single movement or work of scholarship represents an entire discipline).

Cohen-Cruz's example of the Free Southern Theater (FST) models the capacity performance has to advance grassroots critical thinking and active participation in the context of civil rights. FST was more than multidisciplinary entertainment: it provoked, she recounts, "new forms of cognition" for civil rights workers and other citizens of Mississippi. Like Sojourn Theatre, FST deepened new ways of thinking, in this case about political and social struggles. Comparable to Klein and Roessner's keywords of Interdisciplinarity, integrative process entailed "yoking" together and "negotiating" of contradictions between approaches. The boundary

work of interdisciplinarity in this and many other cases depended in significant part on a collaborative dialogic process that "untangled" differences in order to establish connections across boundaries.

Transdisciplinarity

The keywords of transdisciplinarity (TD) in Klein and Roessner's schematic are *transcending, overarching, transforming,* and *transgressing.* In the 1970 typology, transdisciplinarity was defined as a common system of axioms that transcends the narrow scope of a set of disciplinary worldviews through an overarching synthesis. The example was anthropology conceived as a broad science of humans. At present TD is being advanced in three major discourses: transcendence, problem solving, and transgression (Klein 2015). The discourse of transcendence was grounded historically in the quest for unity of knowledge. The emergence of transdisciplinarity was not a complete departure from this ambition, but it signaled the need for new syntheses at a time of growing fragmentation of knowledge and culture. Leading examples of overarching frameworks beyond the example of anthropology have included general systems theory, Marxism, post/structuralism, feminist theory, cultural critique, and sustainability. The label also appears in conjunction with areas of broad scope, including the traditional disciplines of philosophy, history, and literary studies, as well as anthropology and geography.

The discourse of problem solving is not new. It was key to the conception of interdisciplinarity in problem-oriented research at the Social Science Research Council in the early 1920s and central to defense-related research in World War II. The impetus heightened in the late twentieth century, aligning interdisciplinarity with "real-world" problem solving. Its alignment with TD today is a cornerstone of two major initiatives, The first, the US National Institutes of Health connotation of "transcendent interdisciplinary research," is generating new methodological and conceptual frameworks for analyzing social, economic, political, environmental, and institutional factors in health and wellness. The second is evident in the international Network for Transdisciplinary Research, known as td-net. A new form of problem-oriented research appeared in the late 1980s and early 1990s in European contexts of environmental research and, by the turn of the century, case studies were reported in all fields of human interaction with natural systems, technical innovations, and the development context (Klein et al. 2001). TD also became associated with the participation of stakeholders in society, fostering a new trans-sectoral form of problem-oriented research.

The discourse of transgression is not new either. It was part of the push for forms of Critical Interdisciplinarity that gained momentum in the 1980s and 1990s, informed by new poststructuralist practices and cultural critique; historical, political, and sociological turns in disciplinary practices; and a broader discourse of human rights accountability that advances democratic participation and deprivileged forms of knowledge. In contrast to more instrumentalist and opportunities forms of interdisciplinary work in the service of national needs, Critical Interdisciplinarity highlighted interrogation of the existing structure of knowledge and education with the aim of transforming them. The mixed success of earlier movements led to wider adoption of the term transdisciplinarity to reinforce the critical imperative through transgressions of disciplinary boundaries, not simply combining existing approaches. The imperative of TD also aligned with the concept of a "post-normal science" that breaks free of reductionist and mechanistic assumptions about the way things are related, how systems operate, and the expectation that science delivers final precise estimates with certainty.

Cohen-Cruz's New Orleans-based example is a powerful illustration of this transdisciplinary extension. Performers partner with scientists, government officials, nonprofit activists, cultural center leaders, fishermen, and others affected by erosion of the Gulf post-Katrina in *Cry You One*, a site-specific performance about post-Katrina environmental devastation. It is multidisciplinary in opening up hearts and minds, given that few artists are trained to coordinate political actions. It is interdisciplinary in the engagement of separate approaches focused on a common goal. It is transdisciplinary in creating a new overarching approach that also involves stakeholders in society in the production of knowledge and solutions. In the latter case, echoing studies of collaboration across boundaries, traditional hierarchy of decision-making is flattened in favor of distributed leadership models that generate, in turn, grassroots participation. Paralleling studies of interdisciplinary teaching and learning, the conception of a teacher/leader also shifts from the traditional "sage on the stage" to a coach, a guide, a mentor, and even a co-learner. In transdisciplinary teamwork, mutual learning is key to creating common ground and action.

Creativity and innovation

Any discussion of interdisciplinarity and performance would be incomplete without also factoring in the relationship between creativity and innovation. "Innovation" is often equated narrowly with invention

in product design and implementation. It is also associated, however, with creative process in integrative collaborations. In a special issue of the *Creativity Research Journal* on the theme of "Interdisciplinarity, the Psychology of Art, and Creativity," Keith Sawyer highlights a shift from product to process across genres and culture expressions. Sawyer underscores the widening contexts of performance others have noted, while adding implications for folkloristics and the ethnography of speaking, ethnomusicology, studies of scientific practice, and sociocultural psychology. Disciplinary boundaries still impede communication, but the shift from product creativity in fixed and disembodied texts to performance creativity in sociocultural contexts and actions has brought humanists and social scientists together in new ways.

The shift from product to process is also apparent in studies of inter- and transdisciplinary collaboration that examine the role of creativity in generating new understandings and approaches to problem solving (Klein 1990). Most definitions of creativity, David Sill (1996) found in a study of the link with interdisciplinarity, emphasize the appearance of something new. Creativity is heuristic not algorithmic. It relies on rules of thumb or incomplete guidelines to drive learning and discovery, not mechanical rules. It also draws from the richness of the subconscious in relying on nonlogical and nonlinear thought processes. Preinventive structures in the subconscious provide raw material for creative combinations in the form of ideas, images, and concepts. Their ripeness encourages creative insights that tend to be novel, meaningful, incongruent, and divergent. They also contain emergent features.

A recently published book, *Transdisciplinary Sustainability Studies: A Heuristic Approach* (Huutoniemi and Tapio 2014), aligns transdisciplinarity with the performative dynamics of heuristics in collaborative solution-oriented approach to complex problems. The connotation of transdisciplinarity is at the heart of this book. The word *heuristics* derives from an ancient Greek word meaning "to find" (*Oxford English Dictionary* 2012). Over the ensuing centuries, the term was associated with an "art" or type of "logic" that is more fluid and ad hoc than linear and rote deduction of an answer or a solution from a prescribed set of rules. Emerging through discovery of options, each step draws closer to a workable approach. The alignment of heuristics and TD moves beyond older forms of methodological interdisciplinarity that aim to improve the quality of results, typically by borrowing and applying a method or concept from another discipline in order to test a hypothesis, to answer a research question, or to help develop a theory. Awareness of established methods and strategies is important for informed problem

solving. Yet, rules of thumb, guidelines emanating from practice, and comparative weighing of possibilities are of equal importance.

The etymological inheritance of "finding out" also underscores the creative dynamics of learning from each other in collaboration, from trial and error, and from reflection on a team's art of invention that is intrinsic to an integrative conception of performance. Both may be likened, moreover, to heuristics in the discipline of rhetoric. Returning to etymology, the *Oxford English Dictionary* defines heuretics as "the branch of logic which treats of the art of discovery or invention." The rhetorician Gregory Ulmer (1994) extended this concept in *Heuretics: The Logic of Invention*. Continuing a decades-long synthesis of lessons from poststructuralist theory, avant-garde art experiments, and electronic media, Ulmer aimed to find forms appropriate for cultural studies research and teaching writing in the digital age. Ulmer contrasted traditional methods of interpreting print-based texts to the "generative productivity" that occurs in the avant-garde and in composing digital works that mix word, image, and sound. Transdisciplinary sustainability studies are not concerned with hypermedia, but they too are engaged in creating solutions that do not derive from applying traditional methods. They require a new mode of argumentation and a conception of learning akin to Ulmer's belief that learning is closer to invention than to verification. The cognitive process of "finding out," as the editors and authors of this book demonstrate, requires discovery through an expanded repertoire of generative skills, strategies, and schemes.

In the past, scholars of interdisciplinarity have not paid much attention to performance studies. The examples Cohen-Cruz presents underscore why they should, adding valuable insights into evolution of an interdisciplinary field, collaborative process, and integrated actions for handling challenges that include public safety, justice and equality, child development and aging, immigration, sustainability, and housing, and community development. At the same time, they reinvigorate the notion of "public humanities," crossing boundaries of the academy and other sectors of society. New approaches to education, such as the City University of New York (CUNY) Masters of Applied Theatre, also foster the integrative capacity to handle the challenges that face us today. The degree prepares graduate students for cross-sector art-making through reading to broaden their knowledge bases, becoming familiar with the context of a site, articulating intended goals and outcomes, and contextualizing projects historically and culturally. The bottom line is an understanding of what is needed to make both the art and the social components effective.

Part II
Platforms

Part 2
Plutarch

3
Universities, Performance, and Uncommon Partnerships

Reflecting on US higher education's support for art that serves both aesthetic and social goals, I hypothesize three waves. The first was catalyzed by George Pierce Baker, who in 1905 taught the first theater class in a US university (Harvard), emphasizing writing plays based on what the author knows, and focusing on where they are. Like the first mode of socially informed performance I describe in the Introduction, this wave is play-based, emphasizing the playwright. The significance of this one class cannot be overemphasized, its role in the development of a uniquely American dramatic literature having often been noted. I want to emphasize its generative role for the grassroots theater movement. Two of Baker's students, Alexander Drummond and Frederick Koch, passed on the valuing of local culture not only in classes for college students but also to people in the regions where their institutions were located. Drummond's student Robert Gard went on to articulate grassroots theater in a book by that name, which in turn is a source of community-based theater (Cohen-Cruz 2005, pp. 28–30).

The second wave reflects the influence of the 1960s and 1970s on people committed to theater and progressive politics, who found professional homes in colleges and universities. Such faculty members have expanded learning into experiential contexts so that students don't just make theater *about* a subject but also *experience* its impact, however modestly, often through facilitating workshops with people in a range of circumstances. This wave, like the second mode of socially informed performance described in the Introduction, emphasizes artist facilitation of participatory experiences.

I believe a third wave has begun, spurred on by engaged faculty seeking ever more efficacious partnerships as artistic networks increasingly look to higher education for support. Witness the Network of Ensemble

Theaters' 2014 Intersections conference, exploring the relationship between universities and ensemble companies, not only in productions but also in a range of place-based collaborations. The Doris Duke Charitable Foundation's Creative Campus initiative funded university/ college arts presenters and specific artists so to expand and strengthen such relationships, often by moving beyond the arts sector to larger campus and community constituents as beneficiaries of such arrangements (Creative Campus n.d.). Numerous campuses are establishing arts centers open to the public both to contribute locally and to benefit from local largess. This wave corresponds to the third mode I identified in the Introduction, and this book's focus, cross-sector partnerships. In this chapter I look at such relationships and ask how art with uncommon partners, with higher education as a platform, can be fully recognized as part of the artistic continuum and higher education's mission, as both a practice and a subject of study.

Long-term support for such uncommon partnerships requires understanding higher education's culture vis-à-vis: (1) who may facilitate and access resources for such projects; (2) where in the institution's structure they are based, leading to the question of how the engaged arts are seen within/garner support from their respective disciplines, especially cross-sector initiatives that don't align with strictly aesthetic criteria; and (3) what justifies interdisciplinary projects with core non-university partners as appropriate components of the college experience. That is, how does the university situate performance in uncommon partnerships in its mission?

As regards the first question, faculty with tenure tend to be most enabled by administration to set up student learning, including that which takes place in community settings, although other high-level administrators may be so empowered by particular provosts and chancellors. Without tenure, faculty can rarely commit the time this work takes to do well because they are either part-time and also working elsewhere or they are doing what it takes to try and get tenure, which is seldom through engaged scholarship and practice. Without tenure, their positions are subject to the comings and goings of high-level administrators.

As to the second question, most such projects are rooted in particular departments and schools, signaling the need for disciplinary acceptance. Just as performers who integrate aesthetics and social engagement have taken steps to be accepted in institutional theaters, as I describe in Chapter 1, so must teachers and artists whose work extends beyond the aesthetic frame justify its place in theater departments.

My entry point to the last question is the "serving the public good" aspect of the university mission – the sense that universities in a democracy must contribute something to and participate in the place they are situated. In the 1980s, the value universities placed on "the public good" was reflected in the propagation of "service learning" courses and projects, initially largely one-way acts of beneficence emanating from the university. I am among those who prefer to frame such initiatives as public scholarship and creative practice, which both more accurately describes their capacity to deepen student learning, enhance faculty research, and partner with local experts and gets closer to the heart of higher education's purpose. In what follows, I elaborate on this frame, provide case studies of two short and one long performance-infused uncommon partnership, and consider the strengths and drawbacks of academia as a platform. All the case studies exemplify how university constituents – faculty, students, and administrators – engage with people and organizations beyond the institutional walls as part of the fulfillment of higher education's pedagogical and "public good" purpose.

Civic professionalism[1]

Civic professionalism provides a philosophical frame to justify college and university support for the arts with uncommon partners. It interweaves three purposes of higher education: first, critical thinking/learning how to learn; the second, a pathway to a career; and third, the application of one's discipline in the world as part of being a citizen. That is, civic professionalism provides a set of values and a framework for meshing the traditional strengths of the liberal arts with the practical work of sustaining and supporting ourselves and our communities. It synthesizes the needs and goals of a vocational path in the context of a liberal arts education with the skills of effective citizenship in a democracy. According to Scott J. Peters, co-director of Imagining America, "civic professionalism casts professionals' identities, roles, and expertise around a civic mission. It places scholars inside public life, rather than apart from or above it, working alongside their fellow citizens on questions and issues of public importance" (2003). Civic professionalism is a bridge between intellectual and practical learning, and between vocational goals and the common good.

Beginning with the civic component of civic professionalism, cross-disciplinary, cross-campus-and-community projects substantiate higher education's rhetoric as a "public good," contributing as anchor institutions to their geographic communities while instilling students with

an ethos of participation in civic life. The notion of universities contributing to the common good is standard fare for public institutions; the mission of the State University of New York (SUNY), for example, is "to address local, regional and state needs and goals" (SUNY Mission n.d.). Such a stance can be justified at public institutions by the fact that states contribute at least some money to them and it is incumbent to use public monies for public purposes. Yet private institutions often articulate a public purpose as part of their missions as well. New York University calls itself "a private university in the public interest."

But the rhetoric of "serving the public good" raises questions. The notion of "serving" is outmoded, often replaced by the idea of *engaging with* the public; and the idea of "the public good" can cross into paternalistic territory. Moreover, "serving the public good" is open to interpretation. Higher education can make unilateral contributions that keep others on the receiving end, or that benefit the institution more than the off-campus partners. Faculty sometimes forget that while they are paid to work with students who have yet to fully develop craft and interpersonal skills, the community-based "partner" seldom is recompensed for what is in effect on-site professional development. Katy Rubin, director of Theatre of the Oppressed: New York (TO-nyc),[2] has described the many college students who come to her for papers they are writing or to fulfill internship requirements, often without committing enough time or bringing usable skills to make engagement with them valuable (Rubin 2014). Meanwhile youth with whom she works in settings like homeless shelters, alternative sentencing organizations, and LGBT centers, often the same age as the college students, are similarly developing skills in Theatre of the Oppressed but without the money to pay for credentials.

Another way of stating US higher education's larger purpose is preparing students to participate in a democracy. While not the only place, if not in higher education, where does one learn to make the reality of democracy closer to its theory? To cultivate the competencies for everyone to proactively participate in public life would mean embedding such pedagogy on the secondary school level. What does citizenship mean beyond the context of high school "civic" classes about government, or the legal status of belonging, and how it is activated? At the post-secondary level, it entails engaging civically through one's major area of study, as the subject the student knows well enough through which to make a significant contribution.

As to civic professionalism's second component, the pedagogy embedded in campus-community arts projects cultivates students who

can act with empathy and imagination across multiple knowledge and cultural domains. Interacting through the arts with people of different backgrounds, circumstances, ages, classes, and religions, a quintessential civic experience, brings learning alive, grounds theory in practice, and expands student experience, so germane to art-making. Moreover, students are multidimensional beings like everyone else; art partnerships beyond the academy provide a context for integrating their art with whatever else they are drawn to, be it the elderly, the environment, or something else. Campus-community partnerships can be win-win – students finding meaning when applying their growing skill sets to real circumstances, and local participants both enhancing student learning and benefitting from their contribution.

Many students want hands-on experience applying what they are learning both to help prepare them for future careers and to contribute beyond the intense focus on self that characterizes much arts education. Yet too often, students in the cultural disciplines fail to receive the intentional direction and practical experience necessary to prepare them for a full range of post-baccalaureate careers, even as scarce as professional opportunities have always been in the arts. Most faculty are not prepared to mentor students for publicly engaged careers, not knowing how to teach their subject beyond the ways they learned it. Some faculty lack respect for civic applications of the cultural disciplines, and fear that public engagement will diminish the craft or aesthetics of the art form and the rigor of the scholarship. Instructors in these fields need to be educated about the creative and intellectual depth such pursuits encompass. Even faculty sympathetic to engaged scholarship and practice face barriers, doubting that they will earn tenure for community-based work. Support for civic engagement through the disciplines sets up conditions for professors to consider such approaches.

Civic professionalism's third component, finding a professional pathway as an undergraduate, became more acceptable when the recession of 2008 led to fewer employment opportunities. While colleges have long recognized the need to help undergraduates identify career directions, they often balk at anything that looks like vocational training. Even skills acquisition in conservatory programs are framed as learning one's craft, not concretely linked to obtaining a job. Students in theater BFA programs, for example, are often told they will graduate ready to enter their profession, with well-trained voices and bodies and facility in scene work. BFA programs rarely attune young artists to a full range of professional opportunities that include applying such training for purposes beyond the purely aesthetic. The recession also contributed

to a rise in public expectations of what justifies the cost of higher education. Experiential and cross-sector learning are obvious ways for students to explore career paths, including some they might not have considered in a more robust economy, and which additionally, in the case of the arts, align the real map of activity with an imagined one.

Financial and philosophical challenges are also impediments to civic professionalism. The 2008 recession resulted in financial belt-tightening. Numerous college presidents pitted "providing the best education for students" against "serving the local community," spending money on resources used only by students rather than acknowledging how students can benefit when participating in initiatives engaging local people in joint problem solving. The value of campus-community part-nerships is further obscured by a bias against collaboration in many fields of scholarship, which privilege individual accomplishments and written artifacts. Nonetheless there has long been a movement to appre-ciate scholarship's many forms, including "collaborative research, team teaching, hybrid fields, comparative studies, increased borrowing across disciplines, and a variety of 'unified,' 'holistic' perspectives [which] have created pressures upon traditional divisions of knowledge" (Klein 1990, p. 11). The proximity of people with different expertise at colleges and universities can facilitate addressing issues that transcend discrete bodies of knowledge together, and can also promote powerful learning in contexts beyond the classroom.

Another philosophical challenge is the mindset that all knowledge comes from the university, which Harry Boyte (2009) calls the "cult of the expert." Chancellor Nancy Cantor of Rutgers–Newark advocates replacing that idea with the notion of a community of experts: "We're so trained to be such experts on everything ... It's almost like that's what education has become – how you strain out all the humility, all the sense of doubt, all the complexity, all the not knowing something" (Cantor and Lyons 2013). Working with people whose considerable knowledge is constantly tested by experience should be enough of a reminder but not always is.

The best arguments for civic professionalism are strong examples, to which I now turn.

Embedding performance in uncommon partnerships in short-term contexts

For faculty just beginning to explore social engagement through the arts or wanting to undertake something on a modest scale, initiatives that

take students beyond the classroom can be designed as single, course-specific learning components. Amy Steiger's production course Acting, Performance and Community, at the University of Louisville, for example, requires students to connect with people from the local community as part of their character research for a production. When the play at the center of the course was Charles Mee's *A Perfect Wedding*, for example, the assignment included conversing with someone unrelated to the class about the national debate over marriage equality.

Many artist-teachers juggle numerous professional commitments and may prefer shorter-term projects with universities. An example is Michael Rohd, who appreciates "a university's resources: space, students, a shop. A lot of artists are developing more work in universities these days because it's one of the only places they can" (Rohd 2014a). He has been committed to continuing directing a company of artistic peers even as he teaches at Northwestern University.

Rohd created Town Hall Nation: A National Act of Civic Imagination (THN) as an experiment using a current issue to enliven and add a civic dimension to techniques, methods, and theories that students are already learning. He launched it in response to the polarized state of US politics as the November 2012 presidential elections approached, to make space for students to reflect and respond to public events unfolding around them. If taking over class time, such discussions can undermine what professors and students expect and need from a course. Structured as extracurricular, the issue can be trivialized. If ignored, education can seem irrelevant to understanding the contemporary issues of public life.

Rohd was interested in the theatrical possibilities of the town hall format, a model characterized by full participation of residents with diverse points of view and yet with a mandate to make decisions affecting them all. He invited college faculty and community groups to create and perform theatricalized town hall meetings approximately 30 minutes long. He proposed that they use the presentations to articulate positive models of how a group of people in the same situation but with many points of view could come to consensus and make a decision that would actually be carried out. He described such a format as "an imagined fully functioning example of democracy on a local level" (Rohd 2011).

Imagining America: Artists and Scholars in Public Life (IA), a consortium of some 100 US colleges and universities that "advances knowledge and creativity through publicly engaged scholarship drawing on humanities, arts, and design,"[3] of which I was director from 2007 to

2012, supported a component of THN involving campuses and communities. The initiative was announced at IA's October 2011 national conference, so interested faculty had time to insert a Town Hall component into a course they were scheduled to teach that spring or the next fall. Faculty from over a dozen campuses signed on, sharing descriptions of how they would construct the mini-performance event. Themes included conflict between religious ideology and publicly funded healthcare and sex education, neighborhood safety, a regional planning effort to get beyond impersonal surveys to garner more diverse opinions, an upcoming vote on a city income tax, food issues to get at commonalities in a politically polarized region, and the university's role in local gentrification (Town Hall Nation 2011).

Participants joined monthly conference calls facilitated by Rohd beginning in January 2012 to problem-solve challenges they were facing in mounting performances around these issues. Rohd asked: How do you want members of your community to speak with each other? How do you want them to engage with elected leaders? How do you want leaders to respond to their constituents? What would make you feel like your time was well spent? What would make you feel like democracy was functioning in practice? Do you need to consider other artistic tools to reach your goal? They exchanged ideas about techniques and pooled relevant readings. Rohd also offered at least one "tutorial" per project apart from the collective calls.

Over half of the ideas led to public, theatrical town hall events. But even the others were good learning experiences, providing the frame for students to apply their craft to a real public issue in US life and at the same time encounter new career opportunities, partly from hearing diverse uses of the arts from each other on the calls. By the end of the semester, all participants knew a little bit more about interfacing a course with a current public controversy. Applying learning goals to participation in an actual public situation proved to be promising pedagogy. The three goals of civic professionalism were met in Town Hall Nation. Students developed their critical thinking capacity in applying a theatrical format to an issue in their own geographic region. They expanded their sense of what one can do with a theater education by actually making a performance in relationship to current social issues. They played a civic role through this process by engendering a civil way to have a public conversation about a contentious issue.

Notwithstanding, the project would have needed a more robust support system to function maximally. Martha Bowers, co-teaching with Deborah Mutnick at Long Island University, would have liked

IA to provide modest funds to pay a part-time person at each campus to document the projects (Bowers 2014a). John Catherwood-Ginn of Virginia Tech noted on the one hand, that hearing other THN leaders describe their ideas, assets, conditions, quandaries, and unique understandings of "the national dilemma that THN aimed to positively disrupt expanded my thinking about how my team might craft our THN event in southwestern Virginia. Further, I gained key resources from these conversations, one of my favorites being the eclectic collection of essays, *Pro + Agonist.*" He found the early conference calls useful as they conceived their THN project. But the connection was not sustained throughout the year. This was a missed opportunity, as Catherwood-Ginn elaborated:

> I would have loved to learn how the other projects turned out and, more importantly, what the other THN participants discovered as particularly effective tools for fostering open, honest, productive public dialogue, perhaps even building a collective "toolbox" of such methods ... I would have liked key questions built into all the pieces to spark grassroots conversation on the issue. Such a body of responses from community-to-community could have served to counterbalance the overwhelming noise and cynical flair of major news media outlets' reports on subjects like congressional gridlock. (Catherwood-Ginn 2014)

In 2011, Rohd began developing another approach to respond to public issues: a week-long intensive residency in order to make a civically engaged, theatrically inflected, highly participatory event. Called *How to End Poverty (HTEP)*, he initiated it when his home university, Northwestern, invited him to create a mainstage play, with student actors, as part of their season on poverty. With production development thus supported, Rohd had a year to plan, the resources to hire some members of his Sojourn Theatre, and the institutional structure to require students cast in the play to take a class about poverty. He looked at the undertaking as not only a production but also a model that Sojourn would continue to explore, concentrated into week-long residencies, in both regional theaters and other university settings thereafter.

HTEP is an experiment in what theatrical means can contribute to anti-poverty work in the US. Rohd describes it as a combination play, lecture, interactive workshop, and public conversation (Rohd 2014b). Two-thirds of the show is prepared material that complicates and

informs spectator conversation through the sharing of facts, brief scenes
that embody how poverty plays out in people's lives, and theatrics such
as songs and dances to keep the presentation of information engag-
ing. The other third of *HTEP* is a set of discussion opportunities for
erstwhile spectators, embedded at four points during the production.
The audience seating supports small-group conversations. Spectators
on two sides of the playing space are clustered in groups of about 12,
with aisles between each group so that they can interact with an indi-
vidual actor/facilitator and each other at those four moments; literally
pause the stage action and have their own conversations. The first set of
conversations introduces the issue of poverty; the second identifies *the
approaches* of five local organizations (without naming the organizations
themselves); the third involves discussion of tactics and strategies to end
poverty; and the conversation culminates with each audience group vot-
ing on which organization to give the box-office money from that show.
The results are tallied and the money donated accordingly (Figure 3.1).

HTEP provides students with an experience of civic professionalism,
integrating learning about poverty into theater making, stretching

Figure 3.1 A performer asks a community expert, projected behind her, an audi-
ence member's question about poverty in the Chicago area. The expert, recruited
ahead of time, sitting in a booth behind the audience, engages comfortably in a
one-on-one conversation which the audience views.

their sense of what can be done with theater training, and learning to facilitate a public conversation about a challenging social issue. *HTEP*'s first iteration as a week-long residency was at Louisiana State University (LSU), preceded by Rohd's trip to hold auditions. During the week intensive, the cast worked with him evenings, leading up to two performances. The experience provided at least three kinds of learning opportunities: poverty experts talked to the cast so they learned more content; Rohd as a guest director stretched them artistically; Rohd and company members trained the student actors in leading dialogue sessions for the facilitation sections of *HTEP*. This integration of theater skills, ideas, and approaches from other disciplines reflects not only Rohd's specific interests but also his undergraduate BA in performance studies rather than a BFA from a theater conservatory. Moreover, the fact that LSU Professor Trish Suchy had been a colleague of Rohd's in Northwestern's Performance Studies program meant the two had a common language when it came to this residency.

Suchy not only invited Rohd to LSU but her installation class provided an additional context for students to work with him, generating ideas for pre-show experiences. Rohd assigned Suchy's students to create pre-show installations on the subject of poverty, in an engaging way, to get spectators ready to participate in a difficult conversation. All the students, in pairs, created prototypes for the installations, which Rohd critiqued in class. But only those that were ready were taken to completion and set in motion during the 15 minutes before the start of the show, when audience members roamed around the space, interacting at will. In one, for example, spectators were given the xeroxed image of a cafeteria tray, with sections for different kinds of food – protein, vegetable, starch, dessert, and drink. The students had posted a list of foods in each category and the cost per serving for a family of four. Audience members who chose to engage with this installation noted their purchases in the corresponding food category section on their "tray," and then proceeded to a checkout, where they found out how much over the weekly food stamp allotment in Louisiana for a family of four their shopping cost.

The installation exercise required the students to think about poverty hand in hand with artistic means of representing it experientially. It essayed to go beyond illustration of some aspect of poverty to an experience that would engender dialogue and reflection. The students' creativity was a response to solving a real challenge. The selected installations put spectators in the frame of mind Rohd sought given his contention that the route to change is getting people thinking on

their own; he does not think an activity alone will change them (Rohd 2014a). While not everywhere Rohd will bring *HTEP* will offer an installation class, the principle will remain the same: find a class that could benefit by Rohd's one-week input at the same time as helping produce that iteration of the show.

Disciplinary acceptance: an in-depth community–university arts project

How do arts professors integrate long-term uncommon partnerships into academic and practical pedagogies? Such courses must be recognized as pedagogically solid and the art produced must adhere to some accepted metrics of quality. The lead professors must generate student enthusiasm, collegial approval, and, ideally, recognition beyond the home institution. Also helpful are other schools with which the home institution identifies integrating this same conception of art, and respected writers theorizing such work as an innovative direction within the discipline, as communicated through recognized journals and respected presses.

Fulfilling such criteria requires particular conditions. The first is sufficient time. To grasp any artistic practice, more than the addition of a single course over one semester is necessary: the basic unit of engaged scholarship is not the individual course but the project. Moreover, aspiring to contribute to the public good, engaged scholarship cannot be contained in a classroom or a university, with only higher-education participants. The engaged project ideally spans at least one year, sometimes advanced through courses and sometimes by hands-on engagement beyond the classroom, with students and non-university partners.

Faculty initiating publicly engaged practice have been more likely to facilitate such work through their institution after they were well established in their department, although increasingly faculty are hired as "applied theater" specialists. Such projects most often emerge from a confluence of an arts faculty member committed to such work, attuned to the professional art world's "social turn," with a following of students hungry to connect their work to social issues, some supportive upper-level administrator, in-place community partners, and the capacity to raise additional funds to support a multiyear project grounded in but extending beyond specific courses.

A case in point is the Penelope Project, a particularly successful uncommon partnership generated by Anne Basting, a professor of playwriting in the University of Wisconsin-Milwaukee (UW-M) Theatre Department.

Penelope was a collaboration with theater students, the staff and residents of a long-term care facility, professional theater makers, and students and faculty members from other relevant disciplines including gerontology. It represents years of groundwork on Basting's part to build the capacity and partnerships on which such projects rely, and a certain degree of luck at finding herself among supportive people in positions to help move the initiative forward. Not inconsequential, Basting was also facilitator of the Creative Trust, an alliance dedicated to fostering lifelong learning through the arts, hosted by UW-M's Center on Age and Community. This initiative aims to create enduring and meaningful projects in which senior facilities' staff, residents, families, and UW-M students, faculty, and artists can learn and grow through collaboration. While scholars typically learn through experimentation and fieldwork, Basting includes collaborators from sectors other than her core discipline and in circumstances not formally generative of knowledge.

For the Penelope Project, Basting rewrote the end of Homer's *Odyssey* focusing on Odysseus's return to the ever-waiting Penelope, engaging the entire Luther Manor long-term care facility in Milwaukee in the creative process with her UW-M students. Discussion groups, movement exercises, visual art, stories, and music all emerged from this multiyear project that culminated in a professionally produced, original play, *Finding Penelope*, presented inside Luther Manor. The director, designer, and several core actors including Odysseus came from Sojourn Theatre, a company committed to civic engagement through theater and nationally recognized experts in site-based performance. Students got involved through multiple routes. The project was a component of a number of Basting's classes. Students in her Theatre Storytelling and Playwriting classes led creative discussions on *The Odyssey*. Theater independent study students did background research. Acting and production students helped devise and perform it. Applied gerontology students on the graduate level did an element of the research/evaluation.

The Penelope Project evidences both scholarly and arts-based research. Basting has long studied the benefits of the arts for people with cognitive disabilities including dementia. She authored numerous articles and two books, *Forget Memory: Creating Better Lives for People with Dementia* (2009) and *The Stages of Age: Performing Age in Contemporary American Culture* (1998). It was in a workshop situation that she had one of her major breakthroughs:

> I was volunteering at a nursing home to see if some of the creative drama exercises that clearly benefited cognitively healthy older

adults could benefit people with cognitive disabilities. I tried lots of reminiscence-type of exercises and nothing was working ... One day I decided to drop all reference to memory and see if they responded better to making things up. I brought in an image and asked them to make up a new story together. To my great shock (and the staff's as well I should add), we told an elaborate story for about 40 minutes. We sang and laughed. Clearly, they were transformed by the role of storyteller – not of individual memories, but of a shared effort at weaving a new tale from their collective imaginations. After that day, I just kept trying to replicate the magic of that first session ... and teach others to do the same. (Five Questions 2008)

The Penelope Project was a vehicle for Basting and her collaborators to contemplate women's lives in the private sphere of the home. Sources of that knowledge included the elderly residents of Luther Manor, experts in gerontology, and the text itself, which presents Penelope as a woman who could not go fight a war and then explore the world on a long trip home. During the 20 years her husband Odysseus took to return from war, Penelope waited, fending off suitors, raising her son, and overseeing the kingdom. The process of adapting *Penelope* included workshops co-facilitated by students and Sojourn members in which resident responses to questions about themes found in *The Odyssey*, including love, home, and recognition, were used in the text, and found expression in a weaving project with residents that became part of the set.

Basting maximized theater making as a vessel for well-being, working closely with the diverse cohort. Since everyone in the home was welcome to be in the piece, the play did not present a one-sided view of aging. Some performers in the large chorus dozed on and off during the performance; others were mentally alert. Rehearsing together, people across generations enjoyed each other's company, seldom experiencing intergenerational collaboration elsewhere. Students' attitudes about old age expanded beyond stereotypes through meaningful contact with Luther Manor residents who, for their part, were energized by contact with the students and artists. At the same time, the students honed skills of workshop facilitation and assistant directing. All learned something about both gerontology and art-making. The value of theater training that expands into interdisciplinary contexts was palpable as new job possibilities were created.

Through Imagining America – of which the University of Wisconsin-Milwaukee is a member – Basting and I brought a dozen people who work at the intersection of culture and health to Milwaukee from across

the US. We began with a half-day conference at which several artists and scholars made short presentations of their work integrating health and culture – how scholars had dealt with the polio epidemic in the 1950s; environmental threats to health that were shared through story circles; and the development of an autobiographical one-woman show about diabetes. We broke into groups around shared concerns that we had pre-identified – better approaches to assessment, sources of funding, effective partnerships, and aesthetics appropriate to such undertakings.

We then attended *Finding Penelope*. As at each performance, about 50 spectators and as many actors took a half-mile journey through Luther Manor. The experience was a conflation of past, present, and future: the past as represented by *The Odyssey*, bringing us into a great human story; the present of us all together at this performance; and the future we all await, if we live long enough, evoked by seeing old people in situations ranging from fine health and mental acuity to physical incapacity and extreme dementia. These various ways of aging were palpable given how close up the performance was as we moved through the facility, viewing one scene in one space and then another elsewhere, as some residents participated in the show and others simply went about their lives. Familiar images took on a new perspective as older people played characters typically depicted as younger. For example, in the contest that proved his identity, Odysseus's arrow was taken in hand and steered to its target by Athena, the goddess of wisdom, played by a woman in her 80s (Figure 3.2).

As confirmed in our post-performance discussion, none of us in the Imagining America cohort had ever had quite so palpable an aesthetic experience of ourselves as aging human beings as we did beholding the themes of this great story reenacted through the lens of what we all lose – and gain – in old age. Surprises were abundant from the very beginning; as we waited for the play to start in the facility's lobby, a man in rags moved among us whom we soon learned was Odysseus. Thus was a porous boundary between the production and our lives immediately established. At the end, we convened in a more traditional presentational space with all the participating residents on the stage, creating a striking range of images of how humans age. All of us were Penelope, looking to recognize our loved ones and ourselves through the ravages of time. The impact was deepened by the familiarity of this classic story, its themes of journey and recognition, and the reality that some of those around us had lost that capacity. The experience engendered compassion for the people at Luther Manor, older people in our own lives, and ourselves in an imagined future.

Figure 3.2 Aided by Athena (Caroline Imhoff), Odysseus (James Hart) shoots an arrow through 12 ax handles.

The Penelope Project attained all three goals of civic professionalism. It was a context for students to develop critical thinking about aging and experience meaningful impacts of an education; students were face to face with how humans age and what questions become important. Evaluators noted this student's comment as typical of other student participants: "It is amazing being around these women ... an enlightening experience. At first I was terrified. Now, it's funny to think I was. I want to do this again. Are there other courses like this?" (Penelope Project Program Evaluation 2013, p. 67). The learning could not have stretched the students in the same way had it stayed entirely in a classroom with participants all within a few years of each other in age.

As regards career path, *Finding Penelope* was a stunning piece of theater. Being part of its development opened the students to collaborative ways of making theater and expanded their horizons regarding with whom, where, and about what one can do so. The range of constituents enhanced this knowledge: UW faculty and students from different departments (especially theater and gerontology), Sojourn Theatre members, and residents and the staff of the senior facility.

Third, the Penelope experience engendered in the students a sense of how meaningful theater can be when embedded in a social context. At the senior residence, the project enhanced the lives of several hundred people, themselves included, and then opened the facility to audiences to experience a sense of aging in its real context, not removed to a stage. All who participated were part of an enacted civic dialogue about the joys and vicissitudes of aging.

The criteria of civic professionalism overlapped with some but not all criteria on the level of the theater department. For applied theater faculty like Basting in traditional departments, such projects can seem to be "theater-lite, distracting students from the 'real' pursuit of their craft" (Basting 2013). Theater students performing in *Penelope* were there as much to support the older actors as to express themselves. Aligning themselves with a sustainable performance style for people of advanced age and, in some cases, physical and mental challenges, meant the student and professional actors did not always conform to conventional values of pacing, aesthetic distance, and fully developed characters. Articulation of these other aesthetic choices to support the social goals becomes crucial for traditional theater professors to be able to appreciate the work. Also key to the piece's success by theater department standards was the quality of Basting's adaptation and, thanks to the partnership with Sojourn Theatre, innovative use of space, a professional actor anchoring the production as Odysseus, and the role of the chorus partly to compensate for many of the elderly actors' inability to remember lines. Significantly, the Penelope partners have written a book about the project with contributions from experts in the arts, gerontology, and education (Basting et al. forthcoming).

Nonetheless, the university poses specific challenges to art-making across disciplines and sectors. Basting acknowledged that sometimes community members are skeptical of the higher-education base. They fear that academics are focused only on their research goals and not attuned to what community partners need to benefit, too. Within universities, Basting notes that competition for resources is often a challenge, be it among faculty for students in their classes and projects, staff-time for the additional labor of projects over classes, and indirect funds from grants that often must be managed by the lead investigator's department. Department heads may not recognize how much release time a faculty investigator needs to carry out such projects, or how to translate such initiatives in terms of expectations for promotion and tenure.

Basting nevertheless affirms that the advantages of working from a higher-educational base outweigh the challenges. The stability of a job with tenure has made it easier to raise a family. The university base has enabled her "to receive more funding, forge transdisciplinary partnerships, and coordinate complex community partnerships with the resources at hand" (Basting 2013). Specifically, "foundations' increasing focus on outcomes makes it necessary to wrap smart and significant evaluation around work of this kind. Higher education contributes to such evaluation with their IRB [Institutional Review Board] structures and collaborative partners across social science and clinical disciplines." Transdisciplinary collaborations such as the Penelope Project bypass some of the obstacles stated above; such projects cannot be so easily disregarded because of the additional expertise involved and the clear engagement of disciplines and sectors beyond conventional theater.

Basting finds interest in community-based and cross-sector art growing. Reasons include increased recognition by funders, partly because the outcomes of such work can be measured; expanded job opportunities for graduates; and awareness among community partners "of other projects that have been successful. There are more publications ... [and] organizations that are supporting people doing this work." For students to have more opportunities at the intersection of art and another discipline, Basting calls for "business to recognize the new skills these students are developing and create places for them to land." Returning to civic professionalism, college commitment to helping students develop career paths while in school could productively include the real-world sites where students intern. Basting also sees this growing support as "part of a long, slow transition toward reasserting the role of the 'public intellectual/ artist' – the artist as a necessary part of the team in improving our world, not as a separate entity talking only to other artists" (Basting 2013).

To make higher education a more congenial, supportive base from which to collaborate across disciplines and sectors, Basting calls for conversations about how infrastructures are different for different disciplines:

> We can't truly grow transdisciplinary work until we have a basic understanding of how our fields operate. What are the products of your research? What is innovation? How is your work measured/valued within the institution? What is your teaching load and why? What do you need to get promoted? What makes you vulnerable? (2013)

She calls for such exchange both inside the academy, between, say, professors of theater and social work or nursing, and across the sectors

of higher education and community-based organizations as in her partnership with Luther Manor: "When I directed the Center on Age & Community, I facilitated those conversations in an ongoing way and it really made a difference in preparing people for partnership. Even the basic exercise of defining terms can be revelatory."

Basting draws inspiration in the links between arts and community health in England, much of Europe, and Australia – places where prevention is valued because of national health systems. Whereas in the US, she notes, initiatives such as the Penelope Project "tend to be seen as 'treatment' for specific health conditions ... compared to pills and expected to perform and be measured the same as pills." Contrast that view with the holistic experience participating residents described, such as: "My overall experience was 'hooray for young people!' It felt good to be with young people again – no insult intended here – white hairs and all" (Penelope Project Program Evaluation 2013, p. 62). And this remark from a staff member at Luther Manor: "This was *something*; I could see it as [the residents] come down, as they embrace the actors and the students. It was something to look forward to. They felt a part of it" (p. 56).

Basting is now looking to extend the notion of *the project* as the unit of campus–community partnerships to the sustainability factor of *the system*. That is, how can universities contribute to already-existing systems in order to support the ongoing life of the most positive initiatives? Her current effort is through a project called Islands of Milwaukee, created for older people who live alone or are otherwise "under-connected" to community. Engagement begins with a Question of the Day which Basting's team sends out through Home Delivered Meal services, Interfaith and Goodwill meal sites, their own website, and the radio. The questions and responses are used to catalyze a city-wide dialogue about the importance of connecting to community as we age. By continuing to gather the responses to the Question of the Day and find ways to disseminate findings that build community, Basting is using partner capacities already in place and bringing in a modest university role, through UM-W's support of her and staff/student participants, to keep Islands afloat (Islands of Milwaukee n.d.).

Expanding structures of support

How else does the academy draw on the arts to integrate real-world engagement into its structure? One way is opening opportunities for joint educator-administrators; another is as a means to better meet

the needs of students who work or care for families full-time. Some thoughts about each follow.

Opening opportunities for joint educator-administrators

There's a growing presence on campuses of what are called "scholar-practitioners," "alternative academics," or "educator-administrators." These para-academic, intermediary, coordinating, and administering positions at the interface of campus–community partnerships and in the interspaces of the university take place in service learning and humanities centers, minority affairs and diversity offices, pipeline and access initiatives, and university extension programs. Such offices tend to share a mission of cross-sector engagement, and rely on leaders with the ability to interface with students, faculty, and people doing relevant work on the ground. (See the seminar "This Bridge Called My Job," 2013 IA national conference.) While some academics are concerned that allowing administrators to teach undermines faculty under union contracts, the prospects of more satisfying professional lives for administrators and more opportunities for student engagement make this a direction worth exploring.

Kevin Bott's professional trajectory exemplifies this possibility. Bott trained in the theory and practice of musical and political theater, earning a PhD in Educational Theatre at NYU. He developed a passion for engaged scholarship and practice, becoming director of Imagining America's Publicly Active Graduate Education program in 2008, moving to IA's host campus of Syracuse University (SU) in 2010, and later that year, becoming IA's Associate Director. In the winter of 2011, in response to what Bott describes as "the general despair I had been feeling about the state of the democratic experiment and what seemed (and seems) to be a powerful and intentional effort by the powerful to keep average citizens from thinking or acting within the political arena," Bott launched The D.R.E.A.(M.)[3] Freedom Revival (DFR) (Figure 3.3).

DFR – The Doctor Reverend Ebenezer Abernathy's Mellifluously Melodious and Medicative Freedom Revival – is a 20-person choir backed by a rock/reggae/pop/gospel/salsa/musical theater band. The form is grounded in central New York's rich history of freedom struggles and nineteenth-century tent revivals. Whereas nineteenth-century tent shows aspired to revive Christianity, Bott and company re-energize participatory democracy as they perform at various community-based organizations. Each show is themed in relationship to the organization hosting it. Influenced by Augusto Boal's idea of activated spectators, Bott builds in the opportunity for audience members to "testify" vis-à-vis the subject

Figure 3.3 Doctor Reverend Abernathy (Kevin Bott) and The D.R.E.A.(M.)[3] Freedom Revival performing the history of the freedom struggle in Syracuse, New York.

of the particular performance. For example, the focus of "Daughters of the Harvest," created in conjunction with the Matilda Joslyn Gage Foundation in Fayetteville, New York, was "women's power and understanding the contemporary relevance of Gage – the most radical of the suffragists" (The D.R.E.A.(M.)[3] Freedom Revival 2013).

DFR is supported by Syracuse University (SU) insomuch as SU hosts Imagining America. As an independent center, not aligned with one department or school, IA and entities like it provide another way for universities to support local engagement. On the level of IA, DFR so effectively "walks IA's talk" about multiple forms of scholarship and the potential of the arts, humanities, and design in democratic life that first I, and then current IA directors Timothy Eatman and Scott Peters, made it part of Bott's job. (Eatman, in fact, plays keyboards in its band.)

Bott devotes one day a week to DFR. He also teaches one class a year on political theater in the SU Drama Department while continuing his other associate director duties.

Because of DFR's quickly growing reputation, especially in progressive circles, Green Party leadership approached Bott in spring 2013 about running as their mayoral candidate that November, to generate excitement and bring out voters who were frustrated by the incumbent mayor. Based on his DFR persona, Ebenezer Abernathy, who serves as the company's spine, improvises with ease, humor, and warmth, and delivers compelling and thoughtful sermons on various social issues, Bott seemed capable of generating excitement and bringing Green Party ideas to the public.

While fulfilling expectations in his campaign style, Bott quickly hit the harsh realities of finance. With no campaign chest – the incumbent, Stephanie Miner, began with $250,000 – and given her unwillingness to debate, he did not garner as many opportunities to get his message out. Bott nonetheless received a respectable 15 percent of the votes to the incumbent's 70 percent. In the process he went beyond the frames of higher education and art as typically defined, integrating a role across campuses through Imagining America, across community organizations with DFR, and across the city of Syracuse using skills of the arts and democratic discourse in a political platform. Bott's trajectory exemplifies that education happens not only through courses in classrooms but also in community-based performances through songs and monologues, and in political campaigns through speeches and organizing. As Bott brings the experiences of DFR and a political campaign back to higher education, he helps expand the places, formats, and occasions for performance skills to contribute to public life. His job has become more integrative of his various talents and more satisfying personally.

Meeting the needs of nontraditional students and cultural organizational partners

I return to the dilemma of young people who are not in a position to get credentialed when they participate in knowledge-generating public projects. Even among those who go to college, a growing percentage work and/or have families, and lack the time, finances, or circumstances to take on unpaid community-engaged work, which is often a requirement in order to earn credit. College Unbound (CU) is one avenue for such students, its goal to "provide adults with a path to earn a bachelor's degree from an accredited university while working full time. CU fully integrates the adult's job responsibilities with their college

requirements," also requiring students to engage with community as part of their degree (College Unbound n.d.), when possible through their employment. CU recognizes cultural and community-based organizations as knowledge-generating sites and has created a way for one, the Ashé Cultural Arts Center in New Orleans, to provide degrees. There, "students earn their bachelor's degrees in Community & Cultural Development through an individualized curriculum that includes meetings with mentors, documentation of work and life experiences, and class seminars and workshops" (Ashé College Unbound n.d.).

The significance of a cultural organization granting degrees in its area of specialty ought not to be underestimated. In a talk at the 2012 Imagining America conference, director of the Caribbean Cultural Center Marta Vega advocated for exactly what Ashé and College Unbound have put in place: a "university-without walls" with a focus on culture that serves community-based cultural organizations as well as students. This program responds to a concern expressed in a research project called the Curriculum Project:[4] as art allied with social issues is institutionalized in degree-granting programs, higher education might inadvertently become the gatekeeper for what may be most sensitively facilitated by or with people with close ties to their communities. Vega warns that community engagement "can't be detached from the traditions, cultural values, and core principles of the communities being partnered with," of which students unallied to the communities in which they work are often ignorant. Referring to director of Ashé Carol Bebelle, who has long been involved in community arts activism, Vega avows: "Any young person who comes through the doors of Ashé is exposed to an intelligence grounded in actual frontline experiences that generally professors in the universities do not have" (Vega 2013).

A visit with Bebelle and a group of College Unbound students corroborated Vega's perspective. When I asked why they registered for CU at Ashé, students spoke to "a sense of community," "the ability to bring to the table what I've been doing, and already know," "no math 101," and "I was already pursuing a degree, but this makes it easier with my work schedule." One student avowed, "Ashé has helped me open up this container in my head that's full of stuff. I didn't know which direction to go. Coming here regularly is helping me unpack it not on a path but at a place I can start my own trail." A faculty member spoke to their effort to make the curriculum relevant: "We get students to do real live projects attached back to Ashé, or to something they are doing. So we have a legacy. We make sure they are connected to our community in one way or another" (Bebelle et al. 2014).

College Unbound at Ashé is emboldening students, inspiring them to go after what they want. They are learning to recognize what they already know and how bits of what they know relate. Early in the program, they look at their life and what they've done and learned. Bebelle describes this exercise as "arming the student with the full knowledge of how they are valuable to themselves ... It's an awakening of sorts." One student said,

> I could have focused narrowly on becoming a Registered Nurse but I work in home health. There's not a lot of concentration on that in nursing school. I had also been a pre-school teacher. Bringing all those gifts together was not in my field. Ashé opened up how I could approach my job. I sat down with my boss and asked to integrate what I know about working with challenging infants. I wouldn't even have spoken to my boss before. (Bebelle et al. 2014)

Much of the CU learning happens informally, through conversation. For example, one of the students mentioned the resistance she had seen in older African Americans to write up reports when an injustice occurs, leading to this rich exchange:

> Bebelle: That also suggests an intergenerational history mandate: you weren't supposed to know how to read and write; you could get in trouble. As time went on people made fun of those who couldn't write perfectly, and the paper was the proof. There's a cultural prohibition working subliminally. People closer to families who didn't go to school are closer to the prohibition.
> Student: So some people won't file public reports because they're afraid of how they will be judged. How can you get equity/justice if the form is writing?
> Bebelle: They need a consumer-writing course.
> Student: That's what I want to teach!

I have no idea if the student will pursue that idea but the organic relationship between informal conversation and learning is greatly facilitated by College Unbound's ethos.

Another advantage of studying at places like Ashé is, unlike *departments* that offer community arts, cultural organizations are rarely part of larger entities that undertake actions that may contradict the smaller unit's values. For example, commenting on the degree to which universities that offer community-based programs may be, especially in cities,

engines of gentrification, Vega notes, "So at the same time universities are seeking community partnerships, they are destroying communities!" (Vega 2013). On the other hand, universities are not monolithic; it is valuable when people who care about communities have positions in the academy from which they can fight institutional tendencies like expansion-at-any-cost. The vastness of universities means that students working in community arts can be in exchange with other students and professors focused on urban studies, economics, sustainability, and other bodies of knowledge. When upper-level administrators are committed to knowledge-sharing between campus and communities, the results can be dazzling. I endorse Vega's vision of a *community arts university without walls* when both community-based organizations and the academy extend beyond their respective walls:

> You can create learning, significant learning, that transforms communities in any location, by engaging institutions on the ground, by engaging people who are about transformation, and by engaging those people who are studying and researching in ways that can impact issues of concern to the groups they are partnering with. So that institutions [of higher education] are broader than their walls, and the institutions on the ground are broader than their walls. So that we can develop linkages that effect change, lasting change. (Vega 2013)

A lingering concern is that students of modest means may be placed at community sites and those with money at university sites, decreasing opportunities for exchange among people of different backgrounds, fundamental to such initiatives. Projects integrating the arts across sectors demonstrate that we can't learn everything in "higher education"; that "higher education" is larger than colleges and universities *per se.* Cross-sector projects are also a reminder that what we learn in the academy needs to be brought out into the world where its relevance can be tested and other expertise can be brought to bear.

Deliberately designing cross-sector, "Performance *and –*" programs

Some cross-sector initiatives are supported by specific curricula. Cindy Cohen is developing an arts and social justice focus at Brandeis; Buzz Alexander has long provided an opportunity to be involved in the arts in the criminal justice system through the University of Michigan. Yet another example is the Directing and Public Dialogue program that Bob Leonard directs.

Leonard was director of The Road Company, a theater ensemble based in Johnson City, Tennessee, from 1975 to 1998. In 1989, he joined the full-time faculty at Virginia Tech to teach directing, which he developed into an MFA program in Directing and Public Dialogue. Through it, students collaborate with local artists and community-based organizations around sensitive issues. In 2011, for example, Leonard worked closely with Directing and Public Dialogue student John Catherwood-Ginn to initiate the Building Home project with other Virginia Tech theater faculty, students, and local artists, in partnership with the regional planning office. Their purpose was to use storytelling and theater-making techniques to facilitate and stimulate public conversation about the future of the New River Valley region of southwest Virginia. The planning office wanted to increase public involvement and input, which they knew meant going beyond the surveys and public hearings on which they typically relied. Building Home was created to assist in engaging precisely those people who did not participate in conventional data-gathering methods.

Leonard explained their process:

> We met with ... people who work closely with residents of low-income housing and who serve, in a manner of speaking, as gatekeepers, potentially providing us access to people who would not otherwise engage with a regional planning process ... People shared emotional stories, some that led to images of people being forced off land by outside developers. (Leonard 2014)

Leonard avowed that such art-making in public provides "a container for complexity" – citing a phrase used by Brent Blair, who founded the MA in Applied Theatre Arts at the University of Southern California – that is rare and vital for healthy civic discourse. Although Building Home's storytelling sessions met with some resistance, people not having expected so many difficult feelings to be elicited, most soon experienced what Leonard describes as

> a profound turn around, realizing they had made statements, expressed passionately held values, and recognized important realities that they thought they would never reveal in public. They praised the experience because they could see the complexities of the situation through hearing different perspectives and needs. They recognized the importance of sharing and hearing these perspectives as contributing to an essential public conversation. (2014)

One of Building Home's key advisors was Leonard's former student, Michael Rohd. Alumni like Rohd are among the strongest arguments for higher-education support of uncommon partnerships. Just this past semester, I brought in two former students from my own years of teaching at NYU to facilitate sessions of my History of Community-based Theater class. One, Matt Sergi, is now a professor of Medieval Studies (and has written eloquently about the ties between community-based and medieval theater); the other, Monica Hunken, is a performance activist who has done powerful work with Occupy Wall Street, and Reverend Billy and his Church of Stop-Shopping, among others. Former student Jamie Haft now works both with Roadside Theater in Appalachia and Imagining America in Syracuse. Kiyoko McCrae is with Junebug Productions in New Orleans. IA associate director Kevin Bott took an applied theater course with me while earning a doctorate at NYU's Educational Theatre department.

Opportunities for students to engage in uncommon partnerships open up learning and creativity generated by integrating knowledge from other spheres into one's core discipline. Ideas about possible career paths are expanded, the democratic purpose of higher education is experienced, and the real map of performance activity in the US becomes more visible.

Q and A with Chancellor Nancy Cantor

Jan Cohen-Cruz: Nancy, what does higher education offer the arts as a platform that a strictly arts professional frame does not?

Nancy Cantor: Higher education's public mission interweaves three broad threads: to advance scholarship, educate citizens, and connect our work to the challenges facing our communities and the world more generally. This makes higher-education institutions sites where ideas and interests quite naturally collide. And contrary to the idea of universities as places removed from the world – placid, proverbial ivory towers – they really are by design places of tension and, sometimes, even open conflict. But it is precisely this tension that makes them ideal to serve as platforms for the arts.

And as you know from the phenomenal work that you and so many others have been doing through Imagining America, universities are getting better at facilitating intellectual collisions not just among scholars and artists within the academy, but with the communities in which they are embedded and the publics with whom they live and work as neighbors in the most interdependent sense of that concept. Increasingly, we're all leaving our campuses to collaborate with nonprofits such as museums and foundations, as well as with corporations, small businesses, public agencies, and the public at large. We're getting better at eschewing what Harry Boyte has called "the cult of the expert" (Boyte 2009), which positions academics as the only legitimate authorities, and instead forging communities of experts recognizing that expertise often comes without what we may think of as the standard credentials.

So, in this sense, higher-education institutions really are ideal crucibles for the arts. In a world where every day the news brings us horrifying

object lessons in what happens when we don't learn how to live and work with each other across our differences, colleges and universities are ideally positioned to play the kind of convening role our communities need to create platforms where increasingly diverse voices and ideas can engage so we can move forward together.

JCC: What do you see *art-based* campus–community partnerships accomplishing as regards what you've called scholarship in action?

NC: Campus–community partnerships are absolutely essential for universities to have the kind of impact that the public and all of our constituencies – public, private, and nonprofit – expect us to have today. And the key word here is "partnerships," because for too long the primary mode in which universities engaged their communities was really one-sided: *we* would determine what issues we wanted to address, *we* would pick the projects to work on, *we* would determine how long we'd be engaged, and when *we* felt we were done, we'd walk away and go publish our scholarship or exhibit our creative work in venues that were by and large inaccessible to the communities in which the work was done. It's what some people call an "extraction" model.

Besides being elitist in its conception of expertise, that model simply has not been producing the kinds of high-impact results that the world needs. If you treat the arts as something for elites, the work never achieves its potential to affect change on the ground in the daily reality that most people live. You can only get so far exploring issues such as citizenship and patriotism, ethnicity and language, space and place, and the cultural dimensions of health and religion in the abstract. Forging genuine partnerships with our communities not only is more ethical, but it ultimately is higher impact. I think here of the work of people in Syracuse such as Steve Mahan, whose Photography and Literacy project is a partnership with the Near Westside neighborhood and the Syracuse City School District that for years now has been helping local schoolchildren produce truly breathtaking photos and poems capturing how they see the world. And I think of the work of Nick Kline here at Rutgers University–Newark, who has been working for several years with the local nonprofit Glassroots and national nonprofit Witness Justice to help victims of violence and their loved ones heal from trauma by creating "glass books" through which they articulate their stories and feelings. It's impossible to see these works and not be moved, both by the force of the works themselves and the knowledge that the lives of the artists – people in our communities – are, themselves, being transformed by producing them.

JCC: What are the pros and cons of the concept of civic professionalism with its prongs of liberal arts education, professional experience, and civic development?

NC: I see the concept of "civic professionalism" as encapsulating a range of ideas about what it means for a college education to be better attuned to our public mission and to the needs of students. Everywhere we look around the world today, we find explosive intercultural conflict – from the Asian Pacific region, to the Middle East, Eastern and Western Europe, Africa, South and Central America, and here at home. With the unprecedented ability of the aggression of a few – even a single person – to have devastating impact on the lives of many, higher education has a responsibility to become much more intentional about shaping the educational experience – curricular and co-curricular – to cultivate global citizens who are skilled at dialogue across difference in both their professional and personal lives. We have to recognize that this gives us a better chance at producing more engaged citizens who can live more peacefully together.

So, I have to say that I don't really see a downside to this concept, although I do see that there has been a long-standing shortsightedness about this skill set. We have tended to view the ability to empathize with others and work effectively across difference as "soft" skills, when it actually is central not only in domains such as the arts, humanities, and social sciences, but in how we "do" physical science, mathematics, and related disciplines, as well. Scott Page, for example, has done extensive work showing that groups composed of individuals who have diverse perspectives and experience are better at problem solving because they increase the number of approaches to finding solutions to thorny problems (Page 2007).

JCC: How important is scale, either as project scope or replicability, for campus–community performance partnerships? Do you think even deep efforts like the Penelope Project, described in this chapter, need to happen at a certain scale, say with multiple facilities or at numerous university/senior resident partnerships?

NC: When you look at the incredible impact that Anne Basting's work on the Penelope Project had on all of the members of her immediate community of experts – theater students and professionals, residents and professionals from the long-term care facility, and Anne, herself – it clearly was transformative for many of them. In that sense, scale is really beside the point. Even so, one could argue that the work's

impact was larger than might be obvious at first glance. The audiences, for example, become a part of that community of experts by virtue of the impact that their presence and response have on the performers – when they laugh, cry, gasp, or don't react audibly or visibly at all, they have an effect on the performers; in a sense, that's the difference between a rehearsal and a performance. And the audiences are changed by the experience, too. So, we shouldn't underestimate the meaning of the project's effectiveness even if it only is conducted within the community of that facility.

And to be sure, Anne did scale the project up from its original form, taking it from a smaller-scale workshop where this remarkable innovation emerged, then engaging the entire facility. What I see in this is the kind of progression we expect to see in the innovation process. If the impact on the scale of one facility is as promising as it was in this case, then one might well ask, what's next?

At the same time, in my experience I've found that while innovations may be transferable as you scale up, it's critical to recognize that place matters and that the communities of experts in each place where one may wish to reseed a promising innovation need to be able to shape it in ways that make sense for them and are sensitive to the situation on the ground.

JCC: What are the pros and cons of hybrid positions like "scholar-practitioners" or "educator-administrators?" Do they offer alternative ways to make local partnerships that are less tied to the exigencies of departments, schools, formal courses, and majors?

NC: I think that positions like these are becoming increasingly important as ways to help build what Susan Sturm calls an "architecture of inclusion" (2006). The idea is to build into our ways of doing things structures that assure that our practices will be informed and shaped by diverse perspectives, especially the perspectives of people from groups that historically have been left out of defining how higher education does business. That means women and members of underrepresented groups, but it also means people who may not have a traditional academic "pedigree."

I would say that there are three overarching goals in this. One is to create a more robust infrastructure in our colleges and universities that will be able to bring the kind of range of perspectives to the table that will improve our problem solving – so our scholarship will get better. Another is that bringing practitioners inside the academy helps assure that we are much more responsive to our constituents in the world,

including professionals and the general public, who have become increasingly skeptical that academic work has become too insular and disconnected from the many complex challenges we are facing in the world today. And third, it improves the education of our students, helping them see and work with the connections between ideas and reality.

And woven throughout these goals is the benefit that building an architecture of inclusion enables us to leave behind "the cult of the expert" as an outmoded way of conceptualizing knowledge and problem solving. But as we all know, the complexity of the problems we face in the world today is too great and the stakes for solving them too high for us to continue to draw artificial lines of expertise that are founded on social constructs that just don't hold up anymore.

4
Art and Culture in Neighborhood Ecosystems

Culture is the "big mama" that art needs to take root.
– Carol Bebelle, director of Ashé Cultural Center,
New Orleans (2013)

In *Decolonising the Mind*, writer and cultural activist Ngũgĩ wa Thiong'o recounts a time when his Kenyan village of Kamiriithu was only the place he slept, preferring to spend his time with the university community in the nearby capital. Then a local woman paid him a series of visits, cajoling him to "do something" with people in the village. At last agreeing, he led a collective process that resulted in *Ngaahika Ndeenda (I Will Marry When I Want)* (1977). The play, featuring rarely performed, tradition-inspired songs and dances and critiquing the country's neocolonial turn, was a counter-narrative to official history. Ngũgĩ and the local cast invited the rest of the community to the out-of-doors rehearsals, demystifying art-making and encouraging active participation. Neighbors in the midst of their daily activities came and watched the actors at work and shared their responses. Ngũgĩ and his team gauged success by people coming from the least distance to participate in the process rather than the more conventional valuing of people coming from the greatest distance to see a finished product. Through the meaningfulness of developing content specific to that place with people who had experienced it, Ngũgĩ realized that he wanted to direct himself most to his native people, and shifted from writing in English to his indigenous language of Gikuyu. This village as a context for performance, and performance as a context for communal expression, more than held its own with art districts disengaged from the material places and specific histories that informed Ngũgĩ's life.

Ngũgĩ's experience is a jumping-off point for me to examine other artists and cultural organizations working in relationship to people rooted in a shared local context grounding their aesthetic and social commitments, while in many cases continuing to participate in national and international endeavors – like Ngũgĩ, whose books have been regularly translated into many languages and remain part of international discourse. Other major artists, such as James Joyce, Gabriel García Márquez, Eudora Welty, Zora Neale Hurston, Edgar Lee Masters, to name a few, are also strongly identified with specific places; the distinction is between artists who work *with* communities in contrast to the majority of these artists whose work is *about* them. In this chapter I look at why a number of artists and cultural organizations collaborate with people in the neighborhoods and around the issues where they work, using examples in New York City. I also consider how such projects might be appropriately validated according to their multiple goals rather than only along aesthetic lines.

To interrogate the role of networks, I provide examples from Naturally Occurring Cultural Districts-New York (NOCD), a consortium of arts and culture organizations in New York City's five boroughs, embedded in local life, and fulfilling roles including and extending beyond aesthetics. Their integration across sectors has ramifications not only in art but also in local people's relationship to their own histories, experience of being part of their neighborhoods, and quality of life. While the influx of artists to hitherto marginal neighborhoods has been known to speed up the gentrification process and inadvertently lead to displacement of longtime residents of modest means, NOCD artists seek to contribute to local life rather than only fulfill their own need for affordable space. It is an ongoing challenge.

Artists and cultural organizations aligned with their neighborhoods

Naturally Occurring Cultural Districts

NOCD-NY came into being between 2010 and 2011 through a series of conversations among artists, activists, creative manufacturers, nonprofit groups, and policymakers on the role of arts and culture in strengthening New York City communities (Naturally Occurring Cultural Districts n.d.). Recognizing that many artists were participating in the local life of their neighborhoods, often in coordination with other kinds of institutions, they saw an opportunity to move their work into policy by forming a loose-knit consortium.

NOCD-NY draws on the research of Susan Seifert and Mark Stern of the Social Impact of the Arts Project, who developed the notion of a "natural cultural district." A natural cultural district refers to "a neighborhood that has spawned a concentration of cultural agents – organizations and businesses, artists and activists, residents and visitors." Seifert and Stern argue that the presence of such entities is a "reliable indicator of neighborhood revitalization," measured by a decline in its poverty rate and an increase in population and ethnic and economic diversity. Such cultural agents "stimulate social network formation both with and across neighborhoods [that] ... are the critical mechanism for translating cultural assets into neighborhood development" (Stern and Seifert 2013, p. 1).

While not gentrification-proof, natural cultural districts are "associated with high levels of cultural resources and participation" and develop from the bottom up. They tend to be *"Pov-prof* communities (those with a higher than average rate of *pov*erty and *prof*essional workers)" and "'nonfamily households' (including unrelated roommates and gay and heterosexual couples)" (Stern and Seifert 2007, p. 4). Stern and Seifert found that the energizing and participation that increased arts activity can bring to a neighborhood does not necessarily result in the displacement of longtime residents. An example they give is Philadelphia, a city with a slow real-estate market and high owner-occupancy rates. They identified a number of Philadelphia cultural districts "in which economic revitalization goes on for years or even decades, that prevent the social fabric of the neighborhood from disintegrating" (p. 8). They have found that large nonprofits like universities that clear neighborhoods for future use are more likely to bring about gentrification than are locally engaged artists.

Artists and cultural organizations engaged in their communities are not new; like settlement houses that sprung up in the late nineteenth and early twentieth centuries in response to increased immigration, they integrate arts and culture with other social goods and make them available to neighborhood residents as well as creating other artistic initiatives, in some cases as part of national or international networks. While the attraction to areas not defined as art districts may begin with affordable rent, the ability to connect artistically to the life around them provides a significant draw. Artists and staff of cultural organizations may feel ties to a place because of family, history, politics, or spirit – in a word, culture, as the sum total of a people's way of life. Neighborhoods provide contexts in which to give form to their values, through free workshops or participation in public events like street fairs. Or the place may support an identity to which they are committed, related to race, nationality, or another heritage marker.

NOCD member Charlie Lai points out that NOCD-NY cultural districts – like Manhattan's East Village, Hunts Point in the Bronx, Fort Greene in Brooklyn – are not really "naturally occurring" since most are a mix of artists with and without roots in their respective neighborhoods. But they are different from cultural districts that focus on artists and audiences from elsewhere, and highlight art with no specific significance to that place or the people of that neighborhood. Many of the artists and staff of cultural organizations that participate in NOCD-NY are committed to both the people whose culture, history, and/or experience has informed them *and* to art audiences. The romantic notion of the artist who eats, breathes, and sleeps nothing but art and may as well work anywhere, while always something of a myth, is being replaced by a more multidimensional vision, as evidenced through the following descriptions of six NOCD member organizations and affiliated artists.[1]

The Chinatown History Project (CHP) and historical imagination

Founded by community organizer Charlie Lai and historian/activist Jack Tchen, the CHP is "a community documentation project designed to reconstruct the 120 year legacy of what is now the largest Chinese community outside of Asia" (Tchen 1987, p. 158). The project brings together scholars, photographers, community workers, artists, and other neighborhood residents to counter stereotypes and articulate their own experiences as a basis for what Tchen calls reclaiming community pasts.

The Museum of Chinese in America (MoCA), a CHP initiative, was founded as a platform for the communication of what the Chinese contribute to the US and who Chinese-Americans are beyond stereotypes. Tchen notes that unlike most historical projects, the CHP has worked with artists, for extended periods of time, since MoCA's beginnings in 1979–80. For CHP, history is not just nonfiction; the founders always cared as much about the living performance of culture as about details of what has passed. The CHP is thus committed to what Tchen calls artists with a historical imagination – who communicate creative and survival processes from different times, through their work, in ways that written documents cannot. The artists don't improve the historical data but rather evoke how history pervades the present (Tchen 2014).

Artist Tomie Arai, for example, has had a long relationship with MoCA, contributing both to an understanding of Chinatown and impacting the content and form of her work. With scholar Lena Sze, Arai initiated an oral history and visual art project, *Portraits of New York Chinatown*. Articulating the value of Arai's visualizations of oral histories, Sze writes, "oral history ... is about constructing meaning out of subjective experience, rather than

simply extracting factual evidence as a means of uncovering a single historical truth" (Sze 2014). One of the themes recurring through their interviews with 27 neighborhood residents and leaders were concerns about gentrification and displacement. Sze notes that Arai captures what it means for actual people to live in a place in the process of gentrifying. And she does so through their participation, not dependent on their formal expertise but rather their experience, which is part of what constitutes history, and which they communicated through art.

Elaborating on the difference between what historians and artists bring to a historical museum, Sze writes about Arai's contribution to the affordable housing crisis: "Arai wades through this sea of experiences and perceptions to assert that memory, or a historical feeling, of place is never finished or complete, but nonetheless an urgent thing in these fast-moving times" (Sze 2014). The context of a history rather than an art museum for such work underlines the role that aesthetic expression plays in understanding our past.

Fourth Arts Block: sustaining a multicultural space

Historically, people from many cultural backgrounds have situated arts initiatives in Manhattan's Lower East Side (LES). The economic downturn of the early 1970s brought in a new wave of artists, many of whom identified with cultures outside of mainstream norms, not only ethnically but also sexually or philosophically. At that time the area was perceived as dangerous, so the city offered artists inexpensive live/work space there, through agreements with, for example, community-based organizations like Adopt-a-Building, which made a former school, PS 64, available as an art space (Places That Matter n.d.). According to Tamara Greenfield, co-director of NOCD-NY and director of the LES's Fourth Arts Block (FAB), no one was vetting the art before renting out space.

The rise in the presence of artists shifted the perception of the Lower East Side to "edgy and hip" rather than "dangerous and abandoned," and with it, over time, the demographics, attracting more people with money. As gentrification of the LES intensified through the 1980s and 1990s, the city began selling space long occupied by artists. Housing rights activists, such as the Cooper Square Committee, organized residents of all kinds together to preserve their spaces against gentrification. They resisted efforts to create hierarchy among the artistic groups based on size, culture, or aesthetics. The rich mix of artists and cultural organizations did not subscribe to such hierarchies and were motivated to be at the same political table and work together because of the benefits to be gained for all.

Some 25 years after the explosion of the Lower East Side for an array of artistic and cultural expression, FAB's founders, Greenfield explains, are

> committed to keeping long-time organizations in the spaces that they had helped homestead. They have always included a ragtag mix of multidisciplinary artists and a cross-sector alliance with low-income residents, small businesses, and elected officials who saw the value that these small arts spaces created in the community. Many of the arts groups came out of movements for cultural self-determination in the 60s, 70s, and 80s, and include Spanish language theater companies, African American dance companies, and a Women & Transgender theater collective. There are interesting and eclectic ties to and across diverse communities. (Greenfield 2013)

Today, FAB consists of more than 25 arts groups (individual companies self-described as artistic), 10 cultural facilities (largely places where a range of work, some of it culturally specific, is supported), and 17 performance and rehearsal venues. Its services to members include the development and conversion of 100,000 square feet of arts and cultural space, marketing and promotion of the district, offering discount ticketing, and otherwise supporting community events and programs. It attracts an annual audience of 250,000, serves 1500 artists, and provides more square feet of active cultural use than any other block in New York. The mix of established and emerging artists, the diversity of publics to whom they address themselves, and the multiplicity of forms they use have made FAB "an incubator for new work and diverse artistic voices" enhanced by its "racial and ethnic diversity, free and low cost programs, and training for emerging artists and youth" (Fourth Arts Block n.d.).

Ryan Gilliam, executive director of Downtown Art, is a founding member of FAB. She was inspired by NOCD to co-conceive, with Greenfield, the idea for Lower East Side History Month, which launched in May 2014 and involved over 40 local cultural, historical, community development, religious, and activist organizations. Gilliam explains that since participating in NOCD, her perspective on being a community-based artist has grown

> from a vision of myself as a practicing artist, with 20 years of experience collaborating with local teens and actively engaging with the local artistic and educational community, to becoming a viable instigator of a community-wide initiative, which crosses boundaries,

bringing a larger cross-section of the community into collaboration. Now I see the connection between culture and the city, art and history, and I see history as what happened as recently as yesterday. (2013)

Many of the plays that Gilliam makes with local teens take on historic themes of the Lower East Side, like one on the role of women organizing a strike over 100 years ago to lower the price of meat in the neighborhood (Figure 4.1). Gilliam also embraces community responsibilities including programming three floors of a building on East 4th Street that will open in 2015, "for artists and small companies wishing to develop projects in any art form for which community engagement is a central, integral aesthetic concern" (Gilliam 2013).

What began in the LES as organizing resistance to gentrification has developed into a shared appreciation of historical continuity and diversity, says Greenfield: not preservation for its own sake, but because the cultures are still living. Distance from public transportation and housing stock – former tenements – that do not appeal to wealthy apartment hunters slowed down East Village gentrification for a while, but now a

Figure 4.1 Neighborhood girls perform an original musical on the streets where the 1902 Kosher Meat Boycott took place. Spectators move with the actors from site to site, hearing the audio on synced mp3 players as the actors perform silently.

great many people have been priced out. FAB's challenge is allowing for the continuation and evolution of culture that grew out of a particular place and time. They have struggled to stay in place in the tough economic times since the 2008 recession, with less public money available for culture and more profit possible for real estate, to sustain the self-determination and institution-building that the neighborhood's history made possible. While that struggle has only intensified, NOCD and FAB contribute by bringing artists into anti-displacement organizing.

Urban Bush Women (UBW) and foregrounding cultural roots

UBW "brings the untold and under-told histories and stories of disenfranchised people to light through dance" (Urban Bush Women n.d.). The company was founded in 1984 by Jawole Willa Jo Zollar, who envisioned a dance troupe "founded on the energy, vitality and boldness of the African American community [and] ... the vulnerability, sassiness and bodaciousness of the women I experienced growing up in Kansas City" (Urban Bush Women n.d.). Zollar is articulating an aesthetic – that is, the choices that shape the experience through all the senses – as well as the cultural roots of the company's African American inflected forms.

Examples of the influence of African American culture on UBW abound. The sheer presence of a company of African American women of different sizes and shapes, with great strength and multiple kinds of beauty, immediately bespeaks the group's diversity. Not based on Western standards of out-turned feet and toe-shoes, the aesthetic is a reminder of the many sources of art globally. The content and form are examples of how aesthetic choices articulate cultural experience. UBW's piece *Hairstories*, for example, integrates three idioms of African American music in a piece about black women and hair that challenges racism and sexism:

> Demonstrated through often humorous and sometimes-harrowing childhood stories of getting hair done, the blues impulse offers a cathartic release that allows overwhelming experiences to be bearable. The jazz impulse is evidenced through Dr. Professor, a character who questions assumptions of race and gender in language and movement. Jazz also encourages the constant process of redefinition – to self, to community, and to the past. The final impulse, gospel, suggests that redemption, transcendence, and freedom are found communally. (Howell 2011)

Then-UBW Director of Education and Community Engagement Maria Bauman explained in an interview that Zollar's vision has always

included robust exchange between artists and communities. Since Zollar depends on her cultural roots for source material, she needs to make sure that people who constitute that culture receive back what UBW makes. Their idea of community engagement evolved through early touring experiences. The company sought to include audiences in which they could see themselves – women, the working class, and people of color. They were motivated to give something back to people of similar cultural roots and identities from which their own stories and forms often spring. Troupe members invited working-class people they encountered, such as restaurant servers, hotel workers, and taxi drivers, to the shows. Sometimes the cultural organization hosting UBW provided complimentary tickets. But too often such gestures were framed as "outreach," with its unspoken inference of reaching "down" to people who do not pay for seats and thus are not the producers' preferred audience. For UBW, relationships between artists and communities have to go two ways (Bauman 2013).

Also pivotal for Zollar has been interacting with peer artistic groups that embrace similar values. A number of them were brought together through the national American Festival Project (AFP), founded in 1982. AFP was an

> alliance of artists and artists' companies working in communities with ... activists, organizers, artists, and leaders – in a movement that utilizes culture and the arts as both a grounding place and a means for social change. The Project believes in the inherent value of cultural identity, cultural diversity, and cultural exchange. (American Festival Project n.d.)

Reciprocity was a core AFP value; AFP companies were committed to returning art to the communities at its source. The influence of like-minded AFP artists grounded in places significant to them culturally, such as Appalachia for Roadside Theater and a Puerto Rican neighborhood in the Bronx for Pregones, inspired Zollar to situate UBW in a kindred geographic community. Bauman explained, "A core UBW value is that place matters. That mission keeps us honest. How can we ask other dancers to do that and not be accountable to our own neighborhood?" (2013).

So in 2000, UBW settled in Fort Greene, Brooklyn, historically home to a robust African American population, albeit challenged at different periods by gentrification, not least over the past decade. Some of UBW's projects are Brooklyn-based, including Builders, Organizers, & Leaders through Dance, a workshop series that involves dancers and social

activists. But though Fort Greene is an important home base, most of UBW's projects are national in scope; that is, neighborhood-base is a value but does not define the scope of their activity. They offer a ten-day annual Summer Leadership Institute in New Orleans, connecting dance professionals and community-based artists from across the US to encourage widespread integration of the arts in social activism and civic engagement. Zollar frequently collaborates with other national or international artists. At the time of this research, she and choreographer Liz Lerman were developing a performance/social research project entitled *Blood, Muscle, Bone*: *The Anatomy of Wealth and Poverty*, that examines "how wealth and poverty impact the body while asking new questions about how these conditions are defined and imagined ... public offerings ... might include stage performance, prayer breakfasts, lecture tours, workshops, teacher training, panels, and cabarets" (Urban Bush Women n.d.). The synergy between UBW's local and national projects is striking, workshops across class and sector also serving as research for Zollar and Lerman to create both a new piece and a series of compelling and generative public events.

Staten Island Arts and building cohesion across difference

Staten Island Arts Executive Director Melanie Cohn explains that artists and arts organizations bring vibrancy to the neighborhoods through a wide array of activities and programming such as Art by the Ferry, public theater performances by SI Shakespeare on the steps of Borough Hall, Second Saturdays, SIOutLOUD, St. George Day, Deep Tanks Art Festival, Van Duzer Days, and Harborlore:

> Artists create opportunities for the community – individuals, businesses, social service groups – to come together through different cultural experiences and informally build stronger bonds with one another. And they make the neighborhoods livelier. In turn, the neighborhoods give the arts this amazing diversity. We have great community heritages – Sri Lankan, Central American, West African, Italian, to name a few. These rich traditions exist at the core of Staten Island communities. It's inspirational; the artists and cultural groups draw energy from these shared expressions. (Cohn 2013)

While affirming local meaning, the larger world is also important to neighborhood artists. Contact with other NOCD members, especially in Fort Greene where tourism is more established, has shown Cohn that "the addition of tourists doesn't take away neighborhood concerns.

In fact, successful tourism may help increase audience and economic activity, while still bringing some community issues to the forefront" (Cohn 2013).

Place is important in Staten Island as well. While Staten Islanders have experienced divisions across race in particular, many segments of the community were eager to come together in the aftermath of Hurricane Sandy. Local artists, Cohn found, were especially keen to "share the communities' experiences without the lens of a news organization or misappropriation by a political effort" (Cohn 2013). Cohn noted that the artists who participate in SI Arts especially wanted to "build new, strong social connections where ideas, resources and information can be shared" (Cohn 2013). Cohn also noted the bonds that are created out of familiarity with what is special about a place:

> Staten Island is different from the other boroughs and is full of well-kept secrets. It is special because of the community's long memory, the loyalty Staten Islanders have to one another, the amazing resources like abundant and beautiful green spaces, and its rich and quirky history. It also has some insecurities and feelings of being overlooked or looked down upon that is part of being the smallest borough in the nation's largest city. These issues come up in the art that is made and how culture is experienced here ... and in the fissure between what many people *think* Staten Island is versus what Staten Island really is. (Cohn 2013)

The Queens Museum (QM) and community embeddedness

The Queens Museum demonstrates how an arts institution can become an active part of the surrounding community. Already an established museum, the QM expanded its identity in response to Queens's many under-served and newly arrived immigrants with limited English-language proficiency. For example, the QM spearheaded a community coalition to activate and beautify the neighborhood of Corona's public spaces and created a multicultural hub for local residents and businesses. Corona Studio, which marks QM's move to longer-term projects, seeks artists who are "ready, willing, and able" to commit the necessary time to use art for social change. QM aspires "to improve the quality of life for residents of Corona and to create a model for social engagement that can be adapted to the specific contexts of other museums" (Queens Museum n.d.).

Through a careful selection of local and international artists whose work engages with social issues, QM has developed a reputation as a

home for art as public practice, an international movement defined by critic Andy Horwitz as "artistic projects in various disciplines that emerge from engaging with social issues in community, that enlist 'non-artists' in the creation and development of the project and have as a goal some kind of awareness-raising or sociological impact" (Horwitz 2012). Art as social practice casts a broad net. For many practitioners, fusing the social with the aesthetic responds to a desire to serve social justice aims through their work; for others, art as social practice is just about new terrain for artists. The distinction between the two is significant; the former, as characterizes the work of QM, is grounded in commitments that extend beyond the aesthetic even while, importantly, concerned with it.

The Queens Museum strategically links local initiatives to international struggles. In 2011, for example, Cuban artist Tania Bruguera, inspired by immigrant-led civil unrest in the Paris suburbs, initiated Immigrant Movement International in Corona, to put "immigrants in a position of power, whereby their political representation could be strengthened through a political party created by immigrants" (Queens Museum n.d.). Bruguera has proven herself to be as at home in fine-art spaces as in neighborhood workshops, and to take each kind of work as seriously. The space acts as a local educational platform and meeting space, and also as an international think tank engaging activists, artists, critics, and academics in re-envisioning a different legal reality and social role for migrants in the twenty-first century.

At an NOCD public gathering, Prerana Reddy, Queens Museum Director of Public Events, described the expanded idea of the museum beyond the building, gallery, and artworks exhibited. She noted that the museum also includes human resources, including arts educators and community organizers who seek to embed the institution in its community. QM now seeks artists, designers, activists, and cultural producers with skills to match issues they hear from their community partners. The museum has evolved beyond the idea that public art consists of things plopped down in a public space. QM's leaders question whether it is even important for people to know that some projects are conceived as art.

For instance, Immigrant Movement International's storefront space houses classes for immigrants, rehearsal space for local dance and music companies, and workshops to learn English, performance, screen-printing, bike repair, and urban gardening. Ongoing programs are free and led by artists and other skilled community residents interested in lifelong learning, experimental pedagogy, and mutual aid. The project's

diverse cadre of instructors challenges notions that only certain people are cultural producers or that an individual's background defines the areas in which one can become an expert. Instead of functioning as only a receptacle of art objects, QM, with its storefront project, is a model for arts institutions as places that generate and present cultural meaning in various forms.

El Museo de Barrio linking national and grassroots art and culture

In uptown Manhattan, El Museo de Barrio was founded as a grassroots, community-based museum with the intention of reaching national and international art status as the stewards of Latino/Hispanic art. Tensions have existed between those who want it to be *either* part of the museum world *or* part of Latino culture, and those who want to foreground Puerto Rican art or art with other Latino roots. El Museo's multiple foci and borderland location also result in an interesting, diverse audience. Sometimes art lovers come up Museum Mile – the official designation of New York City's Fifth Avenue from 82nd to 105th streets because of the richness and cultural diversity of the nine museums located there – and get their first taste of Latino art at El Museo. Staff encourage such visitors to experience more culture in the neighborhood; Gonzalo Casals, then acting director, described in an interview telling them, "Go into the neighborhood and check out the food, the music, the distinctly Puerto Rican community garden." For people more aligned with Latino culture than art broadly, this may be the first museum they visit. Then, Casals says, "We push them down Fifth Avenue to visit the other institutions on Museum Mile" (Casals 2013).

Valuing artists and cultural organizations in neighborhoods

Arts and culture in neighborhoods make as meaningful a contribution to their constituencies as do city and nationally recognized venues, in some cases involving the same artists. Yet the largest organizations, with budgets greater than $5 million, are seldom neighborhood-involved but receive the lion's share of support, as Holly Sidford, who writes about the philanthropic sector, has tracked:

> Such organizations, which comprise less than 2 percent of the universe of arts and cultural nonprofits, receive more than half of the sector's total revenue. These institutions focus primarily on Western

European art forms, and their programs serve audiences that are predominantly white and upper income. (Sidford 2011, p. 1)

In addition to funding, these large organizations benefit from other established systems of validation – media mention, awards, and employment opportunities (M. R. Jackson et al. 2003, p. 9).

The expansion and articulation of appropriate metrics is necessary to make the value of artists and cultural institutions in neighborhoods more visible. This means: (1) expanding *what* one is evaluating beyond traditional parameters of the artistic product, which includes identifying *how* artistic skills are being used broadly; (2) recognizing that *where* art and culture take place must be understood in the context of their purpose; and (3) seeing *who* the audience is in relationship to the works' purpose.

Recognizing *what* is being evaluated

A core strategy towards valuation is articulating *what* one is evaluating in neighborhood-engaged art and culture. Numerous arts and cultural organizations are valuable not only for the objects they produce but also for the processes through which they undertake such creation. Casals (2013) identified three artistic proclivities in addition to the artwork that enriches El Museo's East Harlem neighborhood, and which apply to other neighborhood-based initiatives as well:

(1) Creativity: While creativity is manifested in many endeavors, it has a strong presence in cultural activities. In East Harlem, creativity specific to Latino cultures is reflected in murals, community gardens, crafted objects such as amulets in botanicas (traditional Puerto Rican shops), bilingual bookstores, and "ethnic storefronts" that people of various Latino/Hispanic heritages bring and that make the neighborhood unique. Such expressions of the creativity of an entire people ought to be part of how neighborhood-based art and culture are validated.

(2) Dialogue: Artistic work is often the result of or the basis for a face-to-face, inclusive exchange of ideas, as compared to the scholarly norm of working alone or in relationship to only other scholars. Dialogue brings in diverse constituents by virtue of the everyday language in which it can take place. Artists may be valuated for the dialogic, inclusive processes they bring into communities.

(3) Collaboration: The arts require making something together over time, frequently calling for different capacities within the same project.

Artists can be evaluated for their skill in bringing diverse groups of people together, with different expertise to contribute to a public good.

One can also evaluate hybrid initiatives that are part art, part something else. So for example, Ngũgĩ wa Thiong'o's project with which this chapter began was as much about involving local people in the expression of cultural identity as it was about the theatrical form it took. Therefore community-wide participation is as much a metric as is technically proficient art. This is also present in Arai and Sze's combined history and portraiture project in Chinatown, which was of value both for including a breadth of people's experience of gentrification and for communicating it effectively through words and images.

Significance of *where* the initiative is located

An obstacle to recognizing the value of some neighborhood-based art is its location. For art that takes place in other than conventional art spaces to flourish, certain assumptions must be recognized and dismantled. Critic Jen Harvie points out that art shown in art districts and mainstream art institutions, taking forms that align with the most entrenched aesthetics, supported by paid staffs, accessible to the most recognized and monied art-goers, and receiving the most prestigious support, is generally assumed to reflect higher quality (Harvie 2009, p. 8). In New York City, she continues, "the received vocabulary for identifying different types of theatre is spatial: there is theatre on the main commercial thoroughfare of Broadway, and there is theatre Off-Broadway, Off-Off Broadway, and so on" (Harvie 2009, p. 25).

By extension, the arts in other neighborhoods – constituting most of the city – are often invisible, situated in what theater critic Marvin Carlson terms a "boundary location – inescapably tied to the city but never truly a part of it" (qtd in Harvie 2009, p. 25). The irony of Carlson's observation is that art and culture emerging from multiple locations more reflect the city in all its diversity than does the art in major cultural institutions, much of which originated elsewhere. This is not to replace the one for the other but rather to provide conditions for all of it to flourish.

Who is the audience/constituency?

In a 2003 study, Maria Rosario Jackson and a team of researchers found that "The most prominent forms [of validation] ... were peer recognition (appreciation of an artist's work by other artists) and audience or

direct public recognition" (Jackson et al. 2003, p. 9). And indeed, artists and cultural organizations are often appreciated by other artists who have chosen similar paths and other constituents in their neighborhoods. But this does not necessarily lead to monetary support because it does not typically lead to arts criticism, another prominent form of validation, "which situates an artist's work within a broader artistic context ... [alongside] media coverage, which exposes artists to the general public" (p. 9). For into what context might such hyphenated artistic work be placed?

Moreover, arts funders tend to assign greater worth to art that attracts people from elsewhere, that is, tourists and the dollars they bring, than that which engages local people, especially if they are of modest means. The privileging of tourist audiences evidences an emphasis on art's role as an economic engine. Carole Rosenstein provides some background on why, beginning with city governments' interest in how their "creative" character can be of economic benefit through tourism. Rosenstein cites economic development scholar Richard Florida's enormously influential image "of successful 21st century cities as places where social tolerance and natural and cultural amenities draw educated workers and new-economy businesses (Florida 2003, 2007, and 2008)" (Rosenstein 2009, p. 1).

However, as Rosenstein explains, Florida's model has not benefitted everyone:

> [T]he policies that public leaders have developed to respond to Florida's call to build "creative cities" that would support the "creative economy" and attract "creative-class" workers ... have undermined the diversity of urban populations and uses because they have encouraged gentrification and privileged real-estate development over economic and community improvements that benefit a broader urban population. (Rosenstein 2009, p. 1)

It's striking that so many of the artists in NOCD's network are grounded both in particular neighborhoods and in national and international contexts, drawing diverse audiences. Looking at the entire art ecosystem, including some of the sources of vitality for very public artists, would be of benefit to all.

Municipal challenges to appropriate metrics for neighborhood art and culture

For as sophisticated a cultural arena as New York City, the blind spots concerning what constitutes art are remarkable. Rosenstein has cited

four ways that much municipal cultural policy hurts neighborhoods (2009, pp. 2–6). All of them reflect a bias in favor of art as a separate activity in culturally designated areas for well-heeled audiences. The challenge of art that does not necessarily look like art can be overcome rather than reinforced through the evaluation process.

Rosenstein's first point is that concentrating cultural resources into downtown business and cultural districts ignores neighborhood-based cultural assets. For example, more public support goes to large museums and less, if any, to local parades and street fairs. In fact, parades and street fairs depend on great skill in the use of space, costume, music, and the flow of the audience in order to be successful. These factors could be assessed when determining what neighborhood-based cultural expression to fund.

Second, Rosenstein notes poor incorporation of neighborhood cultural assets and needs into existing cultural policy infrastructure; in other words, viewing informal, local, participatory acts of expression as other than "real" art with concurrent need for support. But participation could be valued as much as, say, innovation.

Third, city cultural agencies have not well integrated neighborhood expressivity into broader policy conversation and decision-making, which would entail, for example, negotiating the significance of culturally specific parades with the resulting noise, dirt, and traffic jams. Expressivity and cultural meaning are connected, importantly providing people with a sense of ownership of their neighborhoods despite inconveniences like traffic and trash.

Fourth, Rosenstein points out a lack of clearly identifying who from city government has authority vis-à-vis the public cultural sector. NOCD co-director Caron Atlas and Amy Sananman, executive director of the Groundswell Community Murals Project, advised New York City's new administration in 2014 to align many departments with art, rather than silo art into one agency, as I describe later in this chapter. Addressing blind spots regarding neighborhood-based art and culture would be facilitated by expanding evaluative metrics, an initiative to which NOCD is contributing.

Network validation of neighborhood-based art and culture

Caron Atlas, a New York City resident and cultural organizer,[2] and Tamara Greenfield, executive director of New York City's Fourth Arts Block (FAB), have facilitated NOCD in order to increase its members' visibility, expound a public discourse, and develop an action plan that contributes

to neighborhood-based arts organizations and their communities flourishing. NOCD has expanded Stern and Seifert's concept of a naturally occurring cultural district to indicate a *network* of neighborhood-based cultural districts that crosses the city, looking for how the whole can be more than the sum of its parts. NOCD embraces transdisciplinarity, promoting its members both for their arts and cultural work and for their partnerships with a wide range of neighborhood institutions.

Urban planner Maria Rosario Jackson, speaking at an NOCD research exchange (2013), highlighted renewed interest in a comprehensive approach in urban planning and related circles, citing a dimension of the California Endowment's Building Healthy Communities initiative in partnership with the Alliance for California Traditional Arts as an example. It features artists and arts organizations partnering with housing organizations, human services agencies, schools, and other institutions to address a wide range of issues that ultimately affect health outcomes. Reflecting on the historic role of organic arts and culture in communities and the frequent absence of arts and culture as an element of community revitalization strategies, Jackson noted, "If, historically, strategies to disempower communities take away creative expression, then why isn't arts and cultural activity a part of strategies to help empower communities?" Jackson called for increased efforts to build understanding across sectors about how art and culture are inextricable from other community priorities and can contribute to solving local problems (M. R. Jackson 2013).

An example of a problem that cuts across sectors including business, culture, education, and housing is the ongoing gentrification crisis. Rather than compete for affordable space, artists increasingly see that other local institutions have as much to lose as they do when a neighborhood gentrifies. It's a well-known phenomenon: artists move to or stay in a low-income neighborhood because it's what they can afford. If a critical mass of artists prosper, restaurants and cafés follow, people of means move there, and as rents and taxes rise, longtime residents are forced to relocate and, with them, local culture. Soon many of the artists, too, are priced out. The neighborhood loses its unique identity along with the people and institutions that shaped it. Seeking to avoid such a chain of events, various sectors of neighborhoods including artists, with support from networks including NOCD, have been organizing to get city protection for a range of longtime denizens.

NOCD also links individual artists across neighborhoods who then validate each other. Over its first two years, Atlas and Greenfield organized monthly NOCD meetings. They affirmed neighborhood-based art

through contact with each other. They supported such efforts citywide, testifying at City Council public hearings on cultural economies, convening a public forum about ways to access space in a real-estate-driven city, and applying lessons the New Orleans cultural sector learned post-Hurricane Katrina to efforts post-Hurricane Sandy in New York. Next, they organized a public forum, called From the Neighborhood Up.

Increasing value through alliances in the cultural sector

Through From the Neighborhood Up, the consortium sought to bring together other like-minded people working in New York City neighborhoods to build the NOCD alliance more broadly for future work and to demonstrate the vitality of such art and cultural initiatives. The event sought to further a vision of New York City grounded in the cultural and social networks that make communities strong. This vision became the foundation for a shared policy platform to inform New York City's mayoral transition in late 2013. Two ideas were seminal. First, the forum honored, as poet and essayist Wendell Berry wrote, that "what we need is here" (Berry n.d.). That is, every neighborhood has powerful assets to contribute to a resilient and thriving New York City. Second, recognizing the interdependence of cultural organizations throughout the city, it brought them together to develop collaborative strategies to respond to the city's opportunities and inequities (From the Neighborhood Up 2013).

NOCD selected four themes for the forum, all of which point to the cross-sector role of arts and cultural organizations: community health and sustainability, equitable development, innovative uses of urban space, and sustained community resilience and rebuilding post-Hurricane Sandy. Organizers hoped to assemble enough people to discuss the four focal areas such that a vote on policy priorities would have credibility with elected officials.

Planning demonstrated the political as well as aesthetic savvy of NOCD members. They selected El Museo de Barrio as the forum venue, not only because of its appropriate-sized spaces, but also because its location was strategic: in a neighborhood not renowned as a cultural destination but easily accessible to all five boroughs. NOCD members' experience organizing performances and exhibitions was directly applicable to planning the forum. Speakers and workshop leaders were selected for their dynamic ability to communicate and facilitate, to reflect the diversity of artists and organizers in New York City, and to assure their participation at the day's events.

To underline the interdependence of cultural and other neighborhood organizations, attendees began the day with lunch at one of six

community-based organizations near El Museo, immediately putting local concerns on the table and discussing the place of the arts in their activities. One of the venues, for example, Community Voices Heard (CVH), is a member-led multiracial organization, principally composed of women of color and low-income families, that builds power to secure social, economic, and racial justice for all (www.cvhaction.org). The 15–20 attendees discussed the current round of participatory budgeting (PB), a citywide initiative through which community members of eight New York City council districts decide how one million dollars in each would be spent. PB, then in its second year, was an apt subject of conversation given that it cut across arts, culture, and other initiatives that contribute to community vitality. Then everyone who had attended the community-based lunches convened at El Museo.

The opening plenary articulated the value of the arts and culture in neighborhoods through personal testimony. One of the speakers, community development specialist Mitty Owens, described being "a father of a little black girl" in Brooklyn, who was developing identity and self-esteem. He emphasized the importance of her contact with both large cultural institutions like the Brooklyn Museum and small venues like a local dance studio with Caribbean instructors. He said it was crucial that his daughter's everyday experience included "ethnically and women-owned businesses, and a multi-cultural human landscape." For him, the importance of NOCD is "the long overdue recognition it gives to how our identity in the world is formed; and as a bulwark against gentrification and displacement" (From the Neighborhood Up 2013).

Other panelists gave examples of how culture has been a vehicle for their organization to affirm identity, build community, and raise consciousness about local heritage. Panelist Rosalba Rolon, artistic director of Pregones Theater in the Bronx, recounted that some years ago the theater asked a community-sensitive radio station to broadcast an arts and culture show. The manager declined, responding that the station concentrates on community affairs – a context in which the station did not see local artists. Pregones' presence there, not only in creating and presenting extraordinary performances that emphasize diverse expression of Latino experiences, but also through multiple initiatives such as starting a community garden and helping in the effort to preserve WPA-era murals at the local post office, evidences what else artists contribute to community life as culture bearers. But the radio station encounter demonstrates how little understood this larger role usually is.

The forum's 200 attendees broke into four working groups, where NOCD members solicited feedback on their focal areas. For example,

Carol Bebelle, director of the African diaspora Ashé Cultural Center of New Orleans, was invited to the resilience discussion to relate her experience with cultural organizing post-Katrina. The equitable development group featured coalitions challenging private development in two historically immigrant neighborhoods. Then attendees voted on policy recommendations to pass on to elected officials, which included strengthening connections between the arts and cultural sector and grassroots service, activist, and neighborhood organizations; holding developers responsible for providing benefits to existing residents in the neighborhoods they enter; and incorporating legislators, organizers, and artists in a cultural organizing platform.

The process of selecting priorities reflects the consciousness that NOCD seeks to instill among people of different sectors: it's not about any of them alone. The event demonstrated a shift in values from the normally competitive world of producing art to a spirit of sharing resources and information. While the voting process was very analogous to that of many public meetings, it is not a typical modus operandi among artists. The priorities demonstrate that many people involved in the arts and culture are informed or at least concerned about economic policies that could support them and their communities.

Articulating value through interaction with researchers

Soon after From the Neighborhood Up, Atlas and Greenfield invited six national researchers on arts, culture, and community to talk about their work and help NOCD members think about next steps. The researchers included psychiatrist Mindy Fullilove, social scientist Maria Rosario Jackson, the social policy team of Susan Seifert and Mark Stern, philanthropic writer Holly Sidford, and anthropologist Alaka Wali. The professional diversity of the cohort attests to fields beside the arts having something seminal to contribute to evaluating hybrid arts and culture. The multidisciplinarity is also reminiscent of the Animating Democracy Initiative's wonderful book, *Critical Perspectives*, which included responses to three cultural projects by people from three different sectors (Atlas and Korza 2005).

Among the valuable suggestions, Jackson called on NOCD to identify tools people can use concretely once they recognize the value of arts and culture in communities. One possibility is to co-host public gatherings bringing people who work across sectors, including arts and culture, together. Another is to attach a cultural component to grants supporting equitable urban development. Jackson cited the California Endowment's experiment with incentives to enhance local art and culture as part of job development in one "livable cities" funding initiative.

Another idea echoed by a number of the researchers is changing the narrative of neighborhood-based arts and culture. By naming as culture a broader range of activities that go beyond mainstream museums, performance spaces, and galleries, NOCD might generate greater interest and support for local vitality. The promotion of cultural riches across entire cities, rather than only marketing those in established art districts, is one example. As New York City becomes an ever more popular tourist destination – the Museum of Modern Art, for example, now stays open seven days a week to accommodate the crowds – all the boroughs are exploring how to entice more visitors. Melanie Cohn reports that Staten Island is looking to give people something to do once they take the ferry there besides just turn around and go back (Cohn 2013). This opens an opportunity for Staten Island Arts.

In addition to tours to well-known places, many go further afield. Forgotten New York is a program of the Greater Astoria Historical Society that sponsors tours a half dozen times a year to places of interest throughout the five boroughs. There are hip-hop tours of the Bronx and Harlem, neighborhood walks, multi-ethnic food tours, to mention just a few. While many are private, some are sponsored by local cultural organizations, giving people a chance to help support and get to know a neighborhood at the same time. NOCD's understanding of the links between art and culture facilitate thinking about the range of events they produce, from familiar visual and performing arts to neighborhood tours and street fairs.

Contributing to policymaking through alignment with the political sector

The election of Bill de Blasio, the most liberal candidate, as New York City mayor in November 2013 provided NOCD with an opportunity to communicate desired cultural policy to a new administration with compatible politics. De Blasio established a "talking transition tent" in downtown New York City for two weeks following the election, where individuals and organizations, including NOCD, were invited to present ideas for the new administration.

Atlas and Greenfield framed NOCD's session on arts and culture within de Blasio's "One New York, Rising Together" vision, replacing what he called the current "Tale of Two Cities," one rich, one poor. They positioned arts and culture "as essential and integral to a more just and equitable city for all New Yorkers ... rooted in the values of creating a city that cares about our neighborhoods, insists on equality, and embraces civic energy" (Atlas and Sananman 2013). Atlas together with

Amy Sananman, executive director of Groundswell,[3] articulated five strategies "to keep culture at the table during transition planning": integrate arts and culture across policymaking and practice; build arts and culture into civic participation across the city to reach those who have been historically disenfranchised; revitalize New York City from the neighborhood up by supporting community leadership, cultural hubs, and vital social networks; prioritize equitable distribution of opportunities and benefits related to arts and culture; and recognize the wealth of resources and allies among the artists, activists, and cultural organizations working for social change (Atlas and Sananman 2013).

NOCD member organizations have in effect institutionalized the insight that individual artistic expression is nurtured in and at the same time nurtures neighborhoods where that culture thrives. One place this insight is reflected is in non-arts organizations that recognize what the arts bring to their initiatives. At a series of meetings sponsored by the Brooklyn Community Foundation, for example, participants extolled the role that the arts play in engaging youth, educating immigrants, advocating on behalf of better housing and jobs, and building community cohesiveness[4] (Sidford 2014). Indeed, major foundations that fund the arts have collaborated to found ArtPlace America, which "advances the field of creative placemaking, in which art and culture plays an explicit and central role in shaping communities' social, physical, and economic futures" (ArtPlace n.d.).

But there is a distance to go. NOCD, advocating for the arts in close working relationships with other sectors, embraces a boundary-crossing strategy to expand the role art plays in public life. In order for neighborhood-engaged arts and culture to fulfill its promise, cohorts in other sectors must recognize the arts and culture sector for its great potential as well.

Q and A with Maria Rosario Jackson

Jan Cohen-Cruz: Maria, how does the current discourse around creative placemaking relate to the work of the NOCD-NY-affiliated artists?

Maria Rosario Jackson: The background for creative placemaking – placemaking – is not itself a new idea. It's a concept that grew out of urban planning and urban design fields several decades ago. The notion of placemaking is very much tied to citizen engagement and place, and had to do with getting citizens to become more active in determining how a community feels, looks, and behaves.

The idea of *creative* placemaking is more recent, really from a few years ago, taking the original notion of placemaking and infusing it with a particular centrality around the arts. So in terms of the popular term now – there's a wide range of activities that tries to align with it; and at the same time, there's some trepidation about it from the art and other fields that are being encouraged to try to integrate the arts. Creative placemaking requires people to work differently.

In terms of NOCD, there are consistencies in that both lift up the role of artists and the arts as central to revitalization. Again it requires engagement with community and lifting up distinctiveness of place. Within the creative placemaking discourse at its best there's concern with all this and also about protecting against displacement, and protecting affordability. Roberto Bedoya's (2013) work on belonging is a really interesting part of that discourse. There is alignment between what NOCD is doing and important elements of creative placemaking.

JCC: Continuing with the concern of affordability and guarding against displacement – what strategies tend to protect against the acceleration of gentrification in neighborhoods enhanced as a result of arts and cultural activities? On the part of people who think they are embracing

creative placemaking but whose arts and cultural activities end up having a negative impact on longtime residents?

MRJ: That's a question that the community development field has wrestled with a long time. There's no silver bullet but I do think that a community having a strong cultural identity whether it's place-based, racial, ethnic, or something else – community identity and a community that's well organized are elements that help to counter that. A strong infrastructure or network of people with community development acumen is another, as is strong political leaders that protect affordability and more equitable outcomes for historic populations. Knowing how tax policies and real estate can drive inequality and helping to provide alternatives to that are imperative. These are some things that come to mind when I think about protecting affordability and avoiding displacement.

Something else to think about is that not all communities are the same and have the same level of risk. Some communities are certainly more vulnerable to displacement and loss of affordability than others.

It's not useful to be completely resistant to change. In neighborhoods where there's threat of displacement, loss of affordability, or exclusion, I think it's important to think of what mechanisms are necessary or what mechanisms can people draw on to help manage change so that it is potentially beneficial. Some arts organizations and some artists are helping to build community identity and the social fabric that enables communities to consider all these things critically, and to respond appropriately. There's a role to be played, not in creating absolute opposition or hysteria in face of possible change but in wrestling with the question of what change means in a particular environment and how a community can anticipate, manage, respond to, plan for, or, if appropriate, resist it.

There are a couple of things that are concrete and specific that should be on people's radar as it relates to displacement, and one is the notion of protections for affordable housing. Sometimes there are set-asides for affordable housing with new developments. And another is the community benefit agreement. Both require vigilance in terms of enforcement. These are two known tools within the community development field that are often useful or looked to when people are concerned with displacement.

JCC: Do you see a lot of artists and cultural organizations like NOCD-NY that are committed to their neighborhoods, across the US; that see a role both including and beyond aesthetics, to issues like a community's identity, and protecting against displacement? If so, would you give some examples?

MRJ: Generally speaking, there's evidence that many artists and arts organizations want to play a role in helping to address social issues and influence communities. There's more on the rise with social practice and public practice programs, and organizations and artists that feel aligned with this notion of creative placemaking. I think nationally, there's more awareness across policy silos about the roles and value of the arts and some of this has to do with NEA's work in creating cross-sectorial projects relating art to health, human services, and economic development. NEA has an ongoing Arts and Human Development Task Force, created a few years ago, comprised of 19 federal agencies, exploring the arts in human development. The Arts and Human Development Task Force is one of many cross-sectorial collaborations. There are additionally separate relationships with HUD, to influence the Choice Neighborhoods Program, and one with the Department of Education around Promise Neighborhoods, and now there's one with HUD around Promise Zones – so integrating arts and culture into place-based initiatives is something the agency has been encouraging. Nationally, in the arts field, in academic realms, on the federal level with the NEA, and with the focus on creative placemaking from some national funders and others, I think there is increasingly a favorable climate for the kind of work NOCD does and has done.

That said, I don't know anything exactly like NOCD at the local level. There are some organizations that perhaps operate in ways that are relevant to and somewhat like NOCD but not exact replicas of it. In Los Angles, LA Commons connects artists to neighborhoods and important civic issues, but it's not the same kind of network as NOCD. Artists-in-Context in New England has also been active in connecting artists to civic issues and in some instances to neighborhoods. At the local level there are also some really progressive arts administrators who seek to work not only within arts fields but also to create connections with local entities like health departments, community development, transportation, and so forth: Laura Zucker at the LA County Arts Commission; Daniel Brazell, the new manager of the LA Cultural Affairs Department; Tom Finkelpearl in New York; Lynn McCormick in Providence. Through the work of The California Endowment, a health funder, together with the Alliance for California Traditional Arts and other arts partners, some networks of artists in the Building Healthy Communities initiative sites throughout the state are being encouraged to participate in support of various strategies to address socio-economic inequities and help improve health outcomes. So there's evidence of entities with a similar impulse but not necessarily the same structure or exactly the same agenda.

JCC: What are some metrics and underlying principles you've seen or used to appropriately assess and demonstrate the value of neighborhood-based arts and cultural organizations?

MRJ: Metrics really depend on the project; I wouldn't say "one size fits all." The NEA with the Urban Institute did some work trying to address the outcomes challenge of creative placemaking as part of the Our Town program, within the Design Division of the NEA. They worked with practitioners on the ground to identify outcomes that they thought would be useful and plausible. You would find it worth looking at.

But in terms of what metrics are useful, it depends on the work. For example, if you have a project locally that's intended to strengthen the community fabric, it doesn't make sense to apply economic metrics. Lots of projects have multiple intentions; some of the best projects are interested in social, economic, and physical change. You have to see what the work demands as appropriate metrics. It's important when you have various stakeholders, partners, working to bring that work to fruition, to get those people involved with their different perspectives in creating the appropriate metrics. It's also important to be able to detect impacts that may not have been anticipated.

I did an essay as part of the Animating Democracy Project on the evaluation of community arts from an urban planning perspective (http://animatingdemocracy.org/sites/default/files/shifting_expectations.pdf). In it I talk about the necessity of (1), creating a culture of reflection and assessment as part of the execution of the project. So evaluation isn't something that happens at the end but there is an impulse to learn and reflect as the work goes. And (2), the practice of enjoining the perspectives of all the stakeholders in the project to create an appropriate set of expectations.

I think that in the research and evaluation fields there is still much work to be done on capturing the role of arts and cultural activity in the creation of social cohesion and collective efficacy – the ability to act together. Those are important outcomes, and I don't think they are often part of how community revitalization programs, especially when they have an arts and culture element, are examined. How do we develop the tools to account for that better? Back to Roberto Bedoya's idea of belonging – we don't look at metrics of success like that enough. Do people feel like they belong? Feel safe? Are they content in a place? Those are not the only things to look at, but alongside things like economic development, that are more conventional, it's important to bring these things into the conversation, too.

JCC: Turning back to NOCD, and the fact that the individual artists and cultural organizations already were in existence: what does NOCD as a network bring to its constituent members that they could not do alone as regards valuation and support?

MRJ: What stands out the most for me is the important opportunity for peer reflection. Often people and organizations involved in work like those engaged in NOCD are, in some ways, operating in isolation. I say that because in a lot of my previous research when I was looking at hybrid work at the intersection of arts and other fields – how artists engage that kind of work and the support systems required to sustain and encourage it – one of the questions I would ask is who do you see as your peers? They'd often say they had a partnership with so and so at the clinic or in the school. And I'd say no, I understand that those are the partners that help you carry out the projects you are doing. But who do you go to as peers, what other artists do you consult to push the practice, think through something, or workshop an idea? A partner is different from a peer. It seems to me that NOCD is also a forum where people can find their peers.

JCC: Yes, they do that, looking inward to each other. And what about looking outward?

MRJ: The fact that NOCD can be understood as a unit is important politically. It's an entity that helps give voice to a particular point of view, body of work, and interests that perhaps didn't have that unified voice before.

JCC: And of course, often in their neighborhoods, NOCD members work across sectors. What are some examples of networking across sectors, including arts and culture, which you have found to be effective?

MRJ: The NEA work at the national level is hugely important. Locally there are many artists who've become adept at working across sectors. Rick Lowe in Houston, Carol Bebelle in New Orleans, especially with human services, Theaster Gates in Chicago. Seattle-King County Health Department integrated questions about art and culture into its health survey, which is an interesting cross-sector activity. The same is happening in the LA County Health Department. Public Art St. Paul has done a lot of embedding of artists in municipal infrastructure – in planning departments, for example. There's no shortage of examples; the challenge is that a lot of times the work happens without the benefit of the wisdom of people who have done it before. A lot of times

cross-sectorial work is a baptism by fire – a journey without a lot of roadmaps. Integrating arts and culture into other sectors requires getting beyond only thinking about artists as persons doing beautification or performing to attract a group. There's merit to that but it's also looking to artists to help us frame issues and think differently about where we live, how we live, and the systems that support that.

JCC: What do you think it will take for this larger vision of what artists do in communities to be sustainable?

MRJ: There has to be an appetite present not only in the arts sector but it has to become part of practice outside of the arts sector. So that you have, for example, in the field I come from, urban planning, urban planners, looking for artists to participate in that work. And people in the health field also looking for opportunities to integrate artists in their work. There's something that has to happen so it becomes part of our DNA – that the arts have a role to play and that the approach is not with artists and arts organizations as supplicants but as contributors, as resources.

How does that happen? This makes me think about my research on artist support systems and its framework, about elements of support including training and professional development, validation mechanisms including financial resources, opportunities for employment – all that has to be infused with this idea that there is merit and something to be gained by integrating art and culture in these areas that are often void of it.

JCC: Yes. I think this consciousness partly needs to come to people through their separate disciplines and partly through opportunities to see how they overlap.

MRJ: This semester I'm teaching a graduate urban planning class at UCLA and also arts management at Claremont Graduate University. The topics I engage in both of those classes are, to some extent, and in some ways, thematically similar but there's a different approach. Students coming out of urban planning, public policy, and social welfare and other fields are intentionally put together with people pursuing the arts and humanities. So there's a convergence of perspectives and purpose. It's a curated class intended to open people's eyes to other ways of approaching community issues. In the arts administration class, sometimes students come in with a narrow perspective and ambition in terms of what they want to do with their arts administration degree; my job is to complicate that. Even if they decide to remain focused in

a narrower way, my job is to get people to think beyond "what's my role as an arts administrator in the *art* world" to "what's my role as an arts administrator in *the* world." As an educator, that's part of my work.

JCC: I love that. All right. To close up: what advice would you give NOCD for achieving its goals at this junction?

MRJ: To keep at it. It's noble work. A lot of the work at NOCD is political and important, but the peer validation and rigorous critical inquiry around peers is important, too. And pay attention to the pipeline: who are the next generation of folks who will work in this way?

5
Cultural Diplomacy as Collaboration

In 2011–12, the US State Department funded a cultural diplomacy project with an emphasis on artistic collaboration rather than presentation that they called smARTpower. Designed by the Bronx Museum, smARTpower featured an artist or artist collective in each of 15 countries[1] for 30–45 days engaging with especially people under 30 and women, local artists, teachers, and people with expertise from other than the arts aligned with the specific project. Unlike cultural diplomacy programs that send artists abroad to perform or exhibit, perhaps offer a master class, and then move on, smARTpower artists addressed community-based interests and needs such as women's empowerment, climate change, and local history in highly participatory programs. Key to the project design, the artists were each hosted by a cultural organization, not a US embassy, which selected them from several possibilities. I visited 11 of the venues as the project evaluator, Bronx Museum Director of Education Sergio Bessa having based smARTpower on Action Lab, a project on which I worked with him some years earlier.[2]

Joseph Nye distinguishes between militaristic or economically coercive *hard power* and persuasive *soft power* – improving US standing abroad because people admire and aspire to American values, prosperity, and openness (Nye 2004). This initiative takes its name from then-Secretary of State Hillary Rodham Clinton's articulation of "smart power" diplomacy, drawing on a full range of tools to further what is described as people-to-people understanding and good will globally. Collaboration was smARTpower's core approach, to overcome the kind of antipathy that John Stuart Mill articulated thusly: "A neighbor, not being an ally or an associate, since he is never engaged in any common undertaking for joint benefit, is therefore only a rival" (qtd in Putnam 2000, p. 337). Participating in a face-to-face project, especially in a climate

of international wariness about the US, opens up the possibility of a cooperative rather than adversarial relationship, from whence good will might develop. The simple act of working together towards a common goal provides the platform for a co-equal rather than dominating relationship. Grounding in the arts, moreover, is a great leveler, building as it does on self-expression, in which anyone can participate and excel.

SmARTpower collaborations were at once aesthetic and social. The Bronx Museum set up an advisory panel to help choose, from 910 applicants, 15 artists/collectives that integrated aesthetic excellence and the ability to create interactive projects with a broader demographic than typically participate in art events. Related to the contemporary "art as public practice" movement, such visual art projects are less about material objects and more about process and relationship building; numerous smARTpower artists in fact included performance components. Although the money came from the US, both the US and the host country provided creative resources, bringing the partners into a less unequal relationship.

Before examining several of smARTpower's uncommon partnerships, I want to contextualize it within other US cultural diplomacy efforts. One of the great challenges of US arts diplomacy is the relationship with host countries that by and large have profoundly fewer resources. In such circumstances, how can one country contribute culturally to another without being neocolonial? Indeed, US cultural diplomacy has a vexed history, often met with skepticism at home and abroad as a form of coercion and propaganda. During the Cold War, artists were toured around the world to exemplify US individualism, creativity, and prosperity in contrast with what the US described as Soviet Union conformity and economic stagnation (Belmonte 2007, pp. 124–5). Post-World War II, US culture was promoted as equal to its European elite counterpart (Binkiewicz 2007, p. 171). Both models set up cultural competition even as they spoke the language of cultural connection.

Another problem with US diplomacy has been presenting an image of the US that is not always in line with reality. The wildly popular jazz ambassadors of the 1950s and 1960s represented a US to the world that embraced much-heralded African American artists including Louis Armstrong and Dizzy Gillespie, even as people of color were struggling for opportunity and freedom back home. But while touring artists is a strategy of cultural diplomacy intended to improve perceptions of the sponsoring country abroad, it has sometimes leveraged how real processes unfold at home. A case in point is Armstrong's very effective behind-the-scenes advocacy to deploy the National Guard at the

University of Mississippi as it was being integrated, threatening otherwise to cease his international tours (Von Eschen 2004). Armstrong's global popularity positioned him to exert such pressure and thus brought US representation and reality a baby step closer.

Cultural diplomacy needs to balance not only representation and reality but also national promotion and the changed ways that country is perceived internationally. In recent years, the US is less frequently held up as the model to which world citizens seeking input into issues affecting them, economic security, and freedom aspire. Traveling with smARTpower, I frequently heard about people who come to the US to work but want to go home after saving enough money for economic independence. Post-9/11, the opportunity for the US to identify with other countries that have been attacked on their own soil was squandered. In this political climate, a self-aggrandizing model is unwelcome. Wenzel Bilger, Director of Cultural Programs for the Goethe Institut in the US, described Germany following World War II, necessarily having to avoid perception of furthering a global political agenda. Their solution was to focus on supporting culture abroad without an emphasis on self-promotion, which, Bilger mused, might be a good model for the US in these times (Bilger 2013).

The culture a country exports to boost its international reputation and enhance its economic dominance may also be used coercively. Antonio Gramsci used the term hegemony to describe how those in power, without using physical force, manipulate the consent of everyone else such that a dominating worldview becomes the norm, and others buy into values that are not in their own interest. Even in Kosovo, the most US-friendly of the 15 smARTpower host countries, where a statue of a smiling Bill Clinton greets the traveler almost immediately upon arriving in the capital from the airport, people I met expressed gratitude to the US for saving them from Serbian "ethnic cleansing" in 1999 but avowed that now they wanted to shape their own country and not be overshadowed by US expectations and control. Again and again, I heard people describe the US government as imposing itself on other countries. In the realm of culture, globalization was often described as opening the door for countries to import ever more US television and films without reciprocally inviting their national creative output into the US.

So it is significant that smARTpower built on principles of noncoercive dialogue, attempting to avoid hegemony by emphasizing partnerships and providing a context for multiple views. A collaborative approach focusing on a shared process is in tune with these times in a way that simply presenting US artistic products/productions is not.

SmARTpower emphasized democratic ideals of pluralism, equity, and creative potential to a wide diversity of people invited to participate no matter into what class they were born, at the same time showcasing admirable achievements of the US artists selected. The program foregrounded US artistic capacity to work in innovative ways *with* people from other countries.

A challenge smARTpower artists and staff faced was lack of clarity vis-à-vis what State Department personnel wanted, beyond a broad desire to enhance how the US is seen in other countries. Before the artists went abroad, they – core smARTpower staff associated with the Bronx Museum – and I spent a day with personnel from the State Department Bureau of Educational and Cultural Affairs (ECA). What we heard from one person was not always the same as what we heard from the next. Were the US artists cultural ambassadors meant to deliberately represent the US or to have been so capably selected that just doing what they do would fulfill the State Department's purpose? Some ECA officials confirmed the former, others the latter. Did it matter if people experienced the artists as part of an international cultural brother and sisterhood or was the US identity meant to be foremost? Unclear. Did the State Department see, and did smARTpower need to articulate, that the human connection the artists engendered could lead to an improved view of the US? Not discussed. Were residents of the host countries to think better of the US because of their experiences with these artists? The assumption seemed to be yes. How could individual artists' creativity and character be the basis for representing an entire country? This question was not asked. If contact with US artists at least dismantled monolithically negative perceptions of the US, how many people would need that new perception for the State Department to think of smARTpower as a success? I sensed, as evaluator, that the State Department was after greater numbers of people impacted than the program could produce in its pilot year. But to my knowledge, the State Department never articulated specific numerical expectations to the project managers, the artists, and certainly did not to me.

All the smARTpower projects were hosted by cultural organizations not directly aligned with governmental or commercial agencies, known as NGOs – nongovernmental organizations. An NGO is a

> nonprofit, voluntary citizens' group ... organized on a local, national or international level. Task-oriented and driven by people with a common interest, NGOs perform a variety of service and humanitarian functions, bring citizen concerns to Governments, advocate

and monitor policies and encourage political participation through provision of information ... They provide analysis and expertise, serve as early warning mechanisms and help monitor and implement international agreements. (NGO Definition n.d.)

However, smARTpower as a whole reported to the US State Department, in a top-down relationship. Collaboration requires time to align a vision and analyze goals and methods. While smARTpower was the Bronx Museum's response to the State Department's call for proposals, the people who carried it out were expected to fulfill the State Department mandate, though the intermediary was the project manager whom the Bronx Museum hired. The top-down approach also characterized most of the US cultural attachés I encountered abroad, many of whom were offended that the projects had been developed between US artists and local cultural hosts, not determined by them as experts in the respective countries. This top-down structure was not in sync with the program design.

In evaluating smARTpower, I drew on scholars Geoffrey Cowan and Amelia Arsenault's articulation of three tools of public diplomacy – monologue, dialogue, and collaboration (2008). They parallel the dynamics of the three formats of performance that thread through this book – the finished product/play, the participatory workshop, and the cross-sector partnership. Like those formats, rather than one tool superseding the next, all three are valuable. There are times when what Cowan and Arsenault call monologue, that is, an eloquent speech, piece of writing, or, I would add by extension, piece of art, does much for international understanding. But it is equally important to make space for dialogue lest one country feel imposed upon by another. Dialogue suggests different voices that may articulate different opinions, all worthy of being heard, such as takes place in participatory performance workshops. Finally, mutual trust and respect require international representatives getting to know each other, facilitated by the third tool, collaboration, that is, undertaking a task together. To Cowan and Arsenault's three tools I add a fourth, catalysis. In most arts diplomacy programs, exchange is aesthetic, intended only indirectly to address social issues, including international views of the US. SmARTpower projects, in contrast, purposely modeled approaches to social issues drawing on the arts. Thus another metric was local perception of art's role to catalyze progress on a social issue.

In what follows, I revisit four smARTpower projects as examples of uncommon partnerships in the realm of cultural diplomacy. In the Philippines, artist Mary Mattingly addressed climate change, bringing

together architects and high school students to collaborate with artists on wearable and portable architecture. In India, artist Kianga Ford collaborated with struggling young women and local musicians, and, later, also women's rights activists, on an audio tour of Bangalore as a jumping-off point for dialogues around women's equity. Pepon Osorio worked with a team of art students in Nepal to create 12 sets of dinnerware resplendent with local cultural symbols, and then made the dinnerware available for dinner parties intended to generate culturally meaningful conversations. And in Venezuela, raising the most questions for me, artists Seth Augustine and Rachel Shachar partnered with local institutions that opposed the (socialist) leadership, seemingly to demonstrate what culture could do in a democracy.

Art and design in response to climate change

In the fall of 2012, a month after severe flooding and typhoons once again caused great destruction in the Philippines, not least to the fragile shacks in that land's many "temporary settlements," US visual artist Mary Mattingly arrived in Manila. Mattingly studied photo and new media, and is self-trained in architecture. For the past decade, her work has addressed current and future global environmental and political conditions. In the summer of 2009, for example, she led a group of artists, builders, civic activists, scientists, and marine engineers to create the Waterpod Project, a mobile, sculptural, autonomous habitat and public space built on a 3000-square-foot barge. It was an experimental platform to assess the efficacy of onboard living-systems, to provide a public space for conversation, and to question the status quo concerning energy, water, food, and shelter. Addressing climate change was equally relevant to the US and the Philippines and hence set up the conditions for an equitable partnership from the beginning, all engaged with real questions.

Mattingly was hosted by Green Papaya, a cultural organization that "supports and organizes actions and propositions that explore tactical approaches to the production, dissemination, research and presentation of contemporary art practice" (Green Papaya n.d.). Responding to the national crisis around floods and monsoons was for them a new role for art. Green Papaya's staff appreciated that architects and a relevant government representative spoke at Mattingly's first workshop, making them aware that artists have something important to contribute, too. Staffer Lian Ladia remarked finding it refreshing for people to talk about what's happening right now in the Philippines. In 2010, half of Manila

was submerged. So wearable, portable architecture is a very timely topic. Equally important is *how* the conversations took place: Lian explained that education in the Philippines tends to be top down whereas these conversations encouraged participatory exchange.

Mattingly's lectures and workshops provided a space for conversation and were followed by participants, in groups, designing their own projects. Nearly 30 high school students and teachers, artists, and architects worked together beyond the lecture/discussions, designing and creating mobile public habitat for predictable weather emergencies. In their disassembled form, individual units were wearable, like heavy-duty rain apparel complete with backpacks. Or the wearable units could be attached to become a scalable architectural structure, like a lightweight boat or tent, creatively effectuating mobility in case of water disasters and easily assembled as off-the-grid community spaces (Figure 5.1).

Networking across different communities was a palpable pleasure for the participants. One architect said that whereas she thought immediately in terms of how her design would stand up and address basic

Figure 5.1 Artist Mary Mattingly (center with sash) and participants from her workshop transport a temporary shelter they constructed through the streets of Manila.

needs, the high school students appeared to work more intuitively and had something in 30 minutes while she was still conceptualizing. "They freed me from having to think so much, just let it flow. I got into folding and eventually had something. They helped me see what I didn't habitually think about. They also really made use of the materials in different ways."[3] People then constructed what they had designed.

Local Embassy personnel met with Mattingly but were otherwise uninvolved in the project. Notwithstanding, cultural attaché Alan Holst affirmed the importance of developing a local independent socially concerned cultural center like Green Papaya, explaining, "The more socially active they are, the more they involve not just the Embassy's cultural section but also human rights, AIDS initiatives, et cetera." Given the Embassy's lack of involvement, Holst's comment surprised me, raising questions about *how* to make cross-embassy agency engagement possible, since they had not acted on this opportunity. The imaginative and yet feasible designs the workshop generated suggested how a US artist's expertise might be adapted to another country in a process of exploration without inappropriately advocating for particular outcomes. Partnered with environmental experts who might be at the disposal of other Embassy units, this is a direction for cultural diplomacy worth exploring.

This project also makes me wonder if conversations take place between the Educational and Cultural Bureau of the State Department and the National Endowment for the Arts (NEA), as the agencies with most decision-making power about, respectively, international and national uses of US government funds for the arts. In July 2010, even as the Bronx Museum was developing smARTpower, NEA director Rocco Landesman and US Housing and Urban Development (HUD) Secretary Shaun Donovan were collaborating on two funding opportunities: $100 million in grants available through HUD's Sustainable Communities Regional Planning Grant Program, and up to $75 million in grants available through a joint HUD and US Department of Transportation DOT Sustainable Communities Challenge Grant Program. As noted in the press release:

> Under both programs, arts organizations are eligible to partner with state and local governments, metropolitan planning organizations, transit agencies, philanthropic and nonprofit organizations and other eligible applicants to develop consortia grant proposals. "The arts are a natural component to furthering this Administration's commitment to creating more livable, walkable, environmentally

sustainable communities," said HUD Secretary Donovan. "They can play a key role as a partner that is able to enhance the unique characteristics of communities and increase our economic competitiveness through supporting creativity and innovation." "The arts are creative placemakers," said NEA Chairman Landesman. "We are able to work alongside federal agencies like HUD to help create places where people want to live, work and play, both today and in the future" ... the Partnership is designed to remove the traditional silos that exist between federal departments ... [and] to provide communities the resources they need to build more livable, sustainable communities. (HUD 2010)

Did the State Department's Bureau of Educational and Cultural Affairs consider the parallel between this NEA initiative and smARTpower? Once the State Department was committed to spending one million dollars on a visual arts cultural diplomacy project, it could have reinforced what is on one level a community-organizing role of art as a signature artistic expression of the Obama administration. Each initiative could have learned from the other even while stretching dollars in the post-2008 recession climate of tightened belts.

Returning to Cowan and Arsenault, Mattingly used tool no. 1 of public diplomacy, monologue, in her initial lectures, describing her ten years of experience employing art to respond to climate change. Tool no. 2, dialogue, took place in setting up the project with Green Papaya. This could be taken much further, were local residents to debate which design ideas to develop. Tool no. 3, collaboration, is manifest in the workshops themselves. Mattingly brought arts-informed ways of approaching the problem, the students added an improvisational spirit, and the architects contributed their knowledge of real material capabilities and limitations. The hope is that this project leads to a step no. 4, catalysis, which would be a serious effort to include artists and architects in the creation of habitats that provide a modicum of shelter especially for the very poor during climate emergencies. Equally valuable would be a way to highlight what the US as well as the Philippines can learn from the experiments. The collaboration becomes a joint exploration, not a situation in which one country is only on the receiving end.

Art as a vehicle for dialogue and individual development

Kianga Ford, the smARTpower artist in Bangalore, India, uses design-based installation, sound, performance, and site-specific projects to

create scored environments. Since 2003, she has been developing narrative walking tours called "The Story of This Place" – historically informed fictional stories for mapped routes through cities. Conceptually, the pieces are concerned with contemporary social and demographic shifts, local histories, and the positioning of individuals within and between communities. While Ford's research includes written histories and archival materials, she relies most on informal conversations that she holds with individuals on-site. Ford creates an omniscient narrator who recounts various characters' activities moving through that city, characters who are vehicles for stories she heard related to the place's history. Ford writes the narratives and collaborates with musicians, vocalists, and composers to score the walks. Initially they take the form of on-site audio walks; they later become part of a traveling and online archive. While this project is not visual art in the traditional sense, Ford sees her work philosophically and historically as part of contemporary visual arts looking for new forms post-sculpture and cinema. It is also visual art in the sense of providing fresh ways of seeing places.

The "Story of This Place" in India was called Bangalore for Beginners. While Ford often spends a year on one such project, in this case she had just 45 days and was in a country whose major languages she does not speak. She thus developed the narratives for this audio tour collaboratively with a group of nine young women living at Jagruthi, a local NGO. Jagruthi's mission is "to protect children from sexual exploitation and empower them to lead self-reliant lives" (Jagruthi n.d.). The young women residents are either orphans, rescued from the sex trade, or HIV+, who learn the trade of embroidery while living there. Originally, Ford was going to teach the young women how to collect oral histories and personal narratives, to provide access to local perspectives from which she would develop the narrative. However, the young women proved too sheltered to carry out interviews with strangers, so instead Ford worked in depth with them, to open them to the wider world. They created a composite character for the audio tour based on their lives and named her Padma.

Padma's story begins in the under-resourced neighborhood alongside the NGO in which the young women now live, which is very much like neighborhoods where they were raised. Padma is 20 years old and was getting bored taking care of her parents. She considered seeking work in a garment factory but wanted her own family. She went to Lalbagh, Bangalore's beautiful botanic garden, and dreamed of another life. One day coming back from the temple, she saw a young man and they fell in love with each other, soon getting married and moving in with his

mother. But her mother-in-law beat and starved her. Any time guests came to the house, Padma had to cook and was only allowed to eat the scraps. Finally she returned to her familial house and apologized for leaving, promising to take care of her parents again and to look for work in the garment factory. She went back to Lalbagh, but this time with her younger brother and sister to talk with them about their marriage plans despite how badly her own married life had turned out.

Ford set up three opportunities for the young women to discuss the narrative and its relationship to their lives with people having particular expertise. I was present at one with about 20 feminist activists involved with domestic violence and affiliated with Vimochana, an NGO for women's rights, fighting marital violence and dowry harassment. Ford described her decade-long practice of creating audio tours and played a clip of one. Three of the young women with whom she was working, bravely and somewhat tentatively since none had ever spoken publicly before, then introduced Padma, her background, and the story of her development.

The response from the women activists was explosive. On the wedding day, one began, everything is grand and nice; problems begin the next day. Another said it was important to show Padma *not* getting caught in this typical trajectory and *not* having the singular dream of getting married. Marriage is a part of life; a woman still needs to be independent. Someone objected to the story supporting the status quo by having Padma try to get her younger brother and sister married, emphasizing the need to develop one's own identity. Someone else suggested Padma fall in love but live with him, not get married. The focus was on young women developing a larger worldview, not dependent on just marriage and love. The discussants wanted Padma to become a model for others. Someone pointed out that she could rebel even if she stays in the domestic space, or walks out of the space where she is abused. Someone else said that there was nothing wrong with their story but this experience was an opportunity to change the narrative, and that as activists, they are committed to changing the narrative for women. Padma was so realistic now; this could be a space to reimagine her.

The girls listened on the edge of their seats. Ford acknowledged how hard this conversation was for them and explained how much they'd stretched in the previous weeks already. She asked the girls if any wanted to respond. One said they had been petrified to come to this place with "big women" and that just before the presentation her heart was beating loud and fast, because she'd never spoken publicly. They seemed both terrified and thrilled at the prospect of other choices in

their lives. Ford asked if they wanted to go back and take Padma's story in another direction. They shook their heads, yes. It was a profoundly moving afternoon, especially for the young women to see a relationship between what they could imagine and what they could do.

Nevertheless, I wondered what would happen when Ford left, having spent three days a week with them for six weeks. It's great that they can imagine more for their lives than they did before but there will be much stumbling to get there; who will be there to lend a hand? Where is the support for these young women if they open their hearts and allow themselves to imagine something else? Nevertheless, the conversation was deeply valuable as the moment that they saw how art could affect their lives, having just drawn on their lives to help shape a work of art. Had Padma's story stayed in an aesthetic space, and had they not had a conversation with specialists who deal with gender abuse to women, that link may not have been made. Telling stories about their lives was a step in becoming conscious about their reality and that of many young Indian women; being encouraged to imagine something else emboldened them to look for more in their lives as well.

As a result of the conversation at Vimochana, the girls changed Padma's story. Now the purpose of her second visit to the garden was to contemplate two paths, premised on first establishing a successful embroidery trade, for which they were actually being trained. One was the possibility of going back to her husband and the other was to consider options if she didn't. She loved her husband and wanted to be with him but maybe she could insist they forge a life of their own, away from his mother. While that may sound obvious to a Westerner, given women's place in Indian society such questioning required challenging a major cultural norm. It was not just a choice of being married or not, but of how they situate themselves within the larger society. The young women agreed that Padma could remarry if she chose, a possibility, Ford noted, that they had initially only seen as possible if her husband died. They were clearly opening themselves to thinking in a new way.

Ford was very adept at introducing her well-honed practice of creating city-specific audio tours – akin to Cowan and Arsenault's idea of monologue as a tool of public diplomacy. The series of conversations Ford set up exemplified their second tool of public diplomacy, dialogue. Actually creating the audio tours with local musicians and the young women was tool no. 3, collaboration. Because Ford's work had a social dimension, the impacts and ripples give it an afterlife beyond an artwork – drawing on tool no. 4, catalysis. The project provided the

opportunity to create relationships for the girls that could be continued, and could help them find more options in their lives, especially narrowed by gender expectations and class. At the same time, it helped One Shanti Road, the cultural organization that hosted Ford, advance in a direction they were already going, namely focusing on art that extends beyond the studio. The project also provided a creative opportunity for Ford to continue to develop a decade-long project at the same time she helped raise an important social issue in a meaningful way in the public realm. There is no US Embassy or Consulate in Bangalore, and no US cultural attaché was involved.

The integration of the social and the aesthetic was very rich in Ford's project. Exploration of the city and defining how to express it from various perspectives was a form of social anthropology and an education for all concerned. For Ford, the success of this project began with "impacting the girls' lives from this exposure to art and the larger world around them" (2012). For the girls, the space to imagine that narrative coupled with the three dialogues led them to see their role in social life with new eyes, and seek to become more proactive. The idea of training a group of local people to carry out interviews when creating audiotours in countries where Ford does not speak the language is a good one even though it did not work out in this case.

The location of art

As described on the website of public television's *Art 21*, visual artist Pepon Osorio's works often "evolve from an interaction with the neighborhoods and people among which he is working; he says, 'My principal commitment as an artist is to return art to the community.'" I spent a week in 2012 with Osorio in Nepal where I observed the process by which he created an artwork that traveled from home to home. His foundational commitment to access has an impact on how he makes his work, not just what happens once it is made.

Osorio began developing his *Home Visits* series, of which his smART-power project is a part, when he moved to Philadelphia in 2006. But he already had a long history of making art to display in spaces accessible to more and different people than those who typically frequent museums and galleries. Moving after 25 years in New York, he got to thinking about people's homes and their possessions, which led him to imagine losing everything, and how he would respond. He wanted to meet someone who had lost everything and make them a work of art for their home that would tour to other homes as well (Art 21 n.d.).

Congreso, a Latino organization in Philadelphia, connected him with a woman and her two daughters who had lost everything in a fire with the understanding that he would create a work of art with their involvement. Dealing with a person who has lost everything requires time and patience. Osorio knows how to talk with people in a range of situations, partly as a former caseworker but largely because of his compassionate nature. Only after getting to know each other over a month's time did Osorio mention the event that destroyed their house: "And we cried together. It's a lot of tears in my work, I realized." He decided to recreate that home, with their participation, remembering where everything had been. Through the accumulation of stories, some that only Tina and her daughters could tell him, he began to build in details:

> The resin, which looks like that plastic block around the home – I was told that it was in the middle of winter when it happened. So, when the firemen came in, everything turned into ice. It froze, and I thought that was a metaphor: to freeze our possessions, to hold our possessions. And that's what that image comes out of. The only thing that the mother can think of was saving the children, so then she's outside with the children. (Art 21 n.d.)

Historical sources were among his building blocks. Osorio recalled a popular religious tradition, in Latin America and Puerto Rico, of the visiting saint:

> When I was a kid [in Puerto Rico], we were visited by the image of a Virgin of Guadeloupe – sent by the church, I'm sure, to collect money – ... and it came to our home, once every two months. And around that neighborhood, to many of the different families, it just visited; it went from one house to another.

In Nepal, Osorio took the Home Visits series a step further, creating a piece called *Resting Stops: An Alternative Pilgrimage*. It consisted of a set of items used at the dinner table with iconography from Nepali culture – a tablecloth featuring "third eyes" in its design, tiffins (a set of stackable serving dishes indigenous to Nepal and also found in Puerto Rico and elsewhere), napkins made of traditional Nepali cloth, cups with meaningful words engraved in them, and candlesticks in the shape of bare feet, evoking Nepali religious pilgrims. Osorio planned for families to host the work as its temporary owners, organizing their own "openings" and inviting conversations around the table where a meal was

served using the art created. *Resting Stops* is about getting families to eat together and converse, and making culturally meaningful art accessible and part of a broad range of people's experience. Osorio worked closely with Kathmandu University art professor Sujan Chitrakar and seven of his students on every phase of *Resting Stops*. Osorio asked Chitrakar to orient him to cultural imagery and rituals of Nepal to ground the work locally. As one of the students explained, "Most of the sources of this project come from Nepali culture: from a wedding ceremony and other rituals we went to with Pepon. So in the artwork, it will be easy to communicate with any Nepali; it's not a new visual language. My family may be surprised because they've seen that material before but the execution is new."[4]

The Nepalis with whom Osorio connected live in an aesthetically rich culture even though many of them never go to galleries or museums. Osorio was astounded by how, at every corner, he met someone who could make something. When he wanted tablecloths for each set of the traveling "dining art," he and the students designed the imagery they wanted and then identified a local seamstress whom he met in the neighborhood to make them. Osorio talked with artisans, shopkeepers, community organizers, artists, and students, explaining the project. He invited everyone he met to come to any of a series of communal meals that he and the students organized so that people could learn about the project and tell stories about their own experience of the central item in the dinner sets, the tiffin (stacked serving dishes). Osorio led a storytelling process, so in addition to sharing food, people shared stories. Some recounted bringing tiffins to work and breaking at midday for collective meals. Some remembered bringing tiffins to school, which for some was nostalgic, but for at least one person was a reminder of the competition around whose meal was best and whose meal was worst.

Osorio put the stories he heard together in his mind in a way that he could translate visually. He looked for materials to evoke those stories, translating them into art along with the students. Osorio and the students made 24 pieces of everything – 12 sets to send into people's homes, and 12 spare sets to use in case of breakage. Osorio didn't want the tiffins to become objects for art collectors; he wanted them in people's homes, responding to the process that produced them and featuring the stories of people of every background. Some participants were also art collectors, and were very welcome as hosts, but did not have the option of purchasing the art. Osorio wanted many people to have one-on-one relationships with the objects and to put what food they wanted in and on it, rather than look at the objects as separate from

everyday life. For him most important was community interaction; he was determined that people spend time with the art in the intimacy of their own homes. His focus was the human relationships and the conversations with members of the community that the art as a context for communal meals brought about.

The students all affirmed that working with Osorio exposed them to new ideas about art. They had never before connected with local artisans; most of the time they work alone in their studio. They had not thought of their own culture as so rich as they do now because of this experience. Osorio expanded their sense of possibilities by connecting their art to resources readily accessible in their own culture. The art students also functioned as multipliers, who can spread the work through week-long "resting stops" with various families and thus achieve one of the project goals, namely to reach a goodly number of people. The students remarked how novel it was to encounter an art project moving from home to home, with nobody needing to go to a gallery to see it. This was their first experience of art coming to people rather than vice versa. As one student put it,

> Normal people don't go to galleries, only those with special interests do. For this project, art becomes part of their life. Children in the house, parents, they don't need to go out to art *and* they can interact: see the work, be much more comfortable inside their house, ask questions which they may hesitate to do in a gallery. In their home they can talk, walk, and sit beside the art.

And thus did Osorio integrate art as part of the living culture of a place for all its inhabitants.

Art embodying alternatives to the political status quo

The US embassies in the two smARTpower countries with the most adversarial relationships to the US – Venezuela and China – seemed the most motivated to engage with the project, opportunities to contribute to a positive view of the US being scarcest. In Venezuela, then-US cultural attaché Sally Hodgson had a long, active relationship with the cultural host organization the Centro Cultural Chacao (CCC). It was a rare alignment of local Embassy personnel with a cultural host organization, community participants, and smARTpower project. While not necessarily representative, it did provide a clue to what some attachés want from cultural diplomacy.

The CCC is located in Chacao, one of five "municipalities" or official neighborhoods of Caracas, and one of two with an opposition (that is, anti-Chavez, anti-socialist) government. Betsey Caceres, the CCC director, described Chacao as "a small, well-run business district. They pick up trash, monitor street activity, stop people for traffic violations, like a mini-US, which doesn't happen elsewhere in the city."[5] The CCC provides cultural experiences and education to the general population that, Caceres said, are otherwise lacking. It supports emerging visual and performing artists and musicians and increasingly engages artists to work with people without artistic opportunities. It has a new building that Caceres avows will be "booming with activities" and was already quite active when I visited in June 2012.

Distrust is rife between the prevailing government and those who do not support socialism. Caceres avowed that then-President Chavez only rewarded his allies; for example, he had taken over all the major national cultural centers mostly for political meetings and rallies. Other people didn't get to use them; even the orchestra had to move to a new space. Activities not part of Chavez's plan were delegated to university theaters or small independent spaces. Spaces for public cultural events not mandated by Chavez included only the CCC and a museum and theater in a neighborhood called Petare, both in oppositional areas of Caracas. On the other hand, Chavez won a fourth term in the last election and had widespread support among the poor. According to venezuelanalysis.com, former mayor and ongoing political power in Chacao Leopoldo Lopez Mendoza, who "comes from one of Venezuela's wealthiest families and is known for his ... extreme right-wing agenda," is no more likely to work for the good of the entire nation than was Chavez.

SmARTpower puppeteers Seth Augustine and Rachel Shachar facilitated week-long workshops at four organizations in opposition municipalities, creating puppets and a puppet show at each to stimulate dialogue about recycling and to build community capacity to work together. At SEPINAMI, a juvenile detention facility, Shachar and Augustine worked with 12 teenage girls and six of their therapists, who participated so they could continue the program. In Petare, the largest barrio in Latin America and home to people with few material resources, the workshop involved 16 10–18-year-olds and was co-hosted by a museum and a theater. They did a third workshop at Chacao for neighborhood children and a fourth at a facility that supports homeless people. In each case, participants had saved previously used materials from which they made the puppets (Figure 5.2).

Figure 5.2 Augustine (man furthest right) and Shachar (not pictured) facilitate a puppet show in Caracas with homeless people who built the puppets and devised the play.

While all four workshops met with enthusiasm, staff at two of the sites expressed the desire to continue beyond the smARTpower residency. SEPINAMI director Angel Lucie saw the puppet workshop as aligned with their commitment to "a social, holistic education," and struck her as a great way to reach the youth in her programs. Doing theater, becoming another character, exposes one's body/face to an audience: "With puppets you can both express things you wouldn't on a daily basis, and project a person you want to be, create a vision, a hope into the future." Lucie's fervor for the workshop was so strong that she requested a follow-up "train the trainers" workshop so a cadre of staff could strengthen their capacity to continue it. She expressed the value of the workshop, as manifested by the tears in the girls' eyes at the end of the performance – not only that they were taken seriously enough to be offered a free workshop but that they had the chance to "say things." Lucie remarked that "Maybe they don't speak well but being able to do so at all, in public, sets them free, with no one pointing them out as not being good enough." The workshop aligned with SEPINAMI's

pedagogy of "reeducation" by providing a level playing field for therapists and the girls to learn something enjoyable together, at which they could succeed. This included building puppets and a puppet show and recognizing ways materials that are typically discarded could be reused. Carmen Sofia Leoni, director of Barbaro Rivas Museum in Petare, saw the workshop as an instrument of expression for youth participants. Some educators also attended the workshops, and were thinking about starting a puppet group in their community. They could use the neighborhood theater that belongs to the same NGO as does the museum. US Embassy Cultural Specialist Elena Brozowski explained that Petare, the only extant area from colonial times in the city, was building a project around its history. They were in the midst of gathering stories in the neighborhood. If local people could be trained and become trainers, puppetry could be a regular event at the square or in the theater as it becomes a renewed point of interest. The workshop was also valuable in generating thought about recycling and the environment, in the sense that, Leoni explained,

> You see all the detritus in front of you and you realize you can do something with it. It's implicit even if not conscious. And we have tried to do something about recycling at our holiday workshops; we had some guys who recycled materials but all made the same thing, unlike the great diversity of the kids' puppets.

Given the abysmal relationship between the US and Venezuela under then-President Chavez, cultural exchange is not taken lightly as a tool to build people-to-people relationships. US Embassy personnel there were delighted with this project, stating,

> We are trying to blunt the instrument that Chavez keeps hammering us with. We want to show people that we aren't the enemy, and that we are trying to help this country and its people, not beat them over the head like Chavez. In this country, it backfires if we try to bludgeon people. So we try a soft sell, especially in the context of a leftist country where people are used to imposition as a method. Waving the flag does not feel like the best strategy. (Hodgson 2012)

Hodgson also noted that there has been little public funding for culture with the exception of Duhamel's world-famous "La Sistema"; music for militaristic, propagandistic purposes; and graffiti artists who paint pro-Chavez murals in public places.[6] Cultural organizations like the CCC

play an important role in demonstrating the kind of active cultural programming that they believe a government ought to make widely available. Another way to look at the initiative is as the US trying to exert influence over the Venezuelan people and undermine Chavez's legitimate presidency.

There is a rich tradition of oppositional cultural venues configuring themselves as alternatives to official institutions. Among them is Theatre of the Oppressed creator Augusto Boal's work with "parallel government" in Brazil in the early 1990s, manifesting how things could be different under workers party candidate Luiz Inácio "Lula" da Silva than under right-winger Fernando Collor de Mello, who was elected president in 1989. (Lula won the next election.) Boal describes the initiative as a version of the Popular Centers of Culture that existed in Brazil before the coup d'état of 1964:

> Back then the National Union of Students had formed cultural centers, and many trade unions and other organizations did, too ... The principle was the same in all of them – the people who know something well teach it to others. There were free clinics, cooking classes, everything. I held a playwriting class with a steel workers' union. They wrote plays about strikes they had made. (Qtd in Cohen-Cruz 1994, p. 232)

However, the Brazilian parallel government project and activities like the puppet show are significantly different, in more than scale. Parallel government was initiated strictly by local people who were legitimately part of decision-making about their country's future. SmARTpower was put in place by the US State Department. "Parallel government" was a way local people without power still managed to gain agency; an initiative in another country with US government support is something else. One of Boal's great lessons is that only those who will live the results of a decision ought to help make it. This is not a criticism of the smARTpower artists, whose own work was politically neutral, but rather of the context into which it was inserted.

Monologue, dialogue, and collaboration seem less significant terms of assessment in the face of other questions this case raises. On the one hand, the puppet workshop with recycled materials was genuinely appreciated for reasons outside of politics. People with few opportunities to make art were able to go through an entire creative process with a beginning, middle, and end. But what did the workshop serve? Were the US artists put in a position to promote a political choice, by creating an activity only available to people aligned with the opposition,

rather than to simply initiate a collaborative art project? The Caracas Embassy considered continuing to fund the program beyond the six weeks. While this could be interpreted as a sign of smARTpower's success, it can equally be seen as a carrot, rewarding friends and withholding resources from others. How "smart" is this power? Working through the US State Department raises challenges that are difficult to surmount, the first being lack of transparency. These artists were positioned as part of tactics to which they were not privy. Real partnerships on every level would have resolved that dilemma.

Cultural diplomacy's challenges and promise

William Ivey was director of the National Endowment for the Arts (NEA) from 1989 to 1991, during Clinton's second term. He remarked that he was chosen for that position more on the basis of image than on cultural policy philosophy and experience (Ivey 2012). It was in the wake of the Mapplethorpe controversy, which revolved around government support for art that some construed as anti-religious and overly sexual (specifically homoerotic). The political decision was to appoint an NEA director whose image was what Ivey called a "regular guy." President of the Country Music Foundation in Nashville at the time, Ivey fit the bill, because of the audience associated with country music and the organization's location. Jane Alexander, the next NEA director, fulfilled the government's desire for what Ivey described as a public-minded Eleanor Roosevelt image. With such concerns controlling the choice of director, it's no surprise but it is absurd, Ivey said, that the US lacks a cultural policy and a minister of culture. While he was in office, the State Department occasionally asked him to play a ministerial role as the highest-ranking cultural employee in the federal government; but how, given his modest portfolio, could he meet with, say, the Cultural Minister of France (Ivey 2012)? There is a parallel between a lack of cultural policy within the US and uncertainty about cultural diplomacy abroad. How can the US promote cultural diplomacy anywhere without a cultural policy?

Another problem for cultural diplomacy, as artist Judi Werthein was quoted as saying when *The New York Times* first announced smART-power, is this: people around the world may well appreciate and even be transformed by collaborating on projects with US artists, who have much to gain from international engagement themselves. But people know very well that governments determine political change not through cultural diplomacy but through policy decisions (Taylor 2010).

I have come to think about smARTpower's potential a little differently. Through observing 11 of its projects, I am reminded of the potential of independent "third" spaces, neither government nor commercial, to further civil society. One of smARTpower's strengths was being hosted by cultural organizations rather than US embassies. If the goal is to contribute to a freer society where everyone can discuss and weigh in on decisions that affect them, such projects would be well worth US support, indirectly representing the country in a positive light. An atmosphere of free critical creative exchange exemplifies democracy and builds capacity for people to take their lives into their own hands. Again I look to the directors of numerous smARTpower partner organizations who praised the stance of the Goethe Institut, the Alliance Française, and the British Council for supporting critically astute cultural programs without expecting direct improvement of their own national image, urging the US State Department's Bureau of Educational and Cultural Affairs, too, to take such an approach.

Reflecting on the case studies, how might a second wave of smARTpower build on this first attempt? In the Philippines, artist Mattingly, some of the architects who took part, and a government representative might convene to discuss ways that ideas sketched out in the workshop could be tried and brought to scale. In Bangalore, some of the women activists could be brought into ongoing contact with young women trying to cast off the yoke of gender inequality. In Nepal, the project could focus on generating dinner parties using the artwork created. In Venezuela, a permanent puppetry program for under-served youth might be established across neighborhoods whatever their politics. Each of these steps would need to continue a collaborative rather than top-down approach.

The State Department Bureau of Educational and Cultural Affairs and the National Endowment for the Arts could be in conversation about principles underlying US cultural policy at home and abroad. The arts and cultural sector provide a rich opportunity to extend understanding of democracy by embodying those principles in projects. This in no way restricts content or form, but rather suggests that democratic principles can be expressed in politics, economics, *and* culture. Results of smARTpower and transdisciplinary efforts like the NEA undertook with HUD ought to be more widely shared. Why have the US invest in new areas and not examine the results?

But in fact, smARTpower was discontinued after one year. Was it the difficulty of explaining the use of tax dollars for US artists and people of other nationalities during a national budget crunch? Did the program

not garner enough press? Was that because it was not celebrity driven? Was largely qualitative rather than quantitative assessment of the programs not sufficiently convincing? SmARTpower engaged artists, students, teachers, architects, the young, the elderly, the impoverished, those living in temporary shelters, marginalized women, villagers, urbanites, Muslims, Christians, Hindus, Buddhists, people living with HIV, former sex workers, orphans, and people encountered by chance in markets and other public places. They participated in collaborative art projects, instigated by US artists with the robust participation of the largely artistic staffs of their host cultural organizations. The projects dealt with issues including gender inequality, climate change, recycling, the natural environment, respect and exchange between nations and communities, corruption, critical thinking, and recent developments in art itself. For most people engaged country by country, smARTpower was their first actual contact with an American, and the artists strived to be collaborative rather than imposing.

Although numbers of people involved during each artist's stay may have been fewer than attend most performance or exhibit-driven cultural diplomacy tours, the breadth of an initiative's influence ought to be measured not only in numbers of immediate spectators, but also by the effect of multipliers – local people partnering with US artists who continue or adapt what was most meaningful after the artist leaves, reaching more people over time. SmARTpower projects touched more than 2000 people, through direct participation in artist workshops, ongoing roles in projects, or spectatorship at artist events. Even if only half the projects continue in some form, at least as many people will be brought into projects emanating from smARTpower over the next year as have already participated, bringing the number of participants, conservatively, to 4000. Over time, this number will continue to grow because local artist, teacher, and student development will directly translate into continuation of smARTpower initiatives. By contrast, people who hear a concert or see a performance do not have the means to continue, because the public is construed as spectators, not participants or partners.

As cultural consultant Holly Sidford points out, arts grants usually focus on "building *institutions,* and preserving or creating *artistic objects* and products. We have paid far less attention to strengthening *people and communities* through *artistic processes*" (Sidford 2011, p. 27). This requires establishing partnerships with people within and beyond the art world, including the State Department, because those with knowledge and practices from diverse sectors are needed to solve the intractable

problems of our times. I'm left with a contradiction: on the one hand, the collaborations central to smARTpower provided a more equal playing field between the US and other countries, and a chance to experience the value of participatory democracy. Many of the projects downplayed national boundaries in favor of human partnerships. SmARTpower epitomized and exceeded a respected model of cultural diplomacy – drawing on monologue, dialogue, and collaboration, and extending to catalysis. On the other hand, the US State Department did not function like a partner. It seemed to want people to experience America as the strongest and best country, from which all others needed to learn. It seemed to prefer that *US* assets be highlighted, rather than the fruits of the cross-national collaborations. Its bottom line may be funding artistic and cultural events whose outcomes directly benefit the US, rather than those that equally serve the host country. Until these contradictions are resolved, cultural diplomacy will not reach its full potential.

Q and A with Penny M. Von Eschen

Jan Cohen-Cruz: Penny, what do you think of the smARTpower model?

Penny M. Von Eschen: The premise is superb: respecting collaboration. I like the fact that the artists were hosted by local organizations and NGOs rather than the US embassies, suggesting a genuine collaboration instead of a US-imposed agenda. This more people-to-people idea departs interestingly from the jazz tours, which were through the embassies. In the jazz tours the musicians claimed the space of collaboration, sometimes to the delight and sometimes to the dismay of the State Department and local embassies. The smARTpower model seems more along the line of the Goethe Institut, allowing for an open-ended relationship without a specific political agenda. Its goal appears to be to open up into civil society, for lack of a better term.

There's a fundamental strength in government support for the arts and in a program that seems to be generally democratizing the arts in terms of opening up funding; not only going through very established institutions and gatekeepers.

JCC: What's your critique of the model?

PVE: I don't like the name. I cringe at the term "smARTpower," still asserting US power and by default US superiority; it's a terrible word. And it's baffling. It's announcing that one is using art to promote US interests in a way that is counter to its program of collaboration. Was the name intended to placate conservatives in order to get funding? Of course, one could see the name as deeply compatible with the overall approach of the Obama administration and, in particular, Secretary of State Hillary Clinton. And then there is the question, that although smARTpower was hosted by NGOs instead of embassies, who's funding the NGOs?

JCC: So little was explained to those of us carrying out the project. We were told that Hillary Clinton had come up with the term to distinguish it from hard power, meaning military, and soft power, referring to other forms of diplomacy. The Bronx Museum did not propose the name smARTpower for the project.

But please say more about how smARTpower compares with the jazz ambassadors as cultural diplomacy.

PVE: Given the immediate government objectives of the jazz ambassadors, *they* should have been called smARTpower. The thinking of the State Department and the government more broadly then was very much about propaganda, demonstrating the superiority of American art, believing it reflected a democratic society/political system. And they deliberately brought the tours to political hot spots of US intervention and CIA coups. Over time, influenced by the actions of the musicians, many in the State Department and United States Information Agency began to recognize that the didactic messages were irrelevant or not working. What engaged audiences was very open-ended collaboration – that's what mattered to the US artists, too, like the jam sessions they did after scheduled performances.

Very pragmatically, US cultural diplomacy shifted in that direction. SmARTpower embodies some of the best lessons. US artists took the State Department ideas more loosely. They felt they had as much to learn from the people they met in other countries. Over time what the musicians actually did changed the program. But it was complicated. Earlier State Department artistic programs were addressed to global elites. As criticism of US foreign policy escalated, not only about their role in the Vietnam War, but in Africa and Latin America, the government shifted its target to younger, less-elite audiences.

I see the same contradictions in both programs: what actually happened was genuine interaction, unscripted, real back and forth, genuine transformation, making art together. But even going in with the intention of more interaction, given the very pronounced US political and military agendas, to think that these interactions could rise above or mitigate all that is pretty crazy. At the same time, the government is very complicated, encompassing big political differences. Creative people who want a more open society with real interactions always have to defend what they are doing against military types with no patience for anything else. In 1956, conservatives and segregationists found funding Dizzy Gillespie outrageous. Then-Secretary of State Hillary Clinton may embody the negotiation of these elements in one

person. As a strong proponent of the assertion of US power who also has a genuine concern for support of the arts, Clinton and other supporters of these programs are trying to get the legislature to fund these programs. The cycle has been like this for decades. These programs are always under attack by the conservatives. You can take Hillary's most stark self-serving statements of US interests and even with those – she'd have to speak to people who don't want to support education, fix the roads, or support the arts. So it's political strategy. It has to be in terms of congress and funding and towards the rest of the world; we can't expect that to be pure.

JCC: Given that smARTpower artists were not meant to simply show their work but rather to interact with people in the various countries, how much ought they to have known about the cultural context of the part of the world where they were intervening? In most cases, it was not very much.

PVE: That is problematic. In many cases the US has thrown up roadblocks to democracy and now here are these Americans telling people what to do. In India say – talking about the project about women's empowerment – it seems anyone engaging those issues should have a knowledge of the deep history of Indian feminism and women's activism as well as a sense of US–Indian and Pakistani relations. Moreover, in terms of real artistic engagement, with no strings attached, and as a part of civil society, the government gives with one hand and takes away with the other. It's worse than that in some sense; there's a long history of US hostility to India's non-alignment and US military support of Pakistan and most recently Pakistan has been tragically dragged into the war in Afghanistan. In Western discussions of Malala Yousafzai, the young woman from the Pashtun area bordering Pakistan and Afghanistan who was shot by the Taliban because of her support of women's education, there was scant recognition of the region's history of women's heroism and activism, or the fact that the region had been a stronghold of Gandhian nonviolent resistance against the British. You can't forget that history, and the US's fundamental part in destabilizing the region through the current war and the long support of Pakistani dictators makes me squirm. So for any US artist, NGO, or government official to engage in the region, towards women's empowerment, without regard for this history is hypocritical. At the same time, clearly there are people on all sides of these exchanges who passionately welcome the opportunities for artistic engagement. This is the positive part. With

all this history, where does one go from here? The no-strings-attached support of artistic collaboration and intellectuals like the Goethe Institut may be the best model.

JCC: I hear you but, in fact, the artists were not sent to solve the various problems as experts but rather to share artistic approaches to addressing them. For example, the director at the Indian NGO that hosted the US artist was very interested in her approach of gathering lesser-known local histories to tell the story of a place. He is a historian and got very excited about aligning that interest with his role as director of an art space. He had not considered how he could stretch out into the city; he'd only been doing projects in his space. He was given the choice of several artists, but perhaps he and the cultural hosts in all the countries should have chosen the finalists from a large pool of semi-finalists.

PVE: Yes, the cultural organizations should have had more choice and agency and people have to start somewhere. An artistic collaboration doesn't necessarily have to entail a long commitment. And there may be an opportunity to reconnect later. Some jazz ambassadors developed long-term, lifelong relationships with people they jammed with but others only played together once, and that was fine, too. But even the briefest engagements need sensitivity to history and power relations.

JCC: I appreciate your point. What was your involvement with the photo exhibit of the jazz tours some years later?

PVE: I worked with wonderful artistic directors at Meridian International. Their expertise in putting together exhibits and their exuberant energy in tracking down photos not only retraced but also re-energized a jazz community connected to the tours. The project took on more dimensions than Curtis Sandberg, the Artistic Director at Meridian, or I could have ever imagined. The exhibit opened in April of 2008. Later, in the early Obama administration, the State Department bought six partial sets of the photos, one for each region, and they were shown extensively through the State Department as well as in US venues. I confess that I was very relieved that the exhibit traveled for the State Department during the Obama administration and not under Bush or McCain. And photos from the jazz ambassadors were exhibited in the Capitol rotunda just before Obama's inauguration. A classic tale – Oren Hatch loved Louis Armstrong and jazz so it got a major Republican sponsor. I have no illusion that the photos were presented in reflective rather than purely celebratory ways. I am not happy that in these contexts it's

a story contextualized by "Oh, how great the US is," but for me, I don't own the story of these tours. I am grateful that I got to tell my version of the story and facilitate others' engagement and telling of it. Yet in retrospect, my own experiences were discouraging. As a non-partisan and, critically, DC-based organization, Meridian is obliged to offend nobody. We struggled over the exhibit copy and I felt it was pushed towards a happier version of the tours than is warranted.

Through this, I felt acutely how under-funded the arts are and how many strings are attached to any support; what does that mean? Partnerships with the private sector were always a part of the earlier State Department cultural programs, but with even less government funding for the arts today, the private sector is dominant in these partnerships. Such partnerships provide more money but set disturbing limits in terms of what can be said and seen. And some of the people who control private funds, like Wynton Marsalis at Lincoln Center, have too much control. He's a great musician but, I think, too much of a gatekeeper. I share the disappointment of many over what Lincoln Center has become. When the Jazz Tour exhibit appeared there, the copy that accompanied the exhibit was watered-down, even happier than the problematic version of the exhibit. The people there wanted to place a Cadillac directly in front of the photos because they had Ford sponsorship. Fortunately, Robert O'Mealy and Diedre Harris-Kelley, the artistic advisors for the show, won that battle. But the corporate control over content and presentation is just heartbreaking. Is this any different than the control exerted by board members of any nonprofit group like a school? Perhaps not. But it's an incredible constraint on artistic and intellectual freedom. That's why government-supported programs are so important, especially if we can move away from this notion that they have to be serving US interests.

JCC: What do you think a project like smARTpower can reasonably accomplish?

PVE: Nothing unless there's a shift in foreign policy. If foreign policies don't involve genuine listening and dialogue but rather are about imposing an agenda, a smart power cultural program can't change that. Even if it's genuine. Then it's just a tiny nice part of a broader distrustful policy. Then it is a smarter way to impose power – again, that word utterly undermines the ethos of the initiative. Are you genuinely listening, do you want to understand the dilemmas of what people are coping with in another country? And consider changing based on needs of other people in the world?

JCC: Is it worth the money? According to what criteria?

PVE: The problem with US diplomacy is there's so little of it; instead policymakers have resorted too quickly and easily to force. It's always better to have more funding for people interested in listening and negotiations, and cultural programs should be a critical part of that – culture in every sense from all artistic forms to engagements with diversity of interests and worldviews.

JCC: How are cultural diplomacy projects generally assessed?

PVE: Because many conservatives did not want to fund cultural programs, the State Department was always trying to justify the jazz tours in terms of numbers and were very happy when attendance was high, disappointed when lower. There's no indication that the earlier programs were measured only by number of audience members. They would try to count heads of state who showed up at events, and whether they were pleased, or anything had gone wrong, was an important part of how they measured success. State Department personnel put a lot of energy into translating press coverage to ascertain if it positioned the US in a positive light.

JCC: In what I saw, local state department attachés were often the weakest link. Few of them took the opportunity that smARTpower provided to strengthen relationships with local people.

PVE: Did you ever find out why they didn't renew after one year?

JCC: No. The State Department's American Arts Incubator program sounds like a follow-up of smARTpower; its website notes that it sends "artists abroad to collaborate with youth and underserved populations on community-based new media and mural art projects that bolster local economies, influence public policy, and further social innovation." SmARTpower project manager Elizabeth Grady told me that a mural initiative featured smARTpower artist Chris "Daze" Ellis's mural in Quito on its website (http://exchanges.state.gov/us/program/community-engagement-through-arts); and the American Arts Incubator (http://exchanges.state.gov/us/program/american-arts-incubator) foregrounded an image of another smARTpower artist, Art Jones, who was in Karachi.

There was some follow-up individually. For example in September 2014, Mary Mattingly heard from her smARTpower Filipino host, Norberto "PeeWee" Roldan at Green Papaya, that they had received funding from the Japan Foundation to take the wearable, portable

architecture workshops to the next level, into an actual site. Their partner is Design for Villages (D4V), a mobile design laboratory meant to address rehabilitation efforts in remote villages ravaged by typhoons. Mattingly was invited to participate. But smARTpower itself was not continued. I was never told why.

PVE: Frustrating. How can you evaluate if you don't know what one of the stakeholders thinks? I would imagine a very similar conservative backlash to what we can observe in the 50s and 60s with Gillespie. If there isn't buy-in from critical players this obviously presents a major problem on top of the fact that the State Department is getting constant criticism from doing this at all. So these programs are getting bashed from liberal and conservative planks.

JCC: Indeed. What was best about the jazz ambassadors?

PVE: Despite some of the official ideologies, the tours allowed musicians to create real spaces of artistic freedom, although the tours weren't set up for US musicians to interact with the musicians they met on tour. The jazz ambassadors were very generationally specific. Most saw the tours in the context of civil rights and black empowerment, a way to bring black culture to the world. Recognition as great artists was a victory after what they had struggled with in the US, not getting grants, growing up in poverty, negotiating the worst constraints of Jim Crow, internationally acclaimed musicians forced to go through back doors when back in the United States. That's an amazing generational experience: to go from that kind of constraint to that kind of mobility and cultural power. Not that they were given that; they claimed it in ways that the US hadn't imagined, like Clark Terry insisting on doing performances for hotel workers. Bringing their experience of Jim Crow segregation, they weren't going to play for wealthy people some place where the people they identified with couldn't get in. A lot of the State Department people who took the musicians around loved them but were driven crazy because the jazz musicians weren't following the script.

As for the impact of the tours, there was no single causal factor but it was a catalyst for a more international scene. I don't agree that jazz "won the Cold War" but there is a different dynamic with the Eastern bloc where jazz especially appealed to political dissidents. Whereas in the colonized world, where the US was intervening, in the Congo and elsewhere in Africa and Latin America, these tours did not win anyone over to American foreign policy. The way they traveled so closely the route of the coups, courting the neocolonial elite, is striking. So if there

was a messy situation in Iraq, send jazz ambassadors, or after Lumumba was killed, send them to the Congo, as a distraction. We need to keep pro-Americans on our side, do that by any means possible.

The idea that jazz was that important in the collapse of the Soviet Union and Eastern bloc is deeply exaggerated. Most Americans easily forget: Gorbachev and the reform movements throughout Eastern Europe wanted to reform the economy and open the political system to reform socialism, not switch over to capitalism. I think the energy of the jazz tours in the 1960s and 1970s was much more a part of the global rebellion against authoritarian structures in the West as well as the East. Young people in particular were discontent with all those top-down societies including the US and Soviet Union. At that moment, jazz was a great part of the energy.

JCC: What's different about this moment and the possibilities of cultural diplomacy now?

PVE: The possibilities for cultural diplomacy are completely tied to the possibilities for democracy, and, right now, the US is even less demo-cratic politically, has more economic inequality, and is more militarized than in the period of the jazz tours. Things are bleak. No matter how flawed this country is – and currently, I don't think we can possibly make the case that we are a democracy – an accountable government is the only chance we have against completely untrammeled capitalism and more and more deregulation and militarization.

Government funding for cultural diplomacy is so minuscule com-pared with the enormous, destructive military budget. Support for the arts should be the heart of how we regard our own culture as well as people around the world – embracing creativity in the arts as a fundamental part of foreign relations. Even in the worst moments of constraints on the arts, there have been moments when great projects have broken through, just as great democratic movements have broken through horrific circumstances.

JCC: Thanks, Penny.

Coda: The Future of Performance with Uncommon Partners

> "Aesthetic" understood as the opposite of "anaesthetic"
> or numbness has to do with enlivened being and
> connective practice.
> – Shelley Sacks (Social Sculpture Research Unit 2011)

August 2014. I'm at ROOTS Week, the annual gathering of Alternate ROOTS, an organization committed to social and economic justice that "supports the creation and presentation of original art that is rooted in community, place, tradition or spirit" (Alternate ROOTS n.d.). It is being held at the Lutheridge Conference Center in Arden, North Carolina, the same place as the Community Arts Network gathering, ten years ago, with which I began this book. The major finding then was a proliferation of artists inserting their work into a larger picture, defined not by art – such as educational theater or drama therapy – but by a social concern, such as disappearing wetlands or growing poverty. Strikingly, one of ROOTS' signature programs, Partners in Action, reflects the same emphasis on issue rather than art framing as CAN did in 2004.

ROOTS' 2014 Partners in Action grantees include the Global Village Project (GVP), with singer Elise Witt and a school for refugee girls in Decatur, Georgia. They are creating a chorus as a model for integrating the arts into English for Speakers of Other Languages education. In the face of the collapse of the Appalachian coal industry, the Southeast Kentucky Community and Technical College is offering academic credit to people participating in Appalshop's Youth Media Program, helping to make it possible for area residents to acquire a bachelor's degree without having to move away. In New Orleans, artist Jose Torres Tama is making visible what Latinos and Vietnamese have contributed since the

devastation of Hurricane Katrina (2005), by transforming a food truck into a mobile theater dispersing immigrant day laborers' stories. Clear Creek Festival organizers in Kentucky frame their art activities within issues of land, water, and food, locally and cross-regionally. They strive to support people bringing their lives in greater harmony with the land and with each another.

Note that these artists foreground the social context – language acquisition for refugee populations, rural residents seeking higher education, acceptance of new immigrants in New Orleans, and everyone vis-à-vis environmental degradation. Then they look for how art could contribute to concrete improvements regarding those issues. One might say that the direction that CAN saw activist art moving ten years ago is alive and thriving.

But while a growing phenomenon, uncommon partnerships are not in the mainstream. At an Imagining America seminar on "Documentation, Archiving, and Communication" focused on art and culture committed to community contexts and social and economic justice, presenters noted that

> Artists and activists have been working in American society for generations with a goal of realizing the dream of justice for all. Yet much of the work, for all its accomplishments, has remained largely a local phenomenon, with occasional bursts of broader recognition. It has generally been marginalized and unrecognized within the arts, where it is usually assigned to the realms of the experimental or, worse, the province of deviant forms that depart from standards and criteria of art-making; and in the broader society, where all the arts are marginalized as pleasant but non-essential diversions for the so-called leisure class, at best, and suspect for potential disruption of the status quo, far more often. (Leonard et al. 2014)

What follows are seven ways to increase recognition, sustainability, and growth of art integrated into social contexts. They are: inclusion of ways to address social issues in artists' education; systemic appreciation of artists and scholars in each other's professional cultures; writers who both sharpen discourse among artists and disseminate cross-sector practices to a larger public; assessment aligned with joint aesthetic and social goals where applicable; funders who support integrated aesthetic/social initiatives; networks more deliberate about organizing; and artists embedded long term in various ecosystems. I now elaborate on each.

Inclusion of social purposes in artists' education

Students need to be made aware of the largeness of art, including collaborations with partners in social contexts. I am not suggesting that all training makes such partnerships their focus but rather that they acknowledge that the real map of art activity is larger than the mental map most people carry around that is most frequently taught in art programs.

Education for performance integrated across sectors could include different ways that fields come together. The template in the "Partnering" chapter is relevant here. At the level of higher education, a multi-disciplinary approach might mean juxtaposing a set of courses from performance, like devising and improvisation, with a set of courses from other sectors, like community development or public health, keeping each intact, and letting the students and the professors make connections. An interdisciplinary approach could entail constructing cross-sector curricula with professors from, say, gerontology or criminal justice in conversation with instructors of performance so as to maximize how the fields combine within joint courses. Taking a transdisciplinary approach, students could focus on particular social issues, drawing from a full spectrum of theater techniques – movement-driven, text-based, improvisational, solo, musical, collective creation, and workshop-facilitation – and knowledge from other fields in a wide range of settings including schools, community-based organizations, the justice system, healthcare, the political arena, museums, and social service agencies. As a project unfolded, the students would learn to cull expertise from any relevant field.

Students could also explore key ideas regarding art in social contexts, such as theories of change, and acquire the skills, such as participatory action research methods, needed to create and implement such work. Students would learn about initiating partnerships, making productions, facilitating workshops, and collaborating on social issues across sectors. A sense of history could be instilled, not encyclopedic but rather analysis of circumstances that led to particular practices and appreciation of standing on the shoulders of others. Such a program of study would expand how theater is conventionally made and for what purposes, opening up new forms and unexpected collaborations. Meeting artists with hybrid careers would be an important component of such an education.

Also invaluable is recognizing how much every culture brings to performance. Mainstream US acting training tends to remove vocal regionalisms

and corporal particularities so the actor is available to play any role. Some training, such as the method acting of Lee Strasberg, nurtures the actor's own sense memories, which Strasberg believed could be used to provide depth and emotional connection to any character. But Strasberg's system is specific to an individual's past, not to cultural roots.

Cristal Truscott, artistic director of Progress Theatre and chair of the Drama Department at Prairie View College in Texas, explains that while every culture that has ever created art has its methods, not all methods are viewed with equal respect. We have a worldwide archive of technique – why have one approach, one standard? She describes her approach to actor training, called Soulwork: Emotional Availability, as a "philosophy, acting and performance-building method ... developed from the aesthetics and techniques of African American performance traditions in dialogue with various techniques from throughout the African Diaspora" (Progress Theatre n.d.).

Having studied Meisner technique at an arts high school and multiple approaches at NYU Drama Department, Truscott recognizes that different acting methods provide different entry points to living in the moment. At NYU's Experimental Theatre Workshop, Truscott noted, for example, the entry point is the body. In an African American aesthetic approach, Truscott sees the voice as central: "In traditional African American singing, you know how the song goes but you get there your own way. You embellish. Improvise. You have freedom to explore" (Truscott 2014). Truscott avows that everyone steeped in black culture sings: "Rappers sing even if they can't; they speak into singing, because the emotion of the moment calls for it. It's part of black culture, because of church, story traditions, and the call and response tradition of slavery and Negro spirituals." Also central to African American aesthetics is a relationship to emotional urgency and availability. Truscott emphasizes,

> African American experience is always about trying to attain something for a large purpose, for the individual and the group. Why are you doing the work you are doing? What do you have to contribute so the collective goal can be achieved, not just your performance? (Truscott 2014)

Another fruitful direction in training for uncommon partnerships is setting up cross-sector institutes outside of higher education. Such is the case with the Community Arts Training (CAT) program, founded in 1997 in St. Louis, co-developed by Bill Cleveland and grounded in

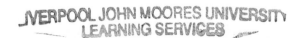

a robust network of artists and social service partners doing strong, sustained, and integrated work:

> The CAT Institute is ... centered on the belief that art has the power to be an agent for social change: as the oldest sustained training of its kind in the country, the Community Arts Training Institute has provided a rigorous multiple-month curriculum to prepare artists of all disciplines and their community partners to collaborate in creating and sustaining significant arts programs primarily in under-resourced community settings, such as neighborhood organizations, social service agencies, development initiatives and education programs. (CAT Institute n.d.)

CAT's community base significantly extends the training's reach.

In the Red Hook neighborhood of Brooklyn, the nonprofit organization Dance Theatre Etcetera (DTE) offers media training for teens and young adults of modest resources. Conceived as both an in-school elective and a summer job training internship, the program includes computer literacy, video production, Photoshop, soft business skills, and an introduction to entrepreneurship, connecting the young people to the local business community, developing their media skills, and introducing basic business planning. The youth meet with people who have successfully started and sustained their own businesses, including restauranteurs, fashion designers, event planners, DJs, tee-shirt designers, and small-business owners.

In DTE's participating high schools, students work as teams to identify a business they would be interested in creating and draft a business plan informed by representatives from the Small Business Development Center at New York City College of Technology. As a final project, students shoot and edit a three-minute video that pitches their business. After the class, the school's Learning to Work program seeks internships for the youth in their area of interest to further potential pathways to employment. The summer program sends participants in teams to create videos for neighborhood businesses and organizations. For example, one team made an educational video about the neighborhood's Community Disaster Plan, developed after Hurricane Sandy flooded the entire area in 2012. The videos are posted to a free neighborhood WiFi network and on relevant websites (Bowers 2014b).

Whatever the context, providers of education about cross-sector uses of art need supportive colleagues, including those who teach other kinds of art and in very different ways. Socially engaged practice has to be

seen as a viable way to be an artist in the world, or students inadvertently get the message that they have failed if they go this route.

Systemic appreciation of artists and scholars in each other's professional cultures

Cross-sector art sometimes finds itself betwixt and between: not taken seriously by scholarly culture for its grounding in practice and collaboration, and not embraced by the traditional art world for going beyond aesthetics and prioritizing its application to something else. That is, the academic world tends to privilege individual over collective intellectual expression. Nor is practice always recognized as a dynamic component of scholarship. And some artists are skeptical of art that has a pre-defined end point, that is, that exists to serve a concrete goal.

Both art world and scholarly cultures can feel like gated communities, each off-putting to people used to the other. Traditional scholarship, presented at conferences or written down, can be cumbersome, requiring careful citing of other work in the field. While important to acknowledge one's sources, it ought not to be assumed that everyone absorbs data in the same way. The language and format that scholars use may alienate artists, although artists often brought the practices that the language refers to into being.

Ernest Boyer, in *Scholarship Reconsidered* (1990), challenged higher education to acknowledge more than narrowly defined research as the only legitimate path to further knowledge. Boyer articulated four interrelated dimensions of scholarship: discovery, integration, application, and teaching. The scholarship of application is one of the rich avenues for artists and scholars to explore together, examining how important ideas can be experienced in performance activities. Boyer's insights suggest that, just as theater is more than plays and visual art more than objects, scholarship is more than books and articles. Scholarship is equally about relationships, dialogue that generates new thinking, the bringing together of hitherto separate ideas for new insights, and what is generated in the classroom.

Boyer's recognition of different forms of scholarship has ramifications on the different ways that performance does its work, which is not only by virtue of its content. Kenyan writer Ngũgĩ wa Thiong'o, for example, observed that in postcolonial Africa, the censorship of his plays was aimed less at his text than at how he wanted the plays produced, which was in spaces well more accessible than theater buildings. He encountered an insistence on maintaining colonial production protocols: "The struggle

may take the form of the state's intervention in the content of the artist's work – what goes on by the name of censorship – but the main arena of struggle is the performance space: its definition, delimitation and regulation" (Ngũgĩ wa Thiong'o 1998). This, in turn, parallels recognition that much scholarly protocol is more about gatekeeping than about "standards of excellence."

Some artists disregard the value of critical thinking around performance, as if conversation taints direct experience and inhibits intuition. Roadside Theater director Cocke emphasizes the benefit of theater that plays an intellectual as well as an artistic role:

> In a lot of countries there's an understanding that art has to have an intellectual core. That there are scholars whose responsibility is to think about these things. They are part of the field, not separate. They sharpen conversations, encourage debate, because of who they are and what they are used to doing. These aren't some tired panel situations. What they bring is not considered secondary, like "Let's get rid of these conversations and get back to the arts." Dialogue and reflection are as important to this kind of art as other elements we take for granted in theater like conflict, character, and setting. The art would be much weaker without these discussions. (2014b)

Especially worth exploring are formats that support artist and scholar collaboration, or that juxtapose the contribution of each. A case in point is the series of conversations that Andy Horwitz has curated for the Public Theater's annual Under the Radar Festival, "a 12-day intensive dialogue about the times we live in, seen through the lens of the world's most innovative theater creators. Embedded in the Festival is a professional symposium that focuses on the global issues of contemporary theater" (Under the Radar n.d.). Presenting plays and conversations about the issues that they reflect during the same 14-day period is a fruitful way to demonstrate the value of and interplay between the two forms of communication.

The role of writers

A robust critical discourse can bring lesser-known roles of the arts to public attention and deepen and sustain ongoing conversations. Such writing identifies local manifestations of a movement, highlights overarching themes, raises questions, and expands who has authority and expertise, through practices such as participants learning to write

critically about their own work. A challenge for critical writing about cross-sector uses of performance is that being less known often leads to being disregarded. So a primary role of writers is to make such work visible and knowledgeably to unpack its significance.

Scholar and puppeteer John Bell insightfully captures the need for writers within this larger frame for art in a reflection on an article about playwright Cynthia Hopkins' "This Clement World." Bell points to the question that *New York Times* critic Jason Zinoman asks – "Where is the great American play about climate change?" – and Zinoman's avowal that "New York theater has mostly avoided" the subject. Zinoman states, "No drama exploring what many believe is the fundamental challenge of our time has made a significant impression." Bell responds:

> a certain solipsism on the part of the *New York Times* (the focus on "plays" and "drama" as the equivalent of theater, and the equation of "New York theater" with the total output of American performance culture) prevents it from seeing the full range of American theater, so that Hopkins' no doubt interesting production ... appears to Zinoman as the first instance of theater about climate and the environment, instead of an addition to a theatrical dialogue that has been ongoing for quite a while. (Bell 2013)

Bell then provides a number of examples of environmentally focused works that the company of which he has long been a part, Bread and Puppet, based in Vermont, has mounted over its 50-year history, in the US and abroad.

A short time after reading Bell's post, I saw *Cry You One*, set in a wetlands near New Orleans badly damaged by climate change. The project also includes a website featuring interviews with people impacted by and working on issues around climate change in the Gulf region who informed the production. Director Kathy Randels of ArtSpot Productions, Nick Slie from Mondo Bizarro, and their collaborators continue to think about how best to situate the work as part of the conversation about policy change regarding detrimental environmental decisions in their area, yet another example of vivid environmental performance. Neither the long history of Bread and Puppet nor the timeliness of *Cry You One* seem to be on the radar of the *New York Times* critic. What is the odd combination of worldliness and solipsism that characterizes the New York art scene? How is it that people very perceptive on the one hand are creatures of habit on the other, circumscribed within a context which though a magnet to a great range of art-making, is not in fact the whole world?

On the other hand, perhaps rather than ask why a particular platform omits cross-sector art, a more fruitful question may be, who needs to know about this work, and how do we reach them? Blogs? Community newspapers? *The New York Times* is not the be-all and end-all for communicating about all art, although it is certainly a steppingstone to significant resources such as funding.

Equally important is the language and form that writers use to reach the desired audience. This can involve experimentation; for example, one form that has proven congenial for serious topics intended for broad audiences is speculative fiction. The term has been in use at least since 1941, and is attributed to science-fiction writer Robert Heinlein. There are various ways of describing the practice. Editor Andy McCann calls speculative fiction "preparation for all futures. One of the purposes of science fiction ... is to extrapolate from today and try to anticipate where we all will be one day, both as people and as societies" (Lilly 2002). Cultural critic Arlene Goldbard orients readers to a desired future in which all the arts are fully a part of everyday life in *The Wave,* her 2013 work of speculative fiction. Part futuristic and part art theory, her creative writing to imagine such uses of art is itself an example of cross-sector art.

In the same spirit, Goldbard, in collaboration with Adam Horowitz, created a speculative *performance,* publicly launching their invented US Department of Art and Culture (USDAC). In a piece about the project written as a 2014 press release to announce USDAC's dissolution, the authors contended that the department could close because "it so successfully integrated arts and culture into United States government departments of education, defense, health and human services, labor, justice, state, and the treasury" (Edell et al. 2014). In the meantime, USDAC "cultural agents" host "Imaginings" in their home communities across the country, integrating the arts in cross-sector gatherings, identifying a range of local concerns, and initiating ongoing arts-infused projects in response (USDAC n.d.). The goal is to manifest how the arts and culture really could be fully integrated in public life in a relatively short time.

Also crucial is how writing is disseminated, which is a determinant of who will have access to it. The Internet, of course, opens up possibilities. Roadside Theater's 2014 web redesign (http://roadside.org) seeks to make coherent and accessible that portion of their 37-year history that has been devoted to practices besides making productions, including collaborating on efforts to address social challenges. Director Dudley Cocke explains:

> The web platform's purpose is to spread knowledge about the important role of art in a democracy. As we know, democracy is founded

on the principle of the many, not the few. When and why did art take a vertical/hierarchical turn toward reflecting the culture of only the few? When art is horizontal/democratic, doesn't it naturally run through all aspects of community life – and become a part of a person's daily experience? (Cocke 2014a)

But given the amount of information on the Internet, who will find their way to Roadside's website or any other rich web source, and how? Aligning face-to-face experiences with web communication helps. A communication strategy ought not to end in social media but also develop pathways whereby a range of people, including artists and scholars, can further the discourse in person. At the same time, for many people online communities are the only way of connecting around particular topics.

On a basic level, written and other forms of documentation are a way of naming something. Sometimes not until a practice that many people have been doing individually is named do people see that they are part of something larger. For example, I know a voice teacher who had a developmentally challenged child who derived a great deal of pleasure from theater games. The woman created a workshop for her daughter and a group of other young people in similar circumstances, informed by her understanding of both their condition and of theater. Her daughter died young, but the woman has continued facilitating the workshop for the many years since. A colleague made a film about it, which led to the woman's realization that this was actually a field of theater; there were others who did this for their professional lives and the joy and growth characteristic of participants in her workshop in fact were widespread in similar groups. She was astounded to learn that this thing she'd been doing on the side, notwithstanding its meaningfulness to her, her student assistants, and to the other participants, was actually part of theater. It was a significant, integrative moment in her life, and an opportunity to contribute what she had learned to the understanding and quality of life of the developmentally challenged and to her theater students. It has led to finding like-minded colleagues and participating in national and international conferences on the subject.

I experienced the joy of finding the language to reach someone I'd have thought I couldn't one day as I was doing some errands. It was 9 a.m., so imagine my surprise when the young woman helping me asked how my day had been so far. I told her it was off to a good start; I was working on a book and had had a good flow. She asked me what it was about. I took the deep breath I always do when asked this question – why is

something so basic as this so difficult to explain?– and said it was about performance and uncommon partners and gave an example or two. To my surprise and relief, her face lit up. Oh yes, she said; these artists nowadays who aren't just about their own fame and fortune but something that's good for lots of people. Yes, I said. That's it. Given how highly valued access is in such work, it was affirming that a total stranger could quickly appreciate it.

Assessment

Impact of any art is notoriously challenging to measure. While efficacy is a coin of the cross-sector art realm, the changes that performance processes help bring about are often qualitative, not quantitative. It's hard to assign numerical value to how much *Cry You One* contributed to effective actions to counter environmental devastation in the Gulf, or attribute to Sojourn Theatre what people that they re-enlivened in the Catholic Charities anti-poverty network went on to accomplish. Given that funders frequently seek numerical measures of value, one response is for project participants to self-select what quantitative data to include. Scholar Sonja Kuftinec gives the example of Irrigate, a Minneapolis-based arts advocacy network, which has determined that since they have to be assessed quantitatively, they want to have a say in what to measure. They decided to use media mentions – something that can be counted that *they* value (Kuftinec 2014). Artists can thus use numbers to support their own narrative about the work's value, articulating why numbers are or are not important in specific cases rather than leaving them out entirely. At the same time, as Maria Rosario Jackson pointed out in the companion piece following Chapter 4, art's qualitative contributions can be more fully described, such as Roberto Bedoya (2013) did around the notion of belonging.

Related to measuring art's efficacy is the time it takes to carry out social goals. Performance is often attributed with catalyzing only temporary change: while in the midst of a project people might interact across race, class, and other differences, the status quo often reasserts itself when the project ends. This does not prove that performance is inconsequential but rather that it needs to be ongoing. That is, conflict doesn't go away but can be lessened through regular connective experiences, so means to overcome conflict must not go away either. What's needed is long-term sustainability, which is not always in the artists' hands; witness smARTpower, an alternative model of cultural diplomacy which was discontinued after a mere one year.

Some artists have come to the conclusion that in order to be efficacious, they must live and work one place for an extended length of time, meaning years and even decades. This points to a need for culture change: rather than art as a pleasurable add-on experience for those so inclined, art as an ever-present asset that responds to inevitable problems (and pleasures) as they arise. For culture change is a very slow process. But look at the alternative. Facilitators instigating promising methods, who come and go at the whim of a funder, cannot interact with the residents of a place long enough to build creative capacity. And when artists leave, what do they leave behind, and to whom? How do they catalyze artistic capacities within that community? What skill sets are most critical? How are cultural leaders in communities without independent artistic communities identified and nurtured? Where is support to develop training methods to pass on? This is not to discount artists who sensitively carry out short-term projects, accomplishing their goals through breadth rather than depth. But it is to understand the needs of cross-sector art.

Aesthetics, also part of assessment, is often misunderstood in socially engaged work. Rather than a universal ideal of "truth and beauty," such art must be meaningful to its audience/community. As Linda Parris-Bailey, director of the African American Carpetbag Theater, said, "We received aesthetics as the hammer of European culture beating down other cultures. So coming up with our own sense of aesthetics was both responsive and proactive; we had to self define" (Parris-Bailey 2014). As in cultural anthropology, meaningfulness to a group often includes adherence to tradition, not innovation, which while a prized aesthetic characteristic of much Western art, is not always relevant in engaged art.

Another assessment assumption to challenge is that to critique and offer fresh perspectives on a subject, artists need to stay at a distance. The idea that artists can also be embedded in social contexts and intimate with participants merits equal consideration. Also in need of questioning is from whose perspective is art embedded in social contexts evaluated. Some funders are only interested in art's potential contribution to a community's economic development, by identifying stimulating places to live and work that may in turn attract largely people of means. Identifying the goals of all the stakeholders, which may vary greatly from group to group, is the sine qua non against which to assess what took place.

A significant component of art's usefulness is its fit in a particular time and place. Imagining America's Assessing the Practices of Public Scholarship (APPS) working group foregrounded Doug Reeler's

"A Three-Fold Theory of Social Change" (2007) at its 2014 conference. This approach includes analysis of social conditions in considering what kind of intervention, including artistic, might be most efficacious. Reeler sets up three models of change according to the social moment. The first model, emergent change, is aligned with "the day-to-day unfolding of life," relying on the "adaptive and uneven processes of unconscious and conscious learning from experience and the change that results" (Reeler 2007, p. 9). Such change relies on very in-the-moment interventions and is hard to plan. The second model, transformative change, focuses on "unlearning, of freeing the social being from those relationships and identities, inner and outer, which underpin the crisis and hold back resolution and further healthy development" (pp. 11–12). The third set of conditions lends itself to projectable change, possible when conditions are stable such that one "begins in the future, plans backwards to the present, devising stepping-stones to the desired results" (p. 13).

The APPS team also presented an evaluative framework developed by Chris Dwyer of RMC Research for Marty Pottenger's integration of the arts into Portland, Maine's Public Works, Health & Human Services, and Police departments. Dwyer's framework provides a method "to systematically define outcomes and indicators that provide evidence of concern to targeted stakeholders and opinion leaders," as described at animatingdemocracy.org/resource/evaluation-plan-art-work-terra-moto-and-city-portland-me (Assessing the Practices of Public Scholarship 2014). Significantly, Pottenger starts by asking partners in the social realm what they want to achieve, not about art *per se*.

Funders supporting art that plays a joint aesthetic and social role

In April 2014, New York City Mayor de Blasio appointed Tom Finkelpearl as Commissioner of the Department of Cultural Affairs. Finkelpearl came to the position after 12 years directing the Queens Museum, where in addition to continuing the traditional role of the museum as a receptacle of aesthetically interesting objects, he hired community organizers to professionalize neighborhood engagement efforts, created a satellite museum to make workshops accessible to a broader population, and furthered the institution's relationship to the diverse immigrant population surrounding it. The mayor and the new commissioner said that the administration would be taking a more populist approach to the arts. Finkelpearl further avowed to the press that he wanted to return a focus to the intrinsic social value of the arts.

Time will tell how Commissioner Finkelpearl translates this philosophy to grant-making and a public discourse about the arts, but his statements are heartening for numerous reasons. One, it aligns the mayor's cultural choices with his social agenda, described as wanting to end the narrative of New York City as a tale of two cities, the haves and have-nots. Two, Finkelpearl is not setting up an "either/or" proposition. The art he displayed at the Queens Museum and wrote about in his book about social practice, *What We Made*, is diverse, well crafted, and multiple in its meanings and strategies. No one has to feel they are losing by Finkelpearl's appointment. And three, government support has a way of spurring on the private sector, by acknowledging the importance of specific kinds of art initiatives. Please may that happen here.

In addition to city government aligning itself with art's social purposes, a number of private foundations not only support art in cross-sector contexts but also try to provide what artists need besides money to thrive across sectors. A Blade of Grass (ABoG), for example, strives to

nurture socially engaged art ... and provide resources to artists who demonstrate artistic excellence and serve as innovative conduits for social change. We evaluate the quality of work in this evolving field by fostering an inclusive, practical discourse about the aesthetics, function, ethics and meaning of socially engaged art that resonates within and outside the contemporary art dialogue. (A Blade of Grass n.d.)

As ABoG's director Deborah Fisher notes, private foundations like theirs have ways to support artists in addition to money. Who ought the artist to meet? Are there particular partners who might complement what they are doing or specific artists who have already solved certain logistical problems they are facing?

Numerous funders now actively partner on projects they fund as they explore broader horizons themselves. Alternate ROOTS, for example, considers itself a participant in, not just a funder of, Partners in Action. They introduce the new Partners projects at an annual meeting, so other attendees, not just ROOTS leadership, can offer advice. ROOTS also looks for other ways to be useful. In support of *Cry You One (CY1)*, for example, ROOTS both contributed $10,000 and organized an open rehearsal for attendees of the Free Southern Theater's 50th anniversary, which brought like-minded people from across the US to the show, and whose responses were generative for the artists. And, notes Nick Slie of the *CY1* team, ROOTS never took their support to mean that they would in any way make decisions about the piece. In the same spirit,

along with money from Rockefeller's MAP fund came access to consultant David Sheingold, who helped the *CY1* team make a more realistic budget, adding, for example, a contingency component. Slie avowed enthusiastically, "They don't want to just give money, they want to know what folks are thinking about the work. It's a big shift from how we've received funding in the past" (Slie 2014). This relationship suggests funder sensitivity to what makes art sustainable in addition to funding.

Bringing grantees together to discuss challenges and share findings furthers learning for funders as well as fundees. For example, artist Michael Rohd saw few models for exploring partnerships with theater artists and civic partners on a small scale. Through his Center for Performance and Civic Practice, he thus launched the Catalyst Initiative, providing funds for five teams of artists and community partners, working within a 60-hour project time frame, "to bring arts-based practice into collision with community activity in meaningful ways" (Rohd 2013c). "Catalyst" refers to the idea that these 60 hours are a jumping-off point for future work, partly to define shared goals and future opportunities and partly to see what can be accomplished in that amount of time. For example, the partnership between *Cry You One* and Gulf Future Coalition to create five all-day salons (described in Chapter 2) was one of the funded projects.

What I describe here is not the norm; it's still a struggle to fund cross-sector art. But private foundations are contagious with each other and with public funders. The Ford Foundation's support of the arts in the 1960s was a steppingstone to the creation of the NEA. As some foundations fund art with aesthetic and social goals, and in the spirit of partnership, others are likely to follow.

Networks and organizing

Scholars Stephen P. Borgatti and Daniel S. Halgin describe a network as "a set of actors or nodes ... that ... interconnect through shared endpoints to form paths that indirectly link nodes that are not directly tied" (Borgatti and Halgin n.d., p. 6). This aligning of who and what were not originally linked, but shared goals, is another way to build support for a practice. Borgatti and Halgin distinguish groups, which have set boundaries, from networks, which do not. Though one could name the members of a network at a given moment, those players are neither static nor only tied to each other. This distinction suggests how theater adherents find like-minded colleagues both within and outside

of the arts through participation in various networks. It is a way of recognizing our membership in multiple communities without downplaying a whole array of ties that bind us – both/and, not either/or. For example, as a member of both the Network of Ensemble Theaters (NET) and Theatre Communications Group (TCG) for regional institutions, Laurie McCants interacted with two sets of theater makers that initially overlapped very little. But over the years, partly because she and others were present in both networks and could communicate about each in the other, attention to the concerns of companies belonging to both has greatly increased, expanding perspectives and opening opportunities for all.

As a member of multiple networks himself, NET director Mark Valdez especially appreciates having related conversations from different points of view, rounding out how he looks at issues. "To talk about race, culture, diversity, or access at Alternate ROOTS or Theatre Communications Group are very different conversations but they inform one another," he avows. Then too, Valdez sometimes finds the multiplicity of networks frustrating:

> We're all having similar conversations but it's hard for organizations to connect them in intentional ways. It takes so much to do the work itself that then to try to align it, or amplify or include another partner, is really hard. It's incumbent on the individuals working between networks to do that work. And maybe that's okay. (Valdez 2014)

More deliberate aligning of such networks is an important direction to pursue.

Foundry Theatre director Melanie Joseph experienced the value of the 2005 World Social Forum as a cross-sector network: "It really excited me to find that the way my company was moving organically was very much within a *Zeitgeist* that I didn't know was proliferating" (Joseph and Maccani 2014). In a similar vein, Dudley Cocke remarked that Roadside Theater, in its work around incarceration, collaborated with a national network of grassroots leaders who had firsthand knowledge of the issue. This included those who worked in prisons, incarcerated and formerly incarcerated people, and their loved ones. Cross-sector partnerships brought national recognition and praise to their production of *Thousand Kites*[1] and increased its effectiveness: "It was part of last year's successful phone justice campaign that changed Federal Communications Commission policy. *Kites* adopted and adapted to new media many of Roadside's methods, and we in turn were energized

and educated by remarkable leaders like Paul Wright of Prison Legal News" (Cocke 2014b).

People often become part of networks for very focused reasons, but over time, other possibilities that they offer come to light. Valdez finds that people often come to NET "looking for support for a project, and join so they can apply for our grants" (2014). Once they are in the network, however, they discover the community, which is often why they stay. When Roadside Theater in Appalachia was just starting out, notes Cocke, Alternate ROOTS provided a set of like-minded cohorts. Over time, practical perks, too, became apparent: "We hadn't been to nonprofit school, so we had to rely on each other through networks, which for us was Alternate ROOTS, to learn how to do what we needed to do – conduct business, write a contract" (Cocke 2014a).

In other instances, people seek out what their discipline-based groups do not provide. A group of Museum Studies faculty from multiple disciplines – art history, anthropology, and teacher education – at Indiana University–Purdue University Indianapolis describe their alignment as "an intricate combination of personal commitments, professional identity, larger goals, and broader perspectives" (Holzman et al. 2014). Similarly, while ensemble theater methodology was at the basis of NET's creation, a collective proclivity reaches beyond aesthetics to collaboration more broadly. Valdez says that the word "ensemble" in NET's title is more important than the word "theaters" (2014).

Networks are also valuable for convening people face to face, which is especially important, while challenging, when collaborators come from different sectors. Imagining America: Artists and Scholars in Public Life has struggled to make its conferences welcoming for engaged artists, designers, and scholars both in higher education and from other sectors. In the same spirit is Open Engagement, which "highlights the work of transdisciplinary artists, activists, students, scholars, community members, and organizations. The conference mission is to expand the dialogue around socially engaged art, as well as the structures and networks of support for artists working within the complex social issues and struggles of our time" (Open Engagement n.d.). Open Engagement seems to attract well more artists than partners from other sectors; the sessions I attended at their 2014 conference involved nearly only visual artists at that, albeit many involved across sectors. This brings to mind Maria Rosario Jackson's excellent point, in her companion piece at the end of Chapter 4, that artists engaged across sectors need both peers – other artists with similar goals, and partners – like-minded experts from other fields – to carry out their joint aesthetic and social goals.

Valdez notes that networks help amplify issues and voices that are significant to individual members by being a collective, unified voice; they help lead, shape, and simply make space for deep conversations and subsequent actions, both in response to what members want and around what the leadership considers important (Valdez 2014). Iterative opportunities to engage with each other around difficult subjects are most dynamic face to face, especially when the network's commitment to those topics has been proven over time. A terrific example was the time carved out at NET's Honolulu MicroFest for a conversation about how interracial violence was depicted in a performed excerpt of *Go Ye Therefore*, about a black and a white southern woman, both daughters and granddaughters of southern Baptist preachers. It was relatively easy to gather those who wanted to discuss the dynamics later that same evening, given NET's commitment to racial equity and understanding. Many of the participants had a history working through issues of racial representation together, facilitated by face-to-face communication that informs in a positive way how people listen and speak to each other.

Also significant are online networks. Rather than connecting with like-minded people at what are typically only once-a-year meetings of networks, online sites provide ongoing platforms. HowlRound, for example, enjoys 25,000 readers, 500 contributors to its journal, viewers of 50,000 hours of HowlRound TV, 4000 organizations and artists who have put themselves on the New Play Map, and 400 convening participants (Howlround n.d.). The face-to-face and virtual communication each serves an important community-sustaining function.

Action Switchboard, in development at this time, is an example of a cross-disciplinary arts web-based network including the arts. It aspires to bring people together

> for creative direct actions ("schemes"), each of which will support a specific campaign goal of interest to one or more NGOs. Users will also be able to propose their own schemes or join existing ones, and a staff of experienced facilitators will help users refine ideas, find collaborators, and generally bring world-changing actions to fruition. (Action Switchboard n.d.)

In the same spirit, the Arts-Policy Nexus of the World Policy Institute seeks to connect artists and policymakers through a series of articles, to be shared on their website, on how artists lead policy change and how policymakers use creative strategies (World Policy Institute n.d.).

Collaborating across networks can powerfully enhance organizing efforts, as exemplified in "Art and Justice for an Equitable City," coauthored by leaders of three networks committed to the arts and equity – NOCD-NY, Arts & Democracy, and Groundswell – and addressed to New York City Mayor de Blasio and other elected city leaders. Most relevant here, the document's proposals include integrating the arts and culture in cross-sector "policymaking and practice including but not limited to: safe streets and transportation, arts education, juvenile justice, early childhood development, education, immigration, sustainability, housing, and community development" (Groundswell n.d.). The coalition urges the mayor to task a staffer at every city agency with thinking about and integrating arts into their agenda with specific programmatic, policymaking, and funding goals, and to hire someone to further arts-related interagency collaboration. The document had more heft by representing constituencies from several networks.

Finally, each of the networks in this book provides opportunities to connect personal expression to organizing, given the robust role for art in each and a network's capacity to transform individual feeling into collective action. Marshall Ganz's model of organizing through story captures this dynamic:

> Public narrative is the art of translating values into action. It is a discursive process through which individuals, communities, and nations learn to make choices, construct identity, and inspire action. Because it engages the "head" *and* the "heart," narrative can instruct *and* inspire – teaching us not only why we *should* act, but moving us *to act*. (Ganz n.d.)

Ganz notes that the three elements of story, strategy, and structure are needed to build a movement or an organization:

> The narrative is the "why" we're doing it. And then the strategy is how we're doing it, not just one tactic, but ... our theory of change ... of how we're going to use our resources to influence those sources of power. And then ... what's our structure through which we're figuring all this stuff out and working at it? (Ganz qtd in Moyers 2013)

How do the energy, inspiration, and directness of story contribute to movement building? Ganz theorizes three levels of story: the story of me, we, and now. He builds on Rabbi Hillel's words: "If I am not for myself, who will be for me? But if I am only for myself, what am I? And if

not now, when?" So story first grounds the individual in what s/he cares about, then connects with like-minded others, and then intervenes in the immediate moment. As regards artists, self-expression is "the story of me," forming networks is a way to express "the story of we," and linking that collective purpose to action is the story of now.

The power of "me, we, and now" is evidenced throughout this book. Anne Basting at UW-Milwaukee adapted the performance technique of sharing individual stories ("me") to the condition of memory loss among people with dementia ("we") and has tailormade techniques accordingly ("now"). For example, using images as prompts, people with dementia and their loved ones make up stories, providing a meaningful activity to share in the present, even if, moments later, the afflicted person has forgotten. As a network, Imagining America aspires to affect the culture of higher education nationally by demonstrating the value of the expressive disciplines to connect what one feels strongly about individually with the aspirations of others, as a step towards using scholarship for the public good.

Naturally Occurring Cultural Districts-New York expressed the story of the cultural sector ("me") in terms of Mayor de Blasio's rhetoric of New York City ("we") as a tale of two cities, one rich, one poor. They emphasized how neighborhood-based artists and cultural organizations serving diverse populations contribute to de Blasio's vision of "one city rising." They drafted a desired story of "now" for the new administration proposing specific policy initiatives regarding the art's role in the vision (Arts and Democracy n.d.).

SmARTpower was a way to multiply rather than merely add to the recognition that some artists are committed to social issues in the world and capably use art to help make an impact. SmARTpower artist selection criteria foregrounded both aesthetic excellence and a track record of contributing to a range of social efforts through their individual art ("me"). This positioned the artists to rely on local partners with more knowledge of the social issue even as they brought in imaginative approaches ("we"). The impact of 15 such projects sent a message that the US did not think it had all the expertise and other countries had none, an important sentiment to communicate in these times ("now").

Not all Network of Ensemble Theaters' member companies include other than theater people in their individual "stories of me." Most important is that, as a network of theater professionals, they acknowledge cross-sector possibilities in their "story of we." The degree to which this is still needed is reflected modestly in the many poignant messages that I have received over the years from theater people who integrate the

social in their work in the vein of "Thanks so much for articulating that you can do xyz and still be a theater person." People don't want their artistic identities to hedge them in but rather be as expansive and generative as is the idea of art itself. Having a network in which to acknowledge diverse artistic identities is invaluable for artists and their communities, which stand to benefit from their participation in local issues.

Also generative is the development of international networks, linking people across the globe who integrate performance in an exhilarating range of endeavors. Eugene van Erven's stewardship of the International Community Arts Festival, since 2001, in Rotterdam, presenting performances, workshops and, increasingly, conversations cross-culturally, has been enormously generative for the exchange of ideas and practices.

Cross-sector artists in larger ecosystems

Time, time, time, time, time; relationships take time to build and art that contributes to social issues takes time to come to fruition and play an ongoing role in social life. Polish artists Krzysztof Czyzewski, his wife Małgorzata Sporek-Czyzewska, and Bożena and Wojciech Szroeder are positioned to have ongoing social impact through recognition of this dynamic. In the 1970s, the four were part of the renowned Gardzienice Theater Company, which traveled to villages around the world, asking people to share stories and songs, and then leaving after a few albeit wonderful days. This material was used to create work that they performed in festivals. But by 1984, the four were finding this model of theater insufficient. People generously gave them stories, songs, and secrets; emotional bonds began to be created, and the people expected some sort of response, some continuation of the connection in their lives. But there was neither time nor tools to do so. As Czyzewski explained, "We were artists. Theater is not meant to stay in a village but to go to theater makers and not go back. But we felt that something was not fulfilled" (2014).

So the four left the company and traveled east, eventually to Sejny, in northeast Poland, drawn to its historic multiculturalism what with constantly changing borders, in search of what Czyzewski has come to call deep culture. When Czyzewski and his partners first arrived in Sejny, they felt foolish at the thought of being actors on a stage telling people something when what they needed was to invert the model and put the people on the stage so they could get to know them (Czyzewski 2014). And in effect they did. They set up various studios in which people of all ages but with an emphasis on youth, could participate in film,

theater, music, and visual arts/ceramics. They founded the Borderland Foundation, devoted to rebuilding and sustaining the rich cultural diversity in Central and Eastern Europe that was nearly destroyed by two world wars. The Sejny model promotes

> multi-cultural education and understanding locally ... [and] involves the whole community, but especially young people, as its mission is to educate them to be community builders, in the belief that they first need to understand the past in order to shape the future. (Polish Cultural Institute 2008)

They also created public exhibitions. In 1998, they showed postcards and photographs from the first half of the twentieth century that were in the center's archives and others collected by Sejny children from the town and region. From this exhibit, the production *Sejny Chronicles* evolved, epitomizing how a rooted relationship to a place and its people and understanding the past to build the future can develop into a remarkable work of art and piece of public education. The Borderland staff invited young people to respond to the exhibition through visual and literary works. Bożena Szroeder, the head of the center's documentation archive and director of the youth theater studio, who went on to direct the *Chronicles*, then asked the children to gather oral histories from their parents and grandparents.

As scholar Ian Watson describes, individual mini-histories and family trees were used to shape a partially true, partially mythical map of the town's past. They matched the stories and legends they heard to specific sites. The children, whose family roots were drawn from most of the various ethnic and national groups in the region, learned each other's songs, including those sung at traditional Lithuanian weddings, old Slavonic chants, and Polish folk songs. They also learned cultural expressions of former residents no longer represented in the village, such as Yiddish and Roma tunes. The play became the story of Sejny's multicultural heritage prior to mass emigration from Poland in the late nineteenth and early twentieth centuries and the slaughter and displacement of peoples during World War II. The children created a clay model of pre-world war Sejny, displayed on a table during the production. The young actors pick up the house or building in question when they tell a story about someone who lived or worked there (Watson 2009) (Figure Coda 1).

Researching the town's multicultural past through each family's participation in it, bringing to light long-buried stories across the generations,

Figure Coda 1 The cast of *The Sejny Chronicles* performing in front of the clay model they made of their town before World War II.

has been as much the point as the performance, a process that continues as new groups of young people take over the production every five years. Part of the pleasure for local people is knowing the story but every five years hearing it told by different young people, featuring different details. Czyzewski compares it to ancient Greek theater audiences who similarly knew the stories underlying the plays they saw annually at theater festivals, appreciating the different points of view playwrights take on them.

Twenty-four years from its establishment in Sejny, the Borderland Foundation now includes multiple studios, an archive, a café, a publishing house, classes for local and international groups, and a magazine. Czyzewski describes his role as largely a dramaturge of Borderland Foundation, shaping the parts into a whole (Czyzewski 2014). Given the friction created when people from different cultures rub up against each other, Czyzewski notes: "It is best not to speak about resolving conflicts, but rather about an ability to live with conflicts, and instead of removing borders, to think about crossing them" (Czyzewski 1999, p. 1).

The Borderland Foundation has shared its methods with people from other countries who have their own cross-cultural conflicts. Ian Watson, a professor at the University of Rutgers–Newark, is developing an exchange whereby Czyzewski and his Borderland colleagues spend time

in Newark, New Jersey, advising Rutgers faculty and students in relevant community collaborations. Watson is also in conversation about opportunities for Rutgers faculty, students, and their community partners to spend time in Poland with the Borderland Foundation. Watson intuits that the sensitivity and creativity with which Borderland deals with difference and conflict in Sejny will be relevant in Newark as well. So while grounded in the town of Sejny, Borderland is also part of international ecosystems, adding their art-informed approaches to cross-cultural partnerships.

Artists in uncommon partnerships are also part of the arts ecosystem, which at one end of the spectrum includes artists who stay quite fruitfully within aesthetic frames. That is, artists ought not to feel compelled to include a social component; rather, let it be part of the spectrum of what artists *can* do if that is what draws them. As Melanie Joseph of Foundry Theatre remarks,

> Let's not have a pendulum swing all one way or the other. From "everyone is an artist" to the French revolution – we did that already. And you need to watch what happens with the financial sources and how much they map the course. There's a long history of denigrating art. As long as I'm with the Foundry I will always be open to out-there projects, and never feel like that's out of character for us. There's a spectrum of activities that are forwarding a broadening vision; one art project might be this, this one has a community relationship, the dialogue might be this; not everything is in every project. But everything is in the movement of energy going forward. That feels really available to extend and extend. (Joseph and Maccani 2014)

Uncommon partnerships also thrive when cultural priorities are embedded in disciplines other than the arts. Scholar Alaka Wali, curator of North American Anthropology in the Science and Education Division at the Field Museum, poses culture and creativity as key ingredients in the resilient design of social processes that respond to adversity. Her research demonstrates that social differences and barriers are crossed in informal, active arts such as drumming circles (Wali 2013). Art is a vehicle, she expounds, that can draw people together; add to that the particulars that other disciplines provide, and people can do something at once in the social and expressive realm, the one strengthening the other. Performance will be seen less as an "add-on" as its methodologies are added to conversations and presentations based in other disciplinary contexts.

Mark Valdez notes that commitment to the local and the social do not leave out creativity and excellence, citing examples of innovative cross-sector partnerships. Rick Lowe's Project Row Houses started with home, a defined geography of place, a way of saying that there's culture and art here, you can make it where you are. Valdez recalls that it wasn't all that long ago that the local was not perceived as art. He cites Marc Joseph Bamuthi's work around the environment through a roving festival that brings issues to the fore and is celebratory at the same time. He marvels at Melanie Joseph of the Foundry Theater adding a community organizer to her staff. It is in specifics like this, Valdez avows, that a community of practice beyond a network is visible and one starts to see the change that is happening (Valdez 2014).

To Valdez, inherent in the ensemble form is recognition that we all carry different expertise and need to create with others who know different things. Valdez emphasizes the need for more time to bring such work to fruition:

> This type of collaboration doesn't happen quickly. Part of that is financing, part is enthusiasm; we want to rush, we're excited, we want to make and share the work, that's what we do as artists. How can we find the right ways to slow it down so people take the necessary time to do the work? But I have nothing but optimism. Things are changing in really positive ways. We couldn't have had this conversation 15 years ago. Many people were doing it; it just wasn't visible, but now it is. I think we are heading in beautiful directions. (Valdez 2014)

Remapping, in its metaphorical sense, refers to arranging elements so as to make them visible in themselves and to articulate the relationship that they have to each other. Remapping is an act of re-cognition, of knowing afresh: in the case of this book, remapping has meant describing instances of performance that cover more ground than strictly aesthetic contexts indicate. For performance can be integrated into what is most important to us, wherever one lives, whatever one cares about, is doing, or sees that one could do. Or feels that one must do.

Notes

Introduction: A Vibrant Hybridity

1. Rick Lowe, recognized in both contexts, raised this important question with Creative Time program director Nato Thompson at that organization's 2013 convening.
2. Finkelpearl discussed these ideas at a public forum at The New School for Social Research in New York City on 19 February 2013.
3. Choreographer Liz Lerman develops related ideas about collaboration in her book *Hiking the Horizontal* (2011).
4. See Schechner (1973).
5. Theatre of the Oppressed is a body of dramatic techniques that reposition spectators to actively rehearse strategies for personal and social change. See especially Boal (1979, 1992, 1995).
6. Kathie deNobriga articulated the organization Alternate ROOTS' sense of the meaning of community, from whence I draw the words "place, spirit, and tradition." She then sums up community in a very personal way: "those people who would call to see if I was okay if my car hadn't moved in three days" (1993, p. 12).
7. Shanna Ratner is the Principal of Yellow Wood Associates, Inc. specializing in rural community economic development.
8. The conversation took place on 8 January 2013, at the Westside Jewish Community Center in Manhattan as part of Lerman and Zollar's residency there.
9. Another rich context for "performance and" not explored in this book is religion and spirituality. As Rabbi Jill Hammer explained to me in an interview, spiritual life requires leaders who are artists and/or collaborate with artists. Because, she said, "Art expresses the creative force of human beings ... our desire to make something, to bring to the world what isn't there already ... for me that's a deeply spiritual impulse. Art connects to our ability to make meaning; it lies close to the impulse to understand why things are as they are, what we are doing here" (2014).

1 The Breadth of Theatrical Territory

1. Periods of great social turmoil are often characterized by alignment of expressive culture and political movement building. The futurists and the Russian Revolution, the Nuremberg Party rallies and the rise of Nazism, troupes of actors that accompanied troups of soldiers as the Chinese Revolution spread across that land, theaters that served as cultural wings to social movements taking place across the US and Europe in the 1960s and 1970s – political movements of all stripes have often communicated to the public through performative means.

2. Thanks to Jerry Stropnicky, who cited this work in his essay on MicroFest: Detroit, "A Community of Practice: NET Learning in Place" (Network of Ensemble Theaters n.d.).
3. The power of culture to support a sense of self and identity among people lacking the capacity to resist US economic domination resonated with many NET participants, such as those from regions controlled by multinational corporations. Many indigenous people resisted US annexation of Hawai'i. An excerpt of one account published in *The Orange County Register* begins, "Poka Laenui [director of the Institute for the Advancement of Hawaiian Affairs] pledges his allegiance to the sovereign nation of Hawai'i, not to the United States government." Missionaries to the islands beginning in 1820 became sugar planters and politicians whose powers soon eclipsed that of Hawai'i's ruling monarchy. The planters wanted Hawai'i to become part of the US, their major market, to avoid paying tariffs. The US minister to Hawai'i, John L. Stevens, brought US Marines to Honolulu to stage a coup, after which Stevens gave sovereignty to the mostly American planters who supported it. President Cleveland fired Stevens and apologized to the Hawai'ian queen, who had resigned to avoid bloodshed. But the next president, McKinley, recognized the authority of the annexation and so it stood (Sforza 1996).

2 Partnering

1. All quotes in this section are from an essay Rohd published online at Howlround, 12 January 2013.

3 Universities, Performance, and Uncommon Partnerships

1. I draw from a grant proposal to the Teagle Foundation that Imagining America National Advisory Board member Amy Koritz and active member/Macalester College representative Paul Schadewald developed with my input. The proposal was funded; Koritz and Schadewald are the principal investigators.
2. Theatre of the Oppressed – NYC generates theatre troupes that tour varied communities using techniques from the arsenal of Theatre of the Oppressed, created by Augusto Boal. Typically, short plays provide a platform for spectators to replace a struggling character and enact possible solutions to an oppressive situation with which they are dealing.
3. For more about Imagining America, including its statement of mission, vision, values, and goals, visit www.imaginingamerica.org.
4. The Curriculum Project can be downloaded from Imagining America's website.

4 Art and Culture in Neighborhood Ecosystems

1. For a complete list of NOCD-NY members, see www.nocd.org.
2. Caron Atlas does similar work nationally as director of Arts and Democracy, which "links arts and culture, participatory democracy, and social justice ... [and] works to increase civic engagement among people who have been traditionally disenfranchised and to build closer ties between arts and culture

and sustained and strategic activism" (animatingdemocracy.org/organization/arts-democracy-project).

3. Sananman initiated Groundswell in 1996 "to bring together professional artists, grassroots organizations, and communities to create high-quality murals in underrepresented neighborhoods and inspire youth to take active ownership of their future by equipping them with the tools necessary for social change" (www.groundswellmurals.org).

4. See also www.brooklyncommunityfoundation.org/brooklyn-insights.

5 Cultural Diplomacy as Collaboration

1. They were China, Ecuador, Egypt, Ghana, India, Kenya, Kosovo, Morocco, Nepal, Nigeria, Pakistan, the Philippines, Sri Lanka, Turkey, and Venezuela.

2. Action Lab was created to promote dialogue in the Hunts Point section of the Bronx through collaborative art-making activities.

3. All direct quotes are from interviews conducted in the Philippines during the week in June I carried out the evaluation.

4. During the week I spent in March 2012 evaluating Osorio's project, I interviewed the seven students as well as their instructor.

5. All direct quotes come from interviews I conducted while evaluating this project in Venezuela in June 2012.

6. Of the 11 projects I visited, at only one did the artists feel inhibited by the State Department. That was the US art collective Ghana Think Tank, that manages a worldwide network of informal think tanks creating strategies to resolve problems in the "developed" world, thus inverting the paradigm. Of 20 problems that Think Tank wanted to focus on in Morocco, the State Department did not approve six of them.

Coda: The Future of Performance with Uncommon Partners

1. Roadside developed *Thousand Kites* from stories of people directly involved in incarceration. Other people can personalize it for their own productions by inserting their own stories and songs.

Bibliography

808 Urban (n.d.) 808urban.org.

A Blade of Grass (n.d.) www.abladeofgrass.org/who_we_are/.

Action Switchboard (n.d.) http://yeslab.org/actionswitchboard/.

Agovino, T. (2014) "Theater Groups to Split $1M Grant." Crains New York: 6 January. www.crainsnewyork.com/article/20130728/ARTS/307289987.

Alternate ROOTS (n.d.) www.alternateroots.org.

American Festival Project (n.d.) www.inmotionmagazine.com/afp2.html.

Art 21 (n.d.) www.pbs.org/art21/artists/pepon-osorio.

Artists-in-Context (n.d.) www.artistsincontext.org.

ArtPlace (n.d.) artplaceamerica.org.

Arts and Democracy (n.d.) artsanddemocracy.org/detailpage/?program=other& capID.

Ashé College Unbound (n.d.) Ashécollegeunbound.tumblr.com.

Assessing the Practices of Public Scholarship (2014) "Art at Work," unpublished handout, Imagining America national conference, Atlanta, 10 October.

Atlas, C., and P. Korza (eds) (2005) *Critical Perspectives: Writings on Art and Civic Dialogue* (Washington, DC: Americans for the Arts).

Atlas, C., and A. Sananman (2013) Unpublished letter to mayor elect Bill de Blasio and transition team, 22 November.

Bartha, M., B. Burgett, P. Korza, and E. Thomas (2013) "Art Gave Permission to Agitate," *Public* I.1. public.imaginingamerica.org.

Basting, A. (2013) Interview with the author via email, 15 March.

Basting, A., E. Nocun, and M. Towey (eds) (forthcoming) *Something Spectacular While Patiently Waiting* (Iowa City: University of Iowa Press).

Bauman, M. (2013) Conversation with the author, Brooklyn, 21 February.

Bebelle, C. (2013) Conversation with the author, New York City: El Museo de Barrio, 30 May.

Bebelle, C., and College Unbound cohort (2014) Conversation with author, New Orleans, 21 February.

Bedoya, R. (2013) "Placemaking and the Politics of Belonging and Dis-belonging." *GIA Reader* 24.1 (Winter).

Belfiore, E., and O. Bennett (2008) *The Social Impact of the Arts: An Intellectual History* (Basingstoke: Palgrave Macmillan).

Bell, J. (2013) Facebook post 10 February.

Belmonte, L. A. (2007) "Exporting America: The U.S. Propaganda Offensive, 1945–1959," in C. N. Blake (ed.) *The Arts of Democracy* (Washington, DC: Woodrow Wilson Center Press).

Berry, W. (n.d.) "What We Need is Here," poemhunter.com/poem/what-we-need-is-here.

Beyond Zuccotti Park panel (2012) NYC: Center for Architecture. New York City, 10 September.

Bilger, W. (2013) Conversation with the author, New York City, 13 January.

Binkiewicz, D. M. (2007) "A Modernist Vision: The Origin and Early Years of the National Endowment for the Arts' Visual Arts Program," in C. N. Blake (ed.) *The Arts of Democracy* (Washington, DC: Woodrow Wilson Center Press).

Bishop, C. (2006) "Introduction," in C. Bishop (ed.) *Participation* (London: Whitechapel).

Boal, A. (1979) *Theatre of the Oppressed*. Trans. C. A. and M. L. McBride (New York: Urizen Books).

—— (1992) *Games for Actors and Non-Actors*. Trans. A. Jackson (London and New York: Routledge).

—— (1995) *Rainbow of Desire* (London and New York: Routledge).

Bookchin, M. (1986) *The Limits of the City*, new edn (New York: Harper and Row).

Borgatti, S. P., and D. S. Halgin (n.d.) *Network Theorizing*. steveborgatti.com/papers/nettheorizing.pdf.

Bowers, M. (2014a) Conversation with the author, New York City, 15 February.

—— (2014b) Unpublished grant proposal. Brooklyn, New York.

Boyer, E. (1990) *Scholarship Reconsidered: Priorities of the Professoriate* (Menlo Park, CA: The Carnegie Foundation for the Advancement of Teaching).

Boyte, H. (2009) *Civic Agency and the Cult of the Expert* (Dayon, OH: Kettering Foundation).

Burnham, L., S. Durland, and M. Ewell (2004) *The CAN Report: The State of the Field of Community Cultural Development: Something New Emerges*. www.communityarts.net.

Campbell, C. T., and O. A. Rogers, Jr. (1978) *Mississippi: The View from Tougaloo* (Jackson, MI: Tougaloo College).

Cantor, N. (2003) "Transforming America: The University as Public Good." *Foreseeable Futures* #3. Imagining America, p. 14.

Cantor, N., and O. Lyons (2013) "Keynote: 2013 Imagining America Conference." *Public: A Journal of Imagining America* 2.1, April. Public.imaginingamerica.org.

Casals, G. (2013) Conversation with the author, New York City, 15 March.

CAT Institute (n.d.) www.art-stl.com/cat/.

Catherwood-Ginn, J. (2014) Email to the author, 28 February.

Cattaneo, A. (1997) "Dramaturgy: An Overview," in S. Jonas, G. Proehl, and M. Lupo (eds) *Dramaturgy in American Theater: A Sourcebook* (Fort Worth: Harcourt Brace College Publishers).

Clifford, J. (1988) *The Predicament of Culture* (Cambridge, MA and London: Harvard University Press).

Cocke, D. (2014a) Email to the author, 9 January.

—— (2014b) Telephone conversation with the author, 8 February.

Cocker, E. (2011) "Performing Stillness: Community in Waiting," in D. Bissell and G. Fuller (eds) *Stillness in a Mobile World* (London: Routledge).

Cohen-Cruz, J. (1994) "Theatricalizing Politics," in M. Schutzman and J. Cohen-Cruz (eds) *Playing Boal: Theatre, Therapy, Activism* (New York and London: Routledge).

—— (ed.) (1998) *Radical Street Performance* (London and New York: Routledge).

—— (2005) *Local Acts: Community-Based Performance in the US* (New Brunswick: Rutgers).

Cohn, M. (2013) Email exchange with the author, 22 May.

College Unbound (n.d.) collegeunbound.org.

Conquergood, D. (2008) "Health Theatre in a Hmong Refugee Camp," in J. Cohen-Cruz (ed.) *Radical Street Performance* (London and New York: Routledge).

Coviello, W. (2013) "Preview: *Cry You One, Gambit bestofneworleans.com*.

Cowan, G., and A. Arsenault (2008) "Moving from Monologue to Dialogue to Collaboration." *The Annals of the American Academy of Political and Social Science*, 16, March: 10–30.

Creative Campus (n.d.) www.creativecampus.org/about.

Cry You One (n.d.) "People Profile," http://cryyouone.com/people/.

CUNY Master's Degree in Applied Theater (n.d.) http://sps.cuny.edu/programs/ma_appliedtheatre.

Czyzewski, K. (1999) "The Culture of Coexistence in the *Longue Duree*," in John Tomlinson (ed.) *Culture and Globalization* 1 (Cambridge: Polity Press).

—— (2014) Conversation with the author, Szcechin, Poland, 24 October.

DeBessonet, L. (2013a) Email to author, 28 February.

—— (2013b) Email to author, 30 September.

—— (2014) Telephone call with the author, 9 January.

DeNobriga, K. (1993) "An Introduction to Alternate ROOTS." *High Performance* 64, Winter: 11–15.

Dent, T. (1966) "The Free Southern Theater: An Evaluation," *Freedomways*, 1st Quarter. www.crmvet.org/info/fst66.htm.

Dent, T., R. Schechner, and G. Moses (eds) (1968) *The Free Southern Theater by the Free Southern Theater* (Indianapolis and New York: Bobbs-Merrill).

Derby, D. (2013) Free Southern Theater Alumni Panel. New Orleans: 18 October.

Doris Duke Charitable Foundation (n.d.) Doris Duke Building Demand for the Arts. ddcf.org/Programs/Arts/Initiatives–Strategies/Doris-Duke-Performing-Artist-Initiative/Doris-Duke-Building-Demand-for-the-Arts.

D.R.E.A.(M.)[3] Freedom Revival (2013) www.dreamfreedomrevival.org.

Dutta, J. (2014) Interview with the author, New Orleans, 20 October.

Edell, D., A. Horowitz, and C. Estel (2014) "US Department of Art & Culture: An Act of Collective Imagination." *Public: A Journal of Imagining America* 2.1: public.imaginingamerica.org.

Ewell, M. (2005) Robert Gard Lecture Series: "Altering the Face and the Heart of America." 21 June, Amherst, MA.

Fenske, M. (2007) "Interdisciplinary Terrains of Performance Studies." *Text and Performance Quarterly* 27.4: 351–68.

Finkelpearl, T. (2013) *What We Made: Conversations on Art and Social Cooperation* (Durham, NC and London: Duke University Press).

Fisher, D. (1993) *Fundamental Development of the Social Sciences: Rockefeller Philanthropy and the United States Social Science Research Council* (Ann Arbor: University of Michigan Press).

Five Questions for Anne Basting (2008) www.alznyc.org/newsletter/spring2008/06.asp.

Flanagan, H. (1940) *Arena* (New York: Duell, Sloan & Pearce).

Ford, K. (2012) Conversation with the author, 15 October.

Fourth Arts Block (n.d.) www.FAB.org.

Free Southern Theater (1965) "Dialogue," *Tulane Drama Review* 9.4, T28, Summer: 63–76.

From the Neighborhood Up (2013) New York City: El Museo de Barrio, 30 May.

Ganz, M. (n.d.) www.hks.harvard.edu/syllabus/MLD-355M.

Gilliam, R. (2013) Conversation with the author, New York City, 12 August.

Goldbard, A. (2013) *The Wave* (Waterlight Press).

Green Papaya (n.d.) www.greenpapayaartprojects.org.

Greenfield, T. (2013) Email to author, 4 February.

Groundswell (n.d.) www.groundswellmural.org/sites/default/files/ArtandCulture foraJustandEquitableCity.pdf.

Hammer, J. (2014) Telephone interview with the author, 6 February.

Harvie, J. (ed.) (2009) *Theatre and the City* (London and New York: Palgrave Macmillan).

Hemispheric Institute (n.d.) http://hemisphericinstitute.org/hemi/en/hidvl-interviews.

Hodgson, S. (2012) Conversation with the author, Caracas, June.

Holzman, L., et al. (2014) "A Random Walk to Public Scholarship." *Public* 2.2, September. public@imaginingamerica.org.

Horwitz, A. (2012) "On Social Practice and Performance." www.culturebot.org/2012/08/14008/on-social-practice-and-performance/.

Howell, R. (2011) "Tools of Engagement in Urban Bush Women's *Hairstories*." Unpublished Thesis, School of Dance, Florida State University.

Howlround (n.d.) www.HowlRound.com/about.

HUD (2010) http://portal.hud.gov/hudportal/HUD?src=/press/press_releases_media_advisories/ 2010/HUDNo.10–140.

Hughes, J. (2011) *Performance in a Time of Terror: Critical Mimesis and the Age of Uncertainty* (Manchester University Press).

Huutoniemi, K., and P. Tapio (eds) (2014) *Transdisciplinary Sustainability Studies: A Heuristic Approach* (London and New York: Routledge).

Islands of Milwaukee (n.d.) www.islandsofmilwaukee.org.

Ivey, W. (2012) In-house panel, Vanderbilt University, Nashville, 13 April.

Jackson, A. (2007) *Theatre, Education and the Making of Meanings: Art or Instrument?* (Manchester University Press).

Jackson, M. R. (2013) NOCD-NY Exchange of Research and Practice. New York City, 12 September.

Jackson, M. R., et al. (2003) "Investing in Creativity: A Study of the Support Structure for U.S. Artists." Urban Institute: www.usartistsreport.org www.ccc.urban.org.

Jackson, S. (2000) *Lines of Activity* (Ann Arbor: University of Michigan Press).

——— (2004) *Professing Performance: Theatre in the Academy from Philology to Performativity* (Cambridge University Press).

——— (2011) *Social Works: Performing Art, Supporting Publics* (New York and London: Routledge).

Jagruthi (n.d.) www.poweroflove.org/jagruthi.

Joseph, M. (2002) *Against the Romance of Community* (Minneapolis: University of Minnesota Press).

Joseph, M., and R. J. Maccani (2014) Interview with the author, New York City, 11 February.

Kester, G. (2004) *Conversation Pieces* (Berkeley: University of California Press).

Kirshenblatt-Gimblett, B. (1995) "The Aesthetics of Everyday Life," in Suzi Gablik, *Conversations Before the End of Time* (New York: Thames and Hudson).

Klein, J. T. (1990) *Interdisciplinarity* (Detroit: Wayne State University Press).

——— (1996) *Crossing Boundaries: Knowledge, Disciplinarities, and Interdisciplinarities* (Charlottesville: University Press of Virginia).

——— (2005) *Humanities, Culture, and Interdisciplinarity: The Changing American Academy* (Albany: SUNY Press).

—— (2010) "A Taxonomy of Interdisciplinarity," in R. Frodeman (ed.) *The Oxford Handbook of Interdisciplinarity* (Oxford University Press).

—— (2015) "Looking Back to the Future: The Discourses of Transdisciplinarity." *Futures: The Journal of Policy, Planning, and Future Studies*. Forthcoming. A special issue on transdisciplinarity revisited from a counterpart 2004 special issue.

Klein, J. T., W. Grossenbacher-Mansuy, R. W. Scholz, and M. Welti (eds) (2001) *Transdisciplinarity: Joint Problem Solving among Science, Technology, and Society* (Basel: Birkhäuser).

Klein, J. T., and D. Roessner (2015) "Degrees of Integration," in J. T. Klein, "Interdisciplinarity and Transdisciplinarity: Keywords Meanings for Collaboration Science and Translational Medicine." *Journal of Translational Medicine and Epidemiology*. Forthcoming.

Korza, P. (2014) Conversation with the author, 11 June.

Korza, P., B. Schaffer Bacon, and A. Assaf (eds) (2005) *Civic Dialogue, Arts and Culture: Findings from Animating Democracy* (Washington, DC: Americans for the Arts).

Kuftinec, S. (2003) *Staging America: Cornerstone and Community-based Theater* (Carbondale and Edwardsville: Southern Illinois University Press).

—— (2014) Correspondence with the author, 29 May.

La Jolla Playhouse (2013) www.lajollaplayhouse.org/about-the-playhouse/our-mission.

Lai, C. (2013) Conversation with the author, New York City, 28 February.

LAPD (n.d.) www.lapovertydept.org/agents-and-assets/index.php.

Leonard, R. (2014) "Building Home: The Dramaturgy of Public Engagement." *Public: A Journal of Imagining America* 2.1, April. Public.imaginingamerica.org.

Leonard, R., et al. (2014) "Documentation, Archiving, and Communication Seminar," internal document, Atlanta, Georgia: Imagining America conference, 10 October.

Lerman, L. (2011) *Hiking the Horizontal* (Middletown, CT: Wesleyan University Press).

—— (2014) Keynote. Council on Undergraduate Research conference. Washington, DC. Marriott Renaissance Hotel, 28 June.

Lilly, N. E. (2002) "What is Speculative Fiction?" www.greententacles.com/articles/5/26/.

Local Initiatives Support Corporation (n.d.) www.lisc.org.

London, S. (2014) "Building Collaborative Communities," www.scottlondon.com/articles/oncollaboration.html.

London, T. (2014) Interview with the author, 2 January.

Lovett, I. (2013) "Surf's Up and So is the Curtain at this Festival," www.nytimes.com/2013/10/09/theater/the-first-without-walls-weekend-is-held-in-san-diego.html.

Maslon, L. (2013) Interview with the author, New York City, 16 December.

Matarasso, F. (2011) "All in This Together," in E. van Erven (ed.) *Community Art Power* (Utrecht: The International Community Arts Festival).

McCants, L. (2013) Email exchange with the author, 21 June.

MicroFest Honolulu program (2013) www.ensembletheaters.net/programs/microfest-usa-national-summit 2013.

Minor, W. F. (1965) "They Are Waiting for Godot, Too," www.thekingcenter.org/archive/document/they-are-waiting-godot-mississippi-too#.

Moses, G. (1965) *The Drama Review* 9.3 Spring: 67.

Moyers, B. (2013) "Moyers: How Storytelling Is at the Heart of Making Social Change" Alternet, www.alternet.org.

NAS/NAE/IOM (2005) *Facilitating Interdisciplinary Research.* Washington: National Academy of Sciences, National Academy of Engineering, Institute of Medicine, The National Academies Press, 306.

National Cancer Institutes (n.d.) Team Science Toolkit. https://www.teamscience toolkit.cancer.gov/Public/Home.aspx.

National Performance Network (n.d.) http://npnweb.org/about/.

Naturally Occurring Cultural Districts (n.d.) www.nocd.org.

Network of Ensemble Theaters (n.d.) www.ensembletheaters.net.

—— (n.d.) www.ensembletheaters.net, Intersections.

New York City Department of Planning (2013) www.nyc.gov/html/dcp/html/about/pr121813a.shtml.

NGO Definition (n.d.) www.ngo.org/ngoinfo/define.html.

Ngũgĩ wa Thiongo (1986) "The Language of African Theater," in *Decolonising the Mind* (Portsmouth, NH: Heinemann).

—— (1998) *Penpoints, Gunpoints, and Dreams: Towards a Critical Theory of the Arts and the State in Africa* (Oxford University Press).

Nicholson, H. (2014) *Applied Drama: The Gift of Theatre*, 2nd edn (Basingstoke: Palgrave Macmillan).

Nye, J. (2004) *Soft Power: The Means to Success in World Politics* (New York: Public Affairs).

O'Neal, J. (2013) Free Southern Theater Alumni Panel. New Orleans, 18 October.

—— (2014) Conversation with the author, Alternate ROOTS. Arden, NC, 8 August.

Open Engagement (n.d.) www.openengagement.info.

O'Quinn, J. (2013) Conversation with the author, New Orleans, 20 October.

Osorio, P. (2013) Telephone conversations with the author, 15 January.

Page, S. E. (2007) *The Difference: How the Power of Diversity Creates Better Groups, Firms, Schools, and Societies* (Princeton University Press).

Parris-Bailey, L. (2014) Learning Exchange Presentation, Alternate ROOTS, Arden, NC: 9 August.

Penelope Project Program Evaluation (2013) www.thepenelopeproject.com/links/materials.

Peters, S. J. (2003) "Reconstructing Civic Professionalism in Academic Life: A Response to Mark Wood's Paper, 'From Service to Solidarity.'" *Journal of Higher Education Outreach and Engagement* 8.2: 165–81.

Pezold, B. (2014) Conversation with the author, New Orleans, 20 February.

Places That Matter (n.d.) http://placematters.net/node/1432.

Pohl, C., and G. H. Hadorn (2007) "Principles for Designing Transdisciplinary Research proposed by the Swiss Academies of Arts and Sciences" (Munich: Oekom Verlag).

Polish Cultural Institute (2008) "Borderlanders: Finding Their Voice." Unpublished multi-page pamphlet with information about the Borderland Foundation's Visit to New York, 9–20 April.

PregonesPRTT (n.d.) http://pregonesprtt.org/.

Progress Theatre (n.d.) progresstheatre.com/generation-progress/.

Proudfit, S., and K. M. Syssoyeva (eds) (2013) *Collective Creation in Contemporary Performance* (New York: Palgrave Macmillan).

Putnam, R. D. (2000) *Bowling Alone: The Collapse and Revival of American Community* (New York: Simon & Schuster).

Queens Museum (n.d.) www.qma.org.

Randels, K. (2014a) Interview with the author, New Orleans, 19–21 February.

—— (2014b) Email exchange with the author, 6 October.

Ransby, B. (2003) *Ella Baker and the Black Freedom Movement* (London and Chapel Hill: University of North Carolina Press).

Rauch, B. (2013) Telephone interview with the author, 5 June.

Reeler, D. (2007) "A Three-fold Theory of Social Change," www.cdra.org.za/threefold-theory-of-social-change.html, Community Development Resource Association.

Richards, D. (1993) "A Community Carol; Dickens Variation for the Inner City," *New York Times*: 21 December.

Rohd, M. (2011) Unpublished document. October.

—— (2012) "Translations: The Distinction between Social & Civic Practice and Why I Find It Useful," www.howlround.com/translations-the-distinction-between-social-civic-practice-and-why-i-find-it-useful.

—— (2013a) Interview with the author, New York City, 13 January.

—— (2013b) *(r)evifesto*. Audience (R)Evolution Learning Convening. Philadelphia: Theatre Communications Group, www.tcgcircle.org/2013/03/revifesto-michael-rohd.

—— (2013c) Email to the author, 27 November.

—— (2013d) howlround.com/translations–cpcp-update-2-the-catalyst-initiative.

—— (2014a) Conversation with the author, Baton Rouge, 18 February.

—— (2014b) lsu.edu/ur/ocur/lsunews/MediaCenter/News/2014/02/item68547.html.

Rosenstein, C. (2009) "Cultural Development and City Neighborhoods," in *Charting Civil Society*, The Urban Institute, No. 21, July.

Rubin, K. (2014) Conversation with the author, New York City, 5 May.

Salmons, J., and L. Wilson (2007) "Crossing a Line: An Interdisciplinary Conversation about Working across Disciplines, Models and Notes, A Trainerspod Webinar," 23 August.

Schechner, Richard (1973) *Environmental Theatre* (New York: Hawthorn Books).

Sforza, T. (1996) www.hawaii-nation.org/betrayal.html.

Sidford, H. (2011) "Fusing Art, Culture, and Social Change," National Committee for Responsive Philanthropy, crp.org/files/publications/Fusing_Arts_Culture_Social_Change.pdf.

—— (2014) Conversation with the author, 28 August.

Sill, D. J. (1996) "Integrative Thinking, Synthesis, and Creativity in Interdisciplinary Studies," *Journal of General Education* 45.2: 129–51.

Slie, N. (2014) Interview with the author, New Orleans, 20 February.

Social Sculpture Research Unit (2011) www.social-sculpture.org/category/projects-and-practices/.

Soloski, A. (2012) "Oskar Eustis Seizes the Moment." An interview with Eustis. www.tcg.org/publications/at/issue.

South Coast Repertory (2014) www.scr.org/get-connected/crossroads.

Stern, M., and S. Seifert (2007) "Cultivating 'Natural' Cultural Districts." www. trfund.com/cultivating-natural-cultural-districts/.

—— (2013) "'Natural' Cultural Districts: A Three-City Study," sp2.upenn.edu/ siap/docs/natural_cultural_districts/Summary.15apr13.pdf.

Sturm, S. (2006) "The Architecture of Inclusion: Interdiscplinary Insights on Pursuing Institutional Citizenship." *Harvard Journal of Law and Gender* 30: 248–334.

SUNY Mission (n.d.) www.suny.edu/about_suny/mission.

Syracuse University Mission (n.d.) syr.edu/about/vision.

Sze, L. (2014) www.mocanyc.org/files/MOCA_Chinatown_beyond_the_streets_ essays.pdf.

Taylor, K. (2010) "U.S. to Send Visual Artists as Cultural Ambassadors," *New York Times*, 25 October.

Tchen, J. K. W. (1987) "New York Chinatown History Project." *History Workshop* No. 24 (Autumn), Oxford University Press: 158–61.

—— (2014) Conversation with the author. New York City, 25 July.

This Bridge Called My Job (2013) session, Imagining America national conference, www.imaginingamerica.org.

Thompson, J. (2009) *Performance Affects: Applied Theatre and the End of Effect* (Basingstoke: Palgrave Macmillan).

Todd, B. (2010) "The most obscene thing I've seen recently is Slumdog Millionaire" theguardian.com, Friday 30 April. www.theguardian.com/stage/ 2010/apr/30/edward-bond-interview-slumdog-millionaire.

Town Hall Nation (2011) Archive from now-inactive website. Contact www. sojourntheatre.org for information.

Truscott, C. (2014) Interview with the author, 12 June.

Ulmer, Gregory (1994) *Heuretics: The Logic of Invention* (Baltimore, MD: Johns Hopkins University Press).

Under the Radar (n.d.) undertheradarfestival.com.

Undergrad Civic Professionalism (n.d.) http://imaginingamerica.org/research/ engaged-undergrad/.

Urban Bush Women (n.d.) "Mission" and "Jawole Reflects," www.urbanbush women.org.

USDAC (n.d.) "Cultural Agents," http://usdac.us/cultural-agents/.

Valdez, M. (2013) Telephone interview with the author, 15 July.

—— (2014) Telephone interview with the author, 6 February.

Vallins, G. (1980) "The Beginnings of TIE," in T. Jackson (ed.) *Learning through Theatre: Essays and Casebooks on Theatre in Education* (Manchester University Press).

Vega, M. M. (2013) "Inquietudes – on Being Uneasy," Plenary Remarks, Imagining America 2012 National Conference. New York City: NYU, 5 October. Available in *Public: A Journal of Imagining America* 1.1. Public.imaginingamerica.org.

Vine, C. (2014) Email exchange with the author, 16 June.

Von Eschen, P. M. (2004) *Satchmo Blows Up the World: Jazz Ambassadors Play the Cold War* (Cambridge, MA and London: Harvard University Press).

Wager, D. (2013) Telephone interview with the author, 19 December.

Wali, A. (2013) Presentation at NOCD research meeting, New York, 12 September.

Walljasper, J. (n.d.) "The Promise of Arts-based Community Development," www.instituteccd.org/uploads/iccd/documents/arts_cd.pdf.

Ward, J. W., Jr. (2013a) jerryward.blogspot.com, 21 October.

—— (2013b) Email to the author, 23 October.

—— (2014) Email to the author, 12 October.

Watson, I. (2009) "Borderland Foundation: Building Bridges Between Diverse People," *About Performance: Issue 9*, University of Sydney. www.livingindiversity.org/2011/04/26/borderland-foundation-building-bridges-between diverse-peoples/.

Wheatley, M., and D. Frieze (2006) "Lifecycle of Emergence: Using Emergence to Take Social Innovations to Scale," www.berkana.org/articles/lifecycle.htm.

World Policy Institute (n.d.) www.worldpolicy.org/arts-policy-blog.

Index

Printed and bound by CPI Group (UK) Ltd, Croydon, CR0 4YY